SOME CALL IT KITSCH:
Masterpieces of Bourgeois Realism

SOME CALL IT KITSCH

masterpieces of bourgeois realism

Aleksa Čelebonović

HARRY N. ABRAMS, INC., *Publishers*, NEW YORK

Translated from the French by Peter Willis
The text of the original French-language manuscript,
Chefs-d'œuvre du réalisme bourgeois,
was adapted and edited by Sacha Tolstoï

Library of Congress Cataloging in Publication Data

Čelebonović, Aleksa.
 Some call it Kitsch.

 1. Kitsch. 2. Paintings, Modern—19th century.
I. Title.
ND192.K54C44 759.05 74-8396
ISBN 0-8109-0233-8

Library of Congress Catalogue Card Number: 74-8396
All rights in all countries reserved by
Andreas Landshoff Productions B.V., Amsterdam
Harry N. Abrams, Incorporated, New York
An Andreas Landshoff Book
Printed and bound in Italy

Contents

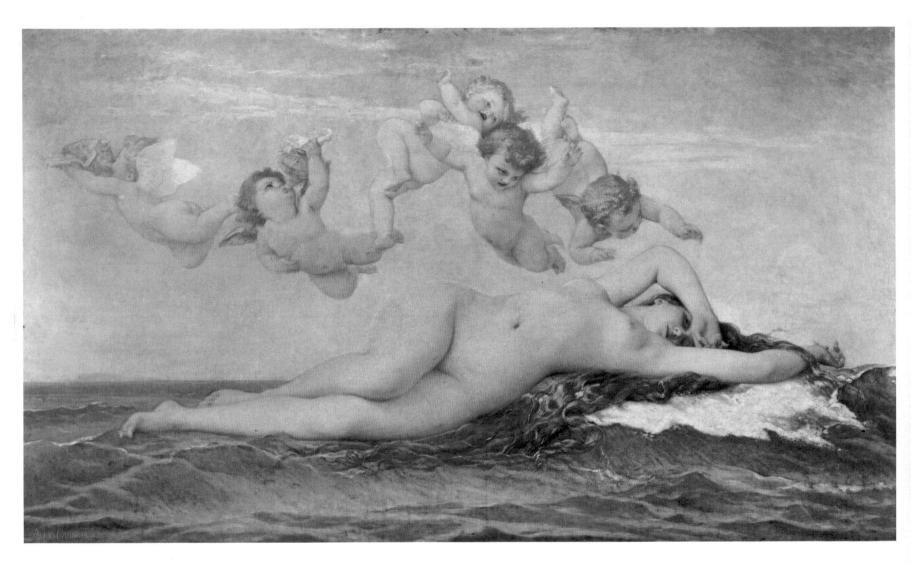

Alexandre Cabanel
The Birth of Venus, 1863
Oil on canvas, 130 x 225 cm (51¼ x 88⅝")
Louvre, Paris

An Overall View

An Unrecognized Trend

Cabanel's picture *The Birth of Venus* shows a naked woman lying, or rather lounging, on the waves as if on a sofa. Its forms conjure up a period when people found entertainment in lavish meals, and had no inhibitions about indulging in the sin of gluttony. They remind us, too, of the female models in the pictures of Rubens, while the warm rosy tones spread over the golden pink are reminiscent of Titian's palette; in other painters these colours only make their impact in contrast to the blue of the sky and the green of the water. Yet one would never feel the slightest temptation to place this picture in a different period from the one in which it was painted.

It was first shown in the Paris Salon of 1863; its public reception was extremely enthusiastic. It was first acquired by Napoleon III himself; in 1879, after he had lost his Imperial title it became the property of the Louvre, and it is still there to this day. The story ends sadly: it was relegated to the museum archives where it was forgotten by critics and art historians, condemned as philistine art, *art pompier*. So it is no longer possible for the descendants of its original admirers even to go and pay their respects to it. There is no doubt that this picture belongs to a different kind of art from the one we have become accustomed to since Cézanne and the Impressionists. It has little in common with the works of the earlier period that the painter clearly has in mind. Neither the lines of the body, nor the softness of the shadows, give the forms any particular significance. The plastic or formal side is underemphasized; so the attention of the spectator is entirely concentrated on the sensuality and, to an equal extent, the harmoniousness of the tender, warm and even artificial colours. The exception lies in the treatment of the face: the drawing of the eyes, the mouth and even the unemphatic wings of the nose recreates the sensuous expression of the gently drowsy model. Cabanel is much subtler in the combination and contrast of the colours he uses than someone like Titian. He appears to have wanted to retain only the Venetian painter's warmth of feeling: so he confines himself to strict, logical, commonsense tones; there is no boldness in his colour. The artist has visibly borrowed certain traits of style from preceding periods, but he combines them and makes them his own. His intention is obvious: he wants to offer the spectator an image of sensuality, but at the same time to demonstrate that he possesses noble qualities inherited from the past.

Thirty years later Cabanel's work was still well known and highly regarded at the other end of Europe. A Polish artist called Wojciech Gerson came under the French painter's influence, and depicted a female character caught in the same pose, in his painting *Resting*. The distinctions between Gerson's and Cabanel's approach are anything but accidental. These differences are not limited to the position of the body, which in the later picture is lying on firm ground,

Wojciech Gerson
Resting, 1895
Oil on canvas, 143 x 195 cm (77³/₄ x 82¹/₄")
National Museum, Warsaw

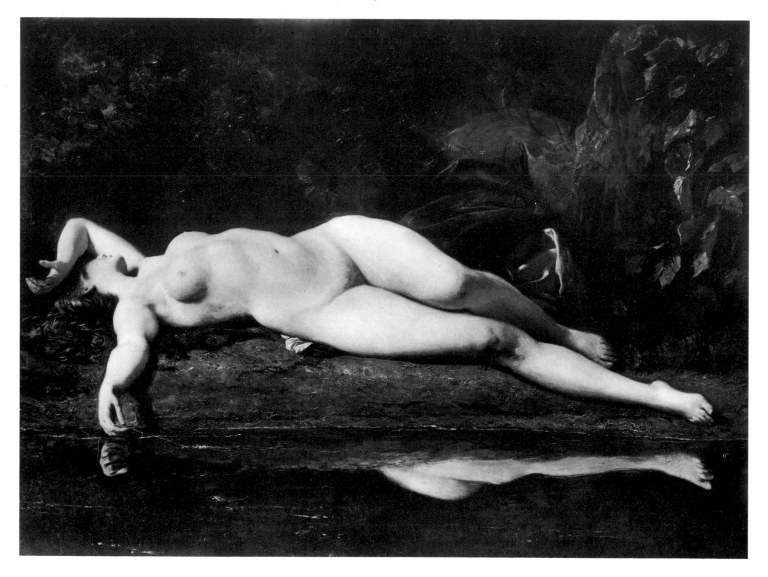

instead of being carried by the waves; here the water is just as much
in evidence, and the model of course is reflected in it. The essential
point is that the drawing is firmer and there is more relief in all the
details. It seems as if Gerson wanted to extend to his whole picture
the precision that Cabanel confined to the face and hair of his model.
The result is that his picture is possibly less sensual than the preceding
one, but more concrete; it is as if the artist is replacing the irresolute
dreams of youth with a photographic record. A comparison of these
two paintings shows that the eclectic composition of the one may
have contributed to the creation of the other. The complex texture of
the first has given way in the second to a firmer, more disciplined
form; consequently, the later picture may have lost something of the
earlier work's visual appeal, but is better equipped to satisfy the
intellect. It would be perfectly correct to conclude that these are works
belonging to the same school; the intentions behind them are quite
clear, and they carry all the hallmarks of a style whose logical evolu-
tion can be traced.

Bourgeois Realism: the Art-Historical Context

It is often said that the nineteenth century is the century of words and the twentieth the century of pictures. It is a statement based on incomplete information and therefore only superficially true. If we incorporate the countless works painted and exhibited in the course of the last century in our history of pictorial art, and if we take into account the vast number of printed words we have been forced to swallow in our own century, then the statement is hard to accept. The end of the nineteenth century and the beginning of the twentieth saw the flowering of a type of realistic painting which was liked and appreciated by the people of the time. Later, this genre fell into almost total oblivion, and since then it has been mentioned in the history of art only unfavourably. Among the most talented members of this school, the names of Cabanel and Gerson are to be found.

It goes without saying that the discovery of new materials which scholarship has hitherto left out of consideration raises new problems in the historical, sociological and aesthetic context. These problems demand to be analysed in such a way as to take account of their various interactions. We should ignore the intolerance and aggressiveness that so often seem inseparable from aesthetic controversies; we should always try to dissociate the works themselves from the problems they pose, and take into consideration the subjectivity that militates in favour of one kind of art and against another. It is indicative of the prejudice with which art historians have treated this period that it was left to the artist Salvador Dali, and not to a historian or critic, to make the following observation: 'Our time has seen the publication of a staggering number of books devoted to contemporary art; there have been practically none devoted to those heroic painters who bear the noble name of *pompiers*.'[1]

The subjects treated by the so-called *pompier* painters, no less than the style of their works, show quite unambiguously that their art was completely bound up with the preoccupations of one or more clearly defined social groups. In the course of their daily life, these groups made such a flagrant display of their conception of the world that their moral values became in a very real way the hallmark of the painting they supported. The direction and importance of this painting were therefore closely linked to its social role; and it is not difficult to understand why it was so highly appreciated by the people of the time, for it provided them with a clearly recognizable picture of themselves. Everyone regarded it equally highly. Official circles showered it with honours and rewards; the leisured classes paid for it to be produced; and even the general public, jostling for entry at the doors of the exhibitions, was eager to admire the works of its most famous representatives.

Thus *The Private View at the Royal Academy,* by Frith, shows us London high society gathering on the occasion of the most important

exhibition of the year. Among those present are personalities from the world of politics, science and the arts: Gladstone the statesman; the poet Browning; Huxley the scientist; the painters Leighton and Millais; and many more celebrities. Surrounded by a group of admirers and sporting a button-hole, Oscar Wilde is conspicuous on the right-hand side of the picture.

The painter was himself a member of the Royal Academy, but it may have been his intention to take the opportunity gently to satirize the social side of these occasions, at which the aesthetes gave free rein to their rather exaggerated raptures. Facing their leader, Wilde, a famous poet and still a young man, the artist places Anthony Trollope, a realistic and anything but eccentric novelist, in the corner. Still on the right-hand side, one of the visitors is contemplating a canvas with his nose practically glued to it, drawn to it no doubt and dazzled by the attention to detail. But for the rest of the guests the exhibition is essentially a social gathering.

Today's aesthetic criteria, which are without any doubt much more tolerant and flexible towards the idea of a copy that emulates the real thing, can help to rehabilitate the realistic painting of this period. The need is being felt to devote more care to the analysis of the genre known variously as *art pompier,* eclecticism, academic painting and even Kitsch; it is preferable, for many reasons, to call it simply Bourgeois Realism. This movement has tumbled from the heights, to be expunged from the history of art and banished from museums and large private collections. There is room for doubt as to the justice of the fate to which it has been condemned: for might this realism not have its own individual mode of expression, and perhaps even a completely different language from the one we have become accustomed to using?

Clearly, the disgrace into which these works have fallen is due to aesthetic reasons; this must be so, because the ideology which produced them has manifestly survived them. Beneath the banner of a new conception of art, scorn has been poured by aesthetes not only on the techniques of Bourgeois Realist painters, which followed principles accepted at the time, but also on their moral ideas; for their painting not only received its inspirations from these views, but also in a way acted as a mouthpiece for them. Nobody has taken any interest in the ideological content of these works, and yet they constitute an irreplaceable document for studying the past and its links with the present. A religious turn of mind is not indispensable to admire the art of the Middle Ages, nor is membership of the economic liberal school of thought essential to an appreciation of the Bourgeois Realist painting of the end of the nineteenth century. Yet if we know about the dogmas and moral laws of the faith which inspired the works of art of the medieval period, our judgment will undeniably become both more penetrating and more objective; and the same applies to Bourgeois Realist painting.

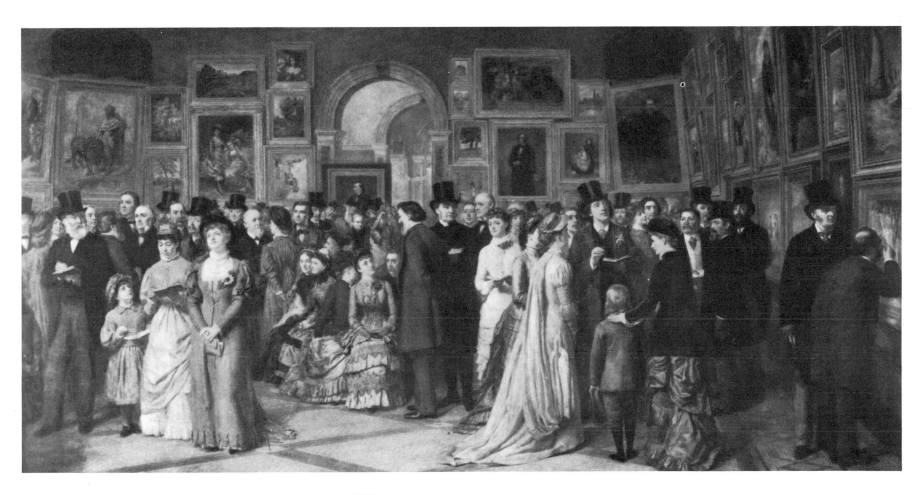

William Powell Frith
*The Private View at the Royal
Academy,* 1881
Oil on canvas, 103 x 196 cm (40½ x 77″)
Mr C. J. R. Pope, London

Sir Hubert von Herkomer
The Old Guards' Cheer, 1898
Oil on canvas, 296 x 192 cm (116½ x 75″)
City Art Gallery, Bristol

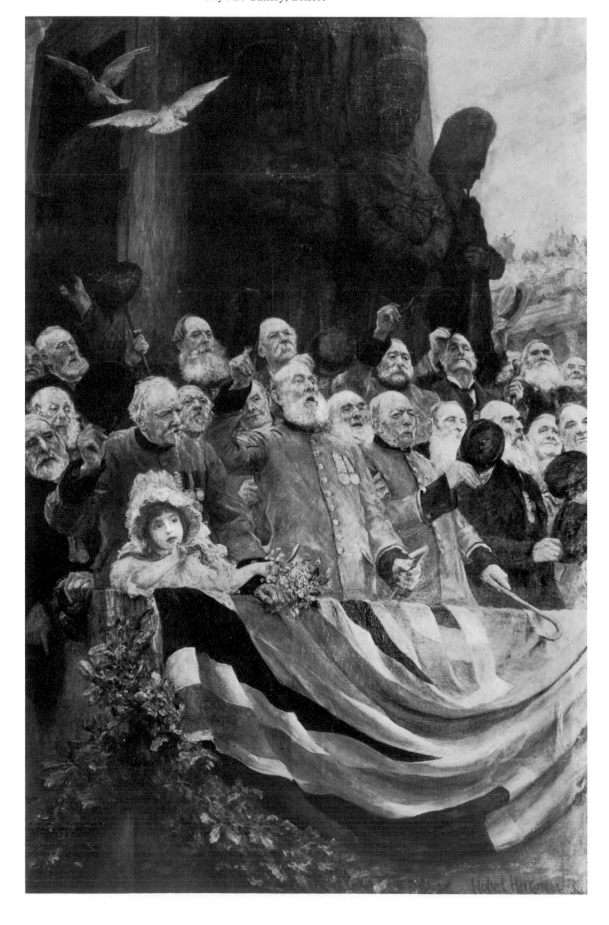

The old soldiers in Herkomer's picture *The Old Guards' Cheer* perfectly embody this ideal. The fact that they come from different backgrounds does not prevent them from taking part in celebrations together and singing the marching songs of their youth. In their patriotic elation they communicate with each other, and the public no doubt shares the same feelings as it welcomes Queen Victoria at Waterloo Place, beneath the Guards' Monument. In order that the spectator may also join in this sentiment without being distracted by the decorative elements of the picture, only the faces and uniforms are treated in detail, and colours are confined within the range of browns. The age of the characters, their perfect physical health, and the respect they receive, all bear witness to a society which shows its gratitude to those who serve it well.

It is not possible to judge a work purely on the basis of optical laws and of an aesthetic awareness conditioned by changes of taste. This much is clear from the vicissitudes of the painting we are discussing. During the past decades, art historians have tended to have eyes only for Impressionism; this movement has been placed at the centre of all artistic problems raised since the end of the last century, because it managed to offer painting new technical solutions. The historians were motivated by the desire to return to the sources of modern art, as has happened again and again in the study of revolutionary currents of the first half of this century. But there were some trends of whose importance they were, for the most part, not aware; and they have failed to draw a complete picture of a period in which the sources of modern art existed only outside the confines of official art, on the very fringes of social and artistic life.

But it would for instance be unthinkable, in a study of the Byzantine period, to ignore the Imperial art of the third and fourth centuries (for instance the mosaics of the Palace of Piazza Armerina), on the pretext that at around the same time the catacombs had given birth to a different kind of painting, namely Early Christian art; and so in the bourgeois period we must not fail to take account of the artistic form which best illustrates the aspirations of the ruling class. Research concentrated on Impressionism and its immediate effect on the world of painting is therefore calculated to interpret the present rather than to draw up a complex chart of the past. So the realistic art of that time suffers ostracism quite simply because it has had no further meaning in the subsequent development of art.

Historical Objectivity

There is no such thing as definitive, absolute truth. On the other hand, one is entitled to demand that the objective historian should define the rules he adopts, and should possess 'the awareness of what, from one period to another, alters the point of view from which the past is considered' (Morazé).[2] The problem of objectivity is the same when studying the history of art as it is when looking at the works themselves. The purpose of objectivity is to establish the existence of different stages in the evolution of art, and then to analyse each of these stages in turn. This segmentation becomes more useful when it uses a large quantity of different sources of information to establish that such and such a stage represents the activity or self-expression of a defined human group. From a historical angle, these stages act as signposts in the labyrinthine maze of the past. This sort of comparison is dictated by the problems of explaining the art of periods when human activities were least sophisticated; yet there is no reason why it should not be applied to other stages of evolution where works of art appear in a technically developed form as products of complex social structures.

The celebrated picture by Repin, *They Had Given up Waiting for Him*, illustrates a very specific social situation in the context of Tsarist Russia. The picture is about exile, with all the dramatic connotations that this carries; it is the very day the prisoner returns home. Without begging the question, the artist evokes the moral problems that confront the revolutionary: his duties towards his family and the knowledge of the sacrifices he is imposing on them. The picture presents a striking contrast between the simplicity of the composition and the dramatic complexity of the moment depicted, and this is what gives it its particular originality. Before arriving at this result, the artist spent a long time contemplating his subject and producing a large number of variations on the same theme. First of all he was not sure whether to make the exile a man or a young girl student. He ended up by choosing the first, no doubt because it was truer to life. In the version belonging to the Tretyakov Gallery, which is rightly considered the definitive one, the exile approaches from the back of the picture and moves towards the foreground. The wide-open door, with the servant girl standing motionless in the doorway, represents the first stage in his progress into the room. One can detect a momentary stupefaction in the attitude of all those present. The old woman gets up from her armchair as if drawn by a magnet and the children look up from their reading. All the faces are fixed; none of them expresses joy.

The history of art necessarily implies a free choice of those works which can be interrelated on the historical map. The more witnesses a period has left behind, the more difficult such a choice becomes. This explains perhaps why people at certain periods were careful to

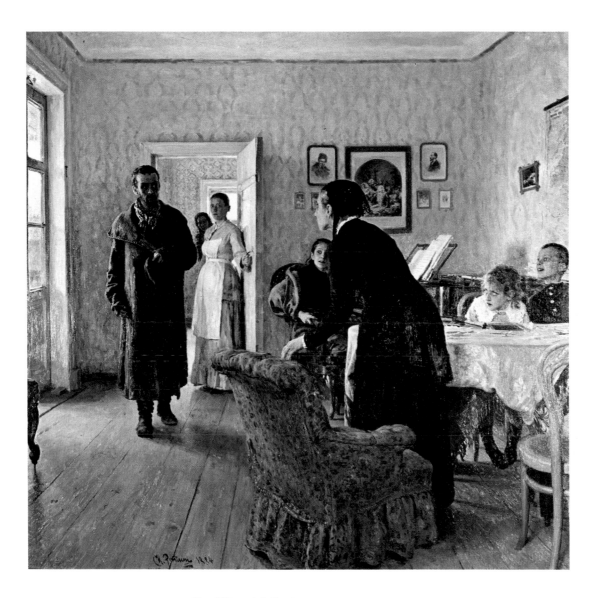

Ilya Efimovich Repin
They Had Given up Waiting for Him,
1884
Oil on canvas, 161 x 168 cm (63⅜ x 66″)
Tretyakov Gallery, Moscow

destroy certain works of art, in order to make them unavailable for subsequent re-interpretation. Jean Dubuffet has paid well-merited respect to these vanished works.[3] He holds that the history of art is based entirely on those creations which the bureaucrats in charge of culture happened to like. For every single work that these people condescended to preserve, many others which may have been more authentic were consigned to oblivion. It is arguable that this is pure hypothesis, especially in the case of the remote past; but as far as the end of the nineteenth century is concerned, there is plenty of evidence that it actually happened. In some countries people have chosen deliberately to ignore certain stylistic or ideological patterns related to this period, and the works corresponding to these patterns have been rejected, with no respect for contemporary opinion, however favourable.

As soon as popular opinion or majority views are invoked in discussions of art, certain observations can be made. Obviously the sheer number of devotees of a work of art is not automatically an indication of artistic worth; similarly, we cannot regard isolated creations as representative of a particular period, basing our judgment purely on that of contemporaries. We must go further and show that there are creative systems in these works from which a style has developed; we must then decide whether these works are random examples or part of a conditioned phenomenon. The relative aesthetic value of an artistic creation is always based on two factors: the possibility of comparing it with similar objects, and the opinion of the person who analyses or perceives it, whether a specialist or an amateur. The first factor permits formal analysis, while the second measures the effect of the work at the moment of this analysis. Consequently, judgments and conclusions depend above all on the person who looks at or appreciates a work of art. Artistic value, both in what it means and how long it lasts, is dependent not simply on the nature of the processes or professional skills behind the creation of an object but equally on what the spectator himself can find in it or impute to it.

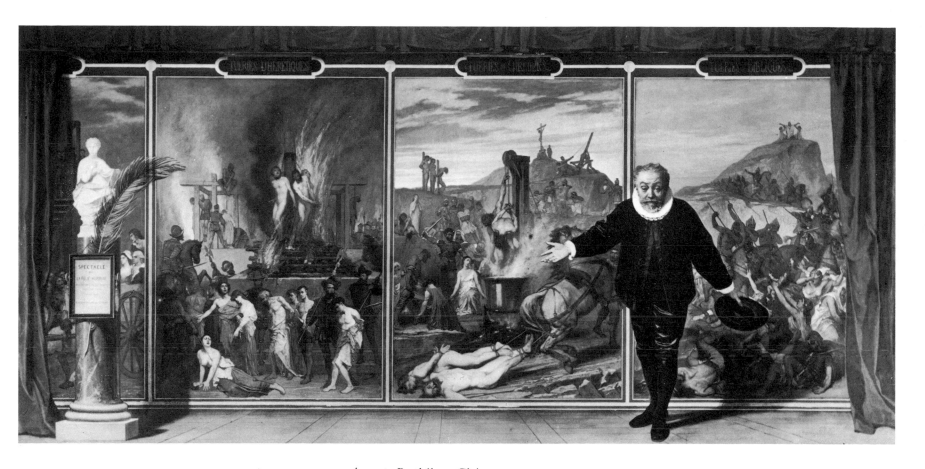

Auguste-Barthélemy Glaize
Spectacle of Human Folly, 1872
Oil on canvas, 142 x 300 cm (56 x 118⅛")
Musée des Beaux-Arts, Arras

Art as a Record of the Past

Glaize's picture *Spectacle of Human Folly* combines the historical event and its interpretation within the same composition. Here, both from the point of view of creative vocation and at the level of the process of exposition, the artist has stepped out of the confines of his role. The theme of the work develops on two parallel planes. On the first plane, reality and the present moment are represented by the face of a man (it may be the painter himself) discoursing on the eternal human tragedy. To provide a contrast with the content of this message, the person transmitting it is wearing a costume apparently borrowed from one of Molière's plays. The central theme is revealed in the second plane and is composed of scenes of torture from different historical periods. It is quite interesting to compare the high degree of realism attained in the *trompe-l'œil* of the foreground with the conventional style of the imaginary pictures. It looks as if Glaize wished to give his work immediacy while at the same time making it a medium carrying a spiritual message from the past.

21

When today we probe into the meaning of a modern picture that has attracted us, it is clear that 'we are, through the symbol provided by the work of imagination, participating in an intangible society which lies beyond it' (Duvignaud).[4] The same phenomenon occurs when we turn in the opposite direction, towards the past. There, too, we can find tokens or symbols in art which contribute to our deductions about the atmosphere of the period, the life of society, its material and spiritual preoccupations; art seems to crystallize or condense them in some way. Thus the painting of the end of the nineteenth century will enable us to make these sorts of deduction about the life of the period; though the motivations that draw us to the painting are no longer the same as those which activated the people of the time. We no longer find in it an echo of our own aspirations, but an obsolete set of attitudes and an imagination that is disarmingly ingenuous. It is not their trueness to life that is so exciting in the skill of those masters, since we do not regard them as competing with the early photographs of the time; it is their approach to their subjects, and their use of a particular technique which is perfectly at harmony with their intentions.

The Reassessment of Bourgeois Realism

The precise attention to detail exhibited by the Spanish painter Vicente Palmaroli in his *Confessions* is the natural product of a powerful narrative imagination. The picture in question reveals all the details of the material with which the young girl's dress is made; nothing goes unobserved, from the artificial flower decorating her hat to the wickerwork of the enormous basket seats. Even the chair lying on its side, its back lightly sunk into the sand, has not been forgotten, in spite of its decrepitude. Of course all this detail has more of an anecdotal than a visual effect. What was the intention of the artist here? Apparently it was to enhance the feeling of tenderness and gentle surprise aroused by the young protagonists of the scene, sitting on a deserted beach when it is still too cold to bathe or to sun oneself. The delicate tones remind one of samples of fabric rather than suggesting any direct contact with nature itself.

From the relationship established between the work of art and the spectator comes the decision to accept or reject its artistic value; this decision is based on the originality of the composition and the balance between technique and content. This relationship in its turn leads to two mutually contradictory and decisive stages. One of them concerns the visual (or formal) aesthetic which has established itself in the course of the evolution of modern art; most of the works of Bourgeois Realism have met their downfall by being attacked from this standpoint. The second stage relates to Surrealism; this movement aroused in artists an increased interest in the narrative genre and the confessional approach. It was Surrealism which extended the

Vicente Palmaroli
Confessions
Oil on wood, 137 x 63 cm (64 x 24¾″)
Prado, Madrid

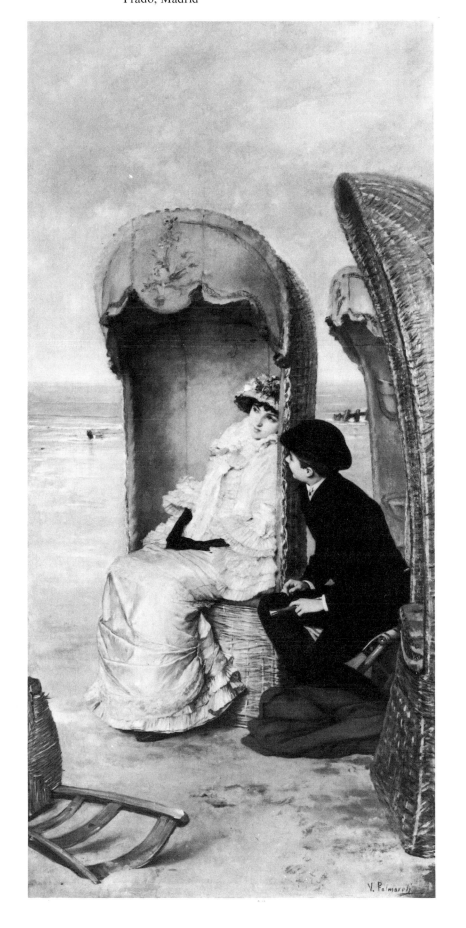

scope of psychological and psychoanalytical problems to affect both painting and criticism, and thus gave these activities a new dimension. This characteristic manifested itself in the appearance of new subjects in which an increased interest in the accumulation of detail was apparent. Whether these subjects related to dreams, the imagination or the subconscious, they were couched in a realistic form, and hence some Surrealist painters showed a predilection for the smooth and detailed technique of their predecessors. This is how works of the Bourgeois Realist school have returned to the forefront of interest, just as much for their technique as for the themes they deal with.

A reconsideration of this realistic movement, which has been trammelled with unfortunate names like 'Kitsch' and *pompier*, leads to one conclusion. If it is true that this genre embodies an original idea, and presents us with a picture of the unfamiliar world of a period in the past; and if it is equally true that it uses methods of expression that draw on the lessons of the past while developing qualities of their own, especially in the naturalistic representation of beings and objects; and finally if this trend was assured of the backing of the social milieu in which it was born, then it must certainly be allowed the status of an authentic movement within the history of art.

Bourgeois Realism, the *art pompier* which was to attract the fury of everyone who wanted to liberate colours and forms, did not appear until after 1860, and enjoyed public favour until the beginning of the following century. After this period, in a different and rather subdued form, works of this genre continued to occupy a place in the artistic life of the pre-war period and even later. Even at its best moments, Bourgeois Realism looks like retrogression in relation to the schools which immediately preceded it: Neoclassicism, Romanticism, as well as Courbet's Realism in its early stages. This conclusion is much the same if one compares it with other movements of the period, such as Impressionism, or indeed the work of Cézanne or Van Gogh. Finally, although it is often associated with Art Nouveau and Symbolism, Bourgeois Realism has neither the evocative force of the one nor the emphatic stylization of the other, and so it plays a less prominent role in the overall evolution of the arts. However, it cannot be called retrograde compared with previous trends, or inferior to other movements of the period, unless one adopts aesthetic criteria that developed after Cézanne and the Impressionists, based on formal analysis. Given that any form of art can only be fairly considered within the limits of the society that produced it, it follows that Bourgeois Realism can reveal its qualities and limitations only if the proper analytical instrument is used. That is why the concept of retrogression, with the condemnation that it implies, cannot be applied to the works of *pompier* painters without certain qualifications. This particular school of art was the most precise reflection of middle-class society at the very height of its prosperity.

Bourgeois Realism and Modern Art

Whenever we study the social role of works of art during the previous century, we never cease to be conscious of the part they can play in our own times. The analogies are highly instructive and rather disturbing, especially if one observes the way in which society, or rather the authorities acting on behalf of society in the field of culture, behave towards works of art. One form of intolerance has given way to another. Just as, in the nineteenth century, all the official exhibitions contained works of the same sort, the majority of museums in the so-called Free World today, which have the responsibility of collecting the works of contemporary artists, acquire specimens which are almost interchangeable. Then as now, works were refused entry if they failed to meet certain requirements or satisfy the demands of official arbiters in cultural matters. It might even be suggested that society feels at ease only when accumulating homogeneous works. What was true of the middle classes of the past is no less valid for the intellectual élite of today. In both cases the choice of works of art collected in museums and private collections responds to a very clear-cut desire to bring the different geographical centres of culture closer together. This choice safeguards the cultural image that society wishes to present to the world – a completely arbitrary image, of course – and destroys any broader picture of the artistic expression of the period.

It would be wrong to think that a new examination of the so-called *pompier* movement is intended to discredit the endeavours of modern art. Similarly, it would be out of place to make forced comparisons between the function of art in society today and at the end of the last century. The ties between art and society are much more numerous today than they have ever been. Industrial society, according to Duvignaud, 'enabled all aesthetic attitudes, and all the functions of art, to blossom',[5] and this was not possible in the eighteenth century when it was still linked to pre-Revolutionary political structures, at least in France. Although art now evolved within a liberal social framework, it nevertheless conserved certain features of the period of centralized monarchies, which were supported by an administrative and commercial middle class. One of the functions of this art was to glorify the established order and to sing the praises of the peaceful life these monarchies had established. Artists continued to draw acceptable themes from the past of history or legend; but they also found them in contemporary life, especially in the lavish official celebrations of their own country or abroad.

In the Bourgeois Realist period, art and especially painting tended to support a certain way of life which was subject to the moral code of the middle classes. Thus a fair number of artistic works bore witness to the excellence of middle-class morality.

The Triumphant Middle Class

Middle class, or middle classes? This is a very important question, even though we are discussing art. Modern sociologists tend to like the use of the plural, since they are accounting for different levels of bourgeoisie with their particular idiosyncrasies. Politicians, on the other hand, more often use the term in the singular, since they are chiefly concerned with the common interests of its various strata, especially with regard to their conflicts with the peasant and working classes. Since official painting offers us plenty of examples of social observation, it is often helpful to make clear distinctions between the different levels of middle class. On the other hand, we need not make such distinctions when we are looking at works which deal with more general problems, such as religious or patriotic sentiments.

The first distinguishing criterion that sociologists use is material wealth. But we must realize that it is not the only one. Habits and modes of existence, as evidenced in art, depend on a conception of the world peculiar to the middle class. Income is, generally but not always, the root of these attitudes and habits; it provides a more or less fertile soil where they can grow, but does not totally condition them. Thus, the situation sometimes arises where the upper middle classes refuse to give up their habits when their incomes decrease or even totally disappear; or on the other hand where a lower middle-class way of life is maintained in much improved material conditions. In the first case it is common to talk of people who are ruined yet refuse to lose their dignity, in the second of *nouveaux riches*. The literature of the last century provides a mass of examples of tremendous upheavals due to people passing from one layer of the bourgeoisie to another. Painters themselves have depicted scenes of daily life showing the effects of such changes.

Martineau depicts the reactions of various members of an English family as they leave their house for ever (*The Last Day in the Old Home*). While the old lady discusses the condition of the sale with a property agent, her son, the father of the family, whose elegant appearance leads one to suppose he may be responsible for the general ruin, stands in the middle of the room with a glass in his hand, before the slightly perplexed gaze of his son.

Social differences also lead to variations in attitudes, modes of dress or psychological behaviour. This is most easily seen in the portrait. There is a sharp distinction between bourgeois portraits and those of the declining aristocracy, just as there is between the upper and lower middle class. These pictures generally draw attention to the slightest social nuances, yet one must be careful and take account of a human trait very common in the nineteenth century: some of those who failed to climb a rung in the social ladder tried to persuade their neighbours that they had actually done so by giving themselves airs above their station.

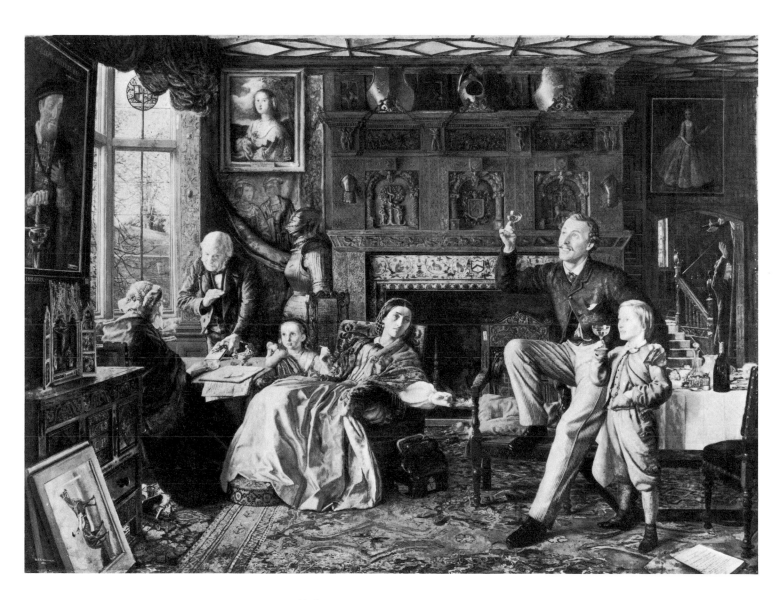

Robert Braithwaite Martineau
The Last Day in the Old Home, 1862
Oil on canvas, 108 x 144 cm (42 x 57″)
Tate Gallery, London

Raymond de Madrazo, a celebrated artist who spent his time between Madrid and Paris, in his *The Marquise d'Hervey, as Diana* portrays an upper-class lady as a goddess. There is nothing surprising about this transfiguration, for it had long been common in painting; on the other hand, the realistic technique contrasts with the eighteenth-century style that the portrait painter took as his model; no doubt he was complying with the wishes of a clientele which looked back nostalgically to a bygone period. In any case, the eclecticism of the whole composition is striking. The Marquise certainly posed for her portrait, to judge by the lighting, which is almost vertical and typical of a studio. She is seated on the back of a seat which has become a sort of rock, and the rest of the countryside with its deep coloured sky is purely imaginary – a memory, perhaps, of a picture by Goya. The cold, arrogant expression of the face can be explained by social considerations. In this period, French high society regarded woman as an ethereal creature, exempt from the travails of earthly life.

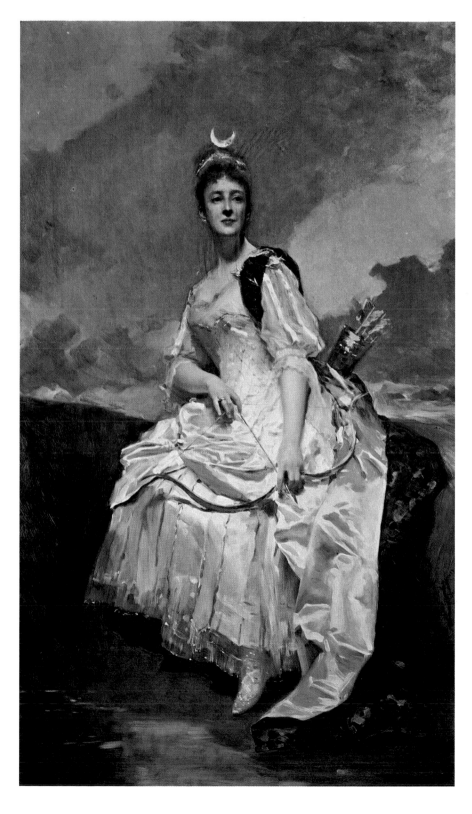

Raymond (Raimundo) de Madrazo
The Marquise d'Hervey, as Diana, 1888
Oil on canvas, 134 x 83 cm (72¾ x 32⅝")
Louvre, Paris

At a time when the aristocrats were doing their utmost to look like gods and goddesses, and the middle classes were imitating the lessons of the aristocracy, the Polish artist Jan Matejko, the most renowned historical painter in his country, succumbed to a similar temptation. His self-imposed task was to arouse the patriotic ardour of his compatriots by offering them vast compositions of the most significant moments in Polish national history; and so, for instance, he painted his young wife (*The Artist's Wife in Wedding Dress*) not as an artist's spouse but as an austere, impressive sovereign. In this picture, everything is subordinate to the glorification of national feeling: the authoritarian expression of the face; the way the woman is sitting,

Jan Matejko
The Artist's Wife in Wedding Dress
Oil on canvas, 138 x 106 cm (54¾ x 41¾")
National Museum, Warsaw

suggesting stability; the sumptuous finery, the necklace, the tassel on the cushion, and even the background with motifs drawn on a tapestry of repoussé leather. Painted with great thoroughness and conviction, this canvas conveys an impression of grandiloquence, especially in comparison with the contemporary works of the Impressionists.

In the portrait *Madame Bittó*, by the Hungarian painter Miklós Barabás, we are confronted with one of the most magnificent examples of a woman conforming to the bourgeois ideal. Dressed with conspicuous simplicity in a gown of transparent grey material (which must have cost a fair amount, as must the two rows of massive pearls) the sitter has chosen a pose that emanates modesty, yet in no way detracts from the complete self-assurance that comes from a sheltered existence and a strict moral code. Furthermore her character is divulged by her way of crossing her hands, her open face and charming look, full of sympathy and gentleness, directed towards someone standing near by. This is an intelligent and cultured woman with plenty of charm, who has decided to hold herself in reserve to

avoid squandering her strength or her income, and instead to devote them entirely to her beloved family.

Bourgeois liberalism is an economic system in which the acquisition of goods and the disposal of incomes are subject to violent changes of fortune. It is easy to become rich, and easy to lose everything; and reversals as well as successes are laid at the door of one's own personal character. In a world in which industrial production increased and diversified daily, and new modern means of transport were always opening up whole new fields of possibilities, easy or even meteoric rises were more common than bankruptcies, especially for those who acted as the middle-men of economic life.

Miklós Barabás
Madame Bittó, 1874
Oil on canvas, 84×66 cm (33×26″)
Hungarian National Gallery, Budapest

The immediate effects of this state of affairs were not long in making themselves felt at the level of the family itself, where the desire and need to enrich oneself had their origin. This is where one must seek the origin of the realist outlook on the world – the origin indeed of a specific ethos and mode of life. To attain the objective unanimously endorsed by the whole middle class – the accumulation of wealth – there was only one method: to cut one's costs while increasing one's income. To achieve this more easily, it was convenient to keep books of accounts under clearly defined headings, so that heads of households could practise a policy of saving that excluded no member of the community. Marguerite Perrot, in a book that is strictly about economics but throws a great deal of light on the way of life of the middle classes in the nineteenth century, went so far as to define the bourgeoisie as 'those families who keep accounts'.[6] Neither the nobility of the previous centuries nor of course the peasants had adopted this habit. The nobility handed everything over to their professional administrators, whose competence was limited

to receipts and expenses relating to the areas under their control; they had no right to examine the personal expenses of their employers. The peasants, if they had any idea at all, only kept an overall account of what they earned or spent. The workers too, far from keeping detailed books, tended to keep no accounts at all.

What Marguerite Perrot discovered in the account books of the middle class was known to us through the literature of the time, but had not yet been subjected to rigorous analysis. It is interesting to look at some examples. It was obligatory, for instance, to employ servants, even if the family budget showed a deficit; the wages of these servants did not vary, in spite of periodical inflation and increases in the cost of living; in the expenses column, an important place was reserved for the attire of the lady and gentleman of the house; it is equally fascinating to see how ingeniously they economized on their children's clothes, school materials and education, which particularly affected the larger families. But the most intriguing of all is the section headed 'Sundry Expenses', which included 'good works, regularly entered in the family budget', subscriptions to newspapers and magazines, annual contributions to various societies, travel and summer holidays, meals at restaurants; in fact all irregular expenses. These 'Sundry Expenses' occupy an important place in the family budget, comprising on average 26·6 per cent of the total outgoings (this estimate holds good for the 1873–1913 period, which is precisely the one which interests us here).[7] We can add at this stage that a major part of the themes dealt with in this period in easel painting recaptured the agreeable moments and exceptional occasions which were represented by the items in this last column of the accounts.

So Bourgeois Realist painters often dealt with the varied aspects of family life in their works. They evoked the ambivalent atmosphere of these bourgeois circles: for here the world of affections and feelings was always subordinate to material considerations. Of course these artists gave priority to anything that enabled the bourgeoisie to recognize and assert itself. In contrast to these affirmative scenes are those depicting the 'reprobate', the person whose behaviour put him beyond the pale; he still enjoyed a certain amount of indulgence, summed up in the epithet 'unhappy' which was applied to him. There is clearly a reminder here of the Christian moral code, and a warning of the penalties incurred by the unrepentant sinner. But the need for redemption had lost all its force, and it was rare for the black sheep's presence in the community to unleash a real campaign of intolerance. The literary works of the period are full of examples in which material interests, and even the world of the feelings, prevail over bourgeois morality. Just look at Flaubert's *Madame Bovary*, Zola's *Nana*, Tolstoy's *Anna Karenina*, Dumas's *Dame aux Camélias*. The authors of these books took upon themselves the task of explaining the psychological mechanism which had led each of their heroines in turn to stand up against the moral laws or even infringe the civil ones; yet they were not interested in condemning free love, as Dante had, in the name of supposedly incontrovertible principles. Society was beginning to take account of feelings and passions, and it sometimes showed that it understood those who had failed in their duties. And understanding is some way towards acceptance.

Eclecticism as the Expression of a Moral Compromise

The Polish artist Franciszek Zmurko, in *The Sinner's Past*, combines sensuality and death in a single image. He appears to have been inspired by the works of the Venetian masters of the end of the sixteenth century, which depicted homage being paid to the Virgin, or to personifications of the city itself. The painter has stripped the women's bodies of their rich brocades, so that his heroine and her servants have more brazen, even more provocative attitudes than their Renaissance counterparts. On the left of the composition stands an old poet, near to death, his body already bent with age but still

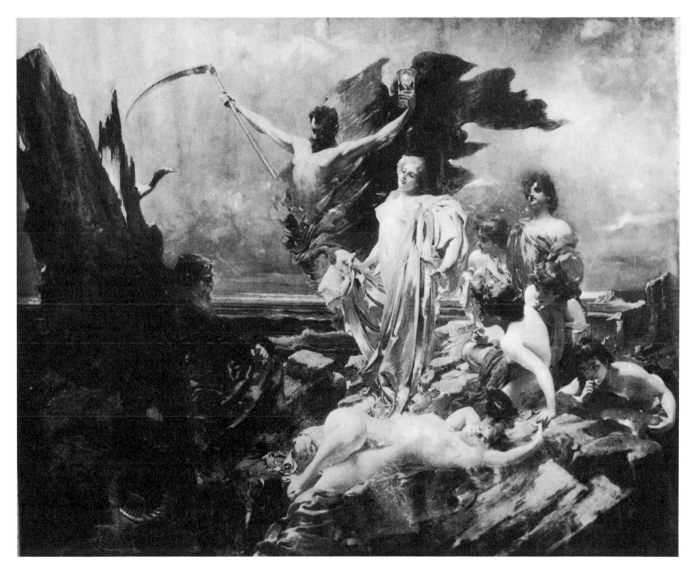

robust, his head reminiscent of Tintoretto; he has replaced the Doges and donors of the past, while the inevitable rows of steps and imaginary buildings have given way to rocks. This is how religious painting made its contribution to the new religion of enjoyment.

It is worth saying a word, perhaps, about the intention of the picture. There is nothing unpremeditated about the rather ambiguous presentation of the subject: it is unclear whether or not the poet is meant to be a sinner and be chastised – apart from the obvious punishment of taking his leave of such an attractive and splendid sight.

In spite of a relaxation of the rules, the nineteenth-century bourgeoisie gives no sign of a real breakthrough in the direction of the free enjoyment of sensual pleasures, which was more than ever before related to the question of income: that is to say, to the size of the amounts inscribed in the account book under 'Sundry Expenses'. The middle classes managed to find a useful compromise between obeying the moral code that governed family life and regulating the permitted pleasures. Another aspect of this problem can be found in

Franciszek Zmurko
The Sinner's Past
Oil on canvas, 275 x 335 cm (108¼ x 131⅞")
Private collection, on deposit at National
Museum, Warsaw

the obedience to rules of traditional morality. This obedience was in no way intolerable in the form it took, thanks to an adroit compromise between the practice of a religion that retained all its prestige and a mode of behaviour that was utterly cynical and irreligious. This system worked in the family itself just as smoothly as outside it. Religious tradition still played an important role as regards the institutions of family and marriage; but it had become an irrelevance where conduct outside the family circle was concerned.

It is common to emphasize the influence of the eighteenth-century Enlightenment and its positivist thinkers on the political institutions of the nineteenth century. Among the direct consequences would appear to be individualism, the right to vote, the separation of Church and State, as well as the system of lay education practised in France at the end of the last century. Bourgeois art, and especially painting, took these splendid ideas under its wing every time it was necessary to comply with the requirements of official commissions. In their turn, works destined for individuals often covered themes closely connected to everyday life, and to the principles which governed it; and these principles too were ultimately derived from philosophical trends, even if one cannot pretend that the ideas of Rousseau, Voltaire or Auguste Comte were likely to crop up frequently in the day-to-day relations between individuals. Furthermore, there was a clear dichotomy between official ideology and the spirit of technical progress, on the one hand, and the social relationships born of the technology of the period, on the other. It is nonetheless true that philosophy gradually permeated the conceptions of the man in the street. Everyone had, as he has today, his own little personal philosophy; but the gap between this and any systematic organization of ideas was enormous.

If the Bourgeois Realist painting of the end of the last century is distinct from the preceding periods, it clearly owes its individuality to its ideological, moral and social content. Eclecticism here takes a distinct and unique form, which excludes the possibility of substituting a different set of borrowings. It is the result of an attitude of compromise which was the particular product of the middle classes. It is based on a reconciliation of the inherited beliefs of the past and the hopes placed in the future; of course, the bourgeoisie only paid lip-service to the former, while observing the greatest caution in their approach to the latter. This was the new ideal: on the one hand, it called for liberty and equality for all men; on the other, it encouraged individualism and egotism which directly conflicted with these noble aims. People preached freedom of thought and of religious persuasion, as well as freedom in work and in its organization. They affirmed the equality of rights and duties of citizens, certain of their belief that everyone's individual liberty could be catered for in this way. At the same time, private life was full of petty conflicts between selfish interests. This was particularly apparent in professional

relationships, in industry and commerce, as well as on all sides of family life.

Contradictions of this sort gave birth to men with two faces. Feelings of enthusiasm for a particular scheme of human progress, and altruistic sentiments towards less fortunate human beings, conflicted with personal interests within the same individual; loyalty to religion was counteracted by an inherited rationalism; and the sense of family responsibilities was an obstacle to adventures of the heart and sensual experiences. It is true that all historical periods have had their own particular contradictions; but the second half of the nineteenth century was exceptional. This period deliberately developed its own contradictions. These are partly related to the values that were officially preached and partly to the unfortunate social repercussions of the economic system of the day.

There are profound reasons for the way in which painting faithfully mirrored all the clashes of daily life. When artists received official requests, which were still very common, they rushed to draw attention to the ideas of which the authorities approved. But when they were dealing with private clients, it seemed quite natural to offer them, not the religious, philosophical or political allegories that tended to leave them cold, but situations which directly affected or concerned them. The house of any important man became a centre of social life and a place where he could display his wealth, a privilege that had previously been limited to the nobility; and he became more and more conscious of a need to establish his personal status and that of his whole family by purchasing decorative *objets d'art* and paintings for his guests to admire. In this way the social position of the head of the household, and the lofty values of the bourgeoisie, were reaffirmed. Almost all the painting in the second half of the nineteenth century is an endeavour to reflect a specific ideology in a flattering way. It offers an attractive image of the life of the relatively small social group that held the strings of economic and political power.

Sources and Style

When Bourgeois Realism appeared on the scene, both Neo-classicism and Romanticism had already made their contribution to artistic expression. The first of these had flaunted the civic and moral values of the heroic and mythical age of antiquity; the second had extolled the forces of nature. Between these two poles appeared the passions and the virtues, and then national consciousness was born, and suckled on the history of a glorious past with its political traditions and cultural treasures. What these subjects did not reflect was the contemporary predilection, not only for conventional abstractions, but for all the values that the bourgeoisie had consolidated in its matter-of-fact daily existence. People did not have the patriotism of the Romans, the courage of the Greeks, the religious devotion of the Middle Ages – or even the military prowess of Napoleon or of his great adversaries. Society was trying to carry on a way of life in a climate that was peaceable, benign and economically prosperous. Everything that was foreign to this way of life, but which nevertheless deserved attention, was automatically pushed back into classical or mythological antiquity; as for more out-of-the-way dramas and passions, whether involving the law, politics or private affairs, it was generally agreed to turn them into episodes from the Middle Ages or the Renaissance.

The new assumptions served as a springboard for the development of a new style. It evolved from the nudes of Neoclassicism, borrowed features from Romantic contrasts and atmospheric effects, and then sought its inspiration among the brand-new themes that had marked the beginnings of Realism. But the decisive influence was that of a new process, first named 'heliography', then 'daguerreotype' and finally 'photography'. At the beginning this influence only made itself felt indirectly. It is already present in the unexpected course taken by the inspiration of certain painters, a number of whom, including some of the most famous of all, tried to do better than the camera. Then the situation evolved, and the same artists began to use photography as part of the creative process.

Between these three sources of influence, Neoclassicism, Romanticism and photography, the interrelations are many and varied. But the intention always remains the same: the result, in content as well as form, should be a finished work. In spite of the incredible proliferation of different motifs and sources of inspiration, Bourgeois Realism remains faithful to a workmanlike attention to detail that is directed more to the cognitive than the sensory faculties of the spectator. In any case, there is much more sentimentality than real feeling in these pictures, and spontaneous expression gives way to affectation. It must be made clear, too, that this sentimentality derives from an attitude to art quite different from our approach today. It seems quite normal today to judge the sensitivity of an artist by the way he works – the

way he uses his brush, his 'hand', quite apart from the way he uses colours. The spectator of the nineteenth century had quite different reactions. His attention first of all had to be attracted by the subject; professional ability in his view was only there to serve the story, which it had to tell as clearly, concisely and accurately as possible. The *finish* of the work was therefore an essential condition; without it the work would not be deemed to exist. Everything else was seen as preliminaries, sketches, preparations for the final result. In spite of all the care lavished on the intermediate stages, there was no question of giving them a status they had no right to: the status of the finished work.

Albert Boine has written a book full of fresh information which helps one to have a better understanding of nineteenth-century painting; he describes the minutest details of the stages through which a future painter had to pass before being accepted by his teachers and the public. Not that people undervalued the inspiration of the moment – the first idea passionately seized on by the artist – or were insensitive to the profusion of colours which seemed to leap up from the sketch; but it was essential for these elements to be in their turn integrated in a precise representation of empirical reality. Furthermore, the situations depicted had to be true to life in themselves, at least conforming to our experience of the external world. This correlation between the pictorial process and the various aspects of immediate reality became the criterion for recognizing good painting.

The subject, too, was never chosen at random. The artist had to be able to see more in it than something merely pleasing to the eye before he was prepared to launch into so complex a task as the execution of a canvas. People expected a message that gave the picture a wider significance, and so made it practically an allegorical work. This symbolic value was completely at one with the morality of the period, and was generally based on a narrative content worthy of the novelists of the day. Finally, the subject never slid towards an abstract arrangement of forms for their own sake, as was to happen in the twentieth century.

Reality and Symbolism

One of the essential differences between the way the Bourgeois Realists expressed themselves and the way painters do today can be found in the process of developing symbols. Today there exists a tendency to say that objects should be utilitarian, and that painting, if it is conceived in symbolic or abstract form, should itself become an object. In the nineteenth century there was a 'prevalence of the object over the symbol',[8] in the sense of a strictly objective interpretation of forms – even if the latter assumed an abstract or allegorical meaning, for the realistic compositions of the pictures very often led to a much wider significance. For instance, the period with which we are concerned held as one of its precepts that any pictorial transposition of a concept should as far as possible take the form of a woman, and a more earthly and unadorned one than had been characteristic of the painting of the eighteenth century. The Glory of Arms, the Motherland and the Republic, Faith, Honour, Vice, Wealth and Poverty, Night and Day, the Sun and Moon, the Stars, the Seasons and many other natural phenomena, as well as a considerable number of moral concepts, borrowed the features of female models; and these features were so true to life that the spectator had the impression of having met these symbols in the street, on the dance floor or in some other familiar place.

Of course this symbolic or allegorical mode of expression could not flourish freely in an atmosphere of positivism and materialism. It had the greatest difficulty in surviving at all, since painting was subject to a technique that left nothing to chance. Every part of the canvas was scrupulously worked, as if the artist was trying to fasten to it not imaginary constructions but actual events. It is for this very reason that sooner or later a movement like Symbolism had to happen. The latter borrowed its methods from Bourgeois Realism, but was much more freely inspired by Romanticism or by the forgotten and sometimes almost unknown cultures of the past; it was distinct from realism in its power of evocation, a form of emblematic figuration, rather than in its formal aspects.

In the painting of the end of the last century, there were thus two simultaneous manners of attributing a symbolic significance to things. The first, the Realist method, is closely dependent on the moral values that it preaches; the second appeals to Symbolism, which conceals the poet's profound desire to escape from a world which has ceased to please him. This latter form of expression was adopted by artists who no longer found any satisfaction either in bourgeois ideology or in the bourgeois way of life, and so they set off in search of new horizons which could tear them away from a world they had renounced; they wished to *plonger au fond du gouffre pour trouver du nouveau* (Baudelaire); 'plunge to the bottom of the abyss to find something new'. The painters of the Symbolist group have rightly

Georges-Antoine Rochegrosse
The Knight of the Flowers, 1894
Oil on canvas, 235 x 375 cm (92½ x 147⅝")
Archives Départementales, Besançon

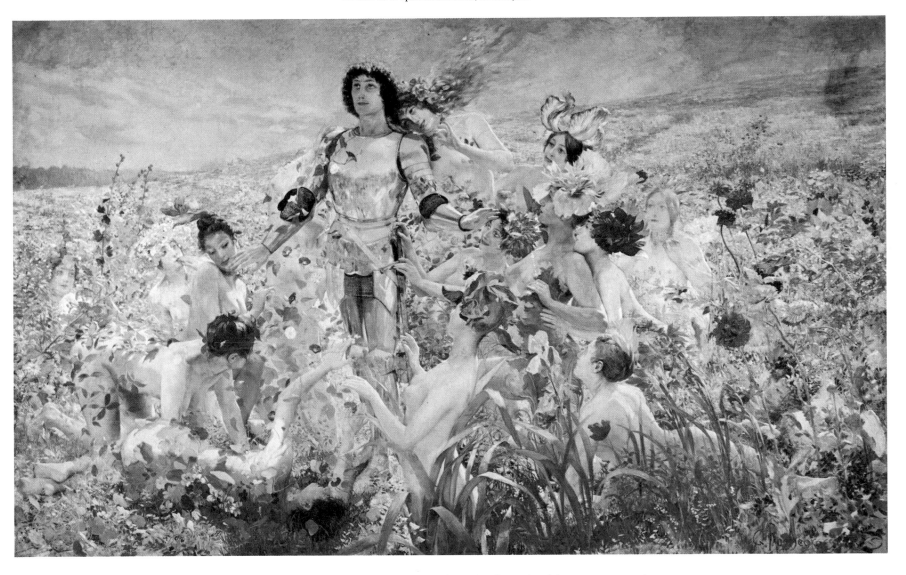

inherited the name of 'decadents' or 'aesthetes'; this was a reaction by their enemies, who professed a limitless love for the unquestionable realities of their time. As Philippe Jullian describes it, the new movement seized the imagination of those who were fascinated by the mysterious, the occult side of life, by bizarre eroticism, exotic archaeology; it is easy enough to see this from the literature of the time. These varied motifs were found less often in painting, although even there one can sense their presence beneath the surface. In this area, the Bourgeois Realists were distinct from their rivals even when they cultivated an allegorical language that was widely used at the time. There is no trace in their works of the atmosphere of mystery and mysticism so alien to the down-to-earth spirit of positivism.

There is a fine example of painting apparently symbolic in content but actually realistic in inspiration in Rochegrosse's *The Knight of the Flowers.* The theme is taken from the myth of Parsifal, as the artist himself indicates on the frame of the picture, where the following commentary is to be found: 'The Predestined One, clothed in the

symbolic Armour of Silver, goes towards the Idea, heedless of life's appeals.' The figure of the knight stands erect in a brightly lit landscape, and his shining armour reflects the sky and the flowers and fields. The soft undulations of the land are deprived of any romantic appeal which might distract one's attention from what is happening in the foreground. Indeed, all around the young man the flowers are changing into young girls. The lower parts of their bodies are for the most part embedded in the earth, as if they themselves were plants of the meadow, and they undulate around their hero in harmonious waves. They are naked, with crowns of leaves and flowers on their heads; some of these head-dresses look like bathing caps, or indeed the floral hats that were worn in the period. The colour has more of a symbolic character than the outline has, so that the painting has a charm quite different from that of a simple mythological scene; the effect is entertaining. There is a whole series of successive circles around the principal character; one feels that for the hero himself a perfectly real scene has changed into fantasy. This principle of metamorphosis runs contrary to the ideas of the Symbolists; in Gustave Moreau, for example, the whole picture would retain its imaginary and unreal atmosphere, even if this was conveyed by details treated in a realistic manner. Rochegrosse, on the other hand, presents a situation which is as real for the spectator as for the knight who actually sees it.

Photography and Art Nouveau

Other artists, whose styles tended to be sympathetic towards Bourgeois Realism, adapted themselves to the forms of Art Nouveau and the colours of the Impressionists. This adaptation was often purely superficial. A number of paintings which at first sight can be associated with one of these two styles were really painted from motivations that complied with the norms of Bourgeois Realism.

In *Flora's Wedding* Lavalley combines the realistic and almost photographic way of conceiving the human body with Art Nouveau elements that are confined to the vegetation in the background. It is very easy to imagine how the painter, in a desire to create a few symbols in a picture so devoid of mystery and symbolism, has used a completely accepted studio technique: thanks to photography he has taken the collection of shots he needed. The numerous photographs of models published at the beginning of the century, under the resonant title of *Le Nu esthétique*, enable us to recapture not only the appropriate state of mind for a particular type of painting, but also an additional proof of the profound and reciprocal influence between painting and photography.

Nymphs, sirens and satyrs cluster together in the exhibitions and salons of the turn of the century. They represent the hidden face of bourgeois morality, rather than the creatures of Greek mythology,

Louis Lavalley
Flora's Wedding, 1897
Oil on canvas
Whereabouts unknown

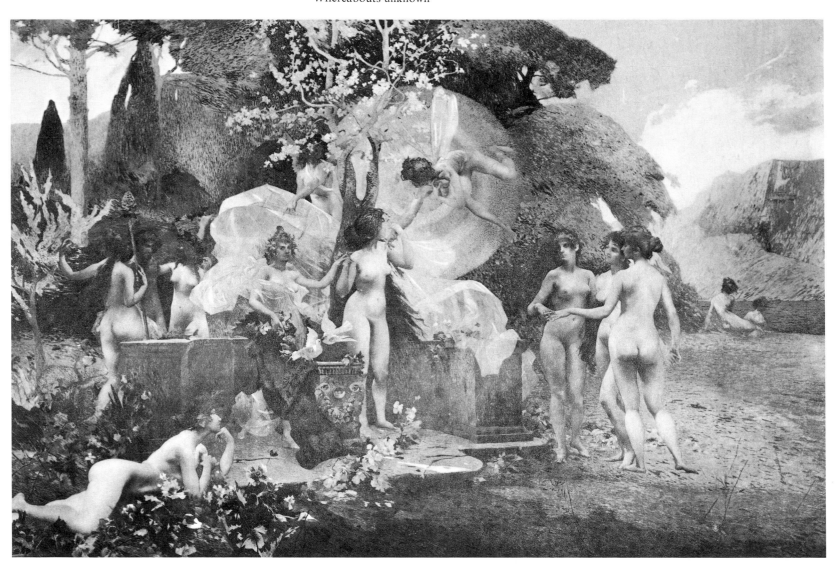

and their poses correspond to the need to redress the balance a little
between proclaimed ideals and accepted entertainments. Could virtue,
for that matter, exist without sin? From the eighteenth century on-
wards, in the bourgeois society that sought indulgence for the poor
creatures of this world by modifying Pascal's idea of a severe Deity,
virtue could not be separated from its opposite, which followed it
everywhere like a shadow. The compromise which was apparent in
daily life communicated itself to art, too, but in a more subtle form.
The propensity to preserve the hedonistic aspect of life – which, in
painting, means the human, carnal side of the models – ended by
compromising the power of the symbolic or moral message.

Photographic imitation and the adroitness with which the painter
learned to render the human body came together in an attempt to
create a new aesthetic ideal. The problem was to make the body look
realistic in compositions whose subjects related to idealized situations
in mental and physical life. Through Chantron's picture *Nymphs
Amuse Themselves* we can follow this interrelation between photo-

41

graphy and painting as it is used for a clearly defined purpose. The
scene takes place in a landscape which evokes not the French ideal
of parks, with their ordered gardens as tribute to the creativeness of
the human spirit, but parks in the English style, imbued with romantic
feeling: these are places where man is in some measure handed over
to the tumultuous forces of nature. Chantron's park is in fact a little
corner of the Bois de Boulogne: a clearing between two riding paths,
which conforms in every way to the landscapes situated at the meet-
ing-point of two different styles, the Neoclassical and the Romantic.
It is thus an unexceptional, unremarkable setting, and one city-
dwellers are used to seeing. Within this framework, the unclothed
young women also seem to be half-way between models posing for a
photograph and schoolgirls on a Sunday-afternoon outing. The latter
theory would be perfectly in order if these young women had kept
their clothes on. However, it would certainly not have altered the
impression produced or the engaging feeling of innocence transmitted
by the reproduction of Chantron's picture (it is not known where the

Alexandre-Jacques Chantron
Nymphs Amuse Themselves, 1901
Oil on canvas
Whereabouts unknown

original is today). Certainly these charming figures have nothing in common with the allegories that we find in painters of all periods, from the Renaissance to Romanticism.

Chantron was a pupil of Bouguereau, and he tried to go further than his master in his attempt to make the appearance of his models even more flattering, regardless of stylistic requirements. According to the conception of these two artists, the task of painting was to make reality more attractive; interpretation was confined to a faithful reproduction of a beautified original. Chantron followed this philosophy to the letter, and drew his inspiration from models as well as photographs, from his experience at the Ecole des Beaux-Arts, and of course from his own enthusiasm. The attempt was not completely successful, perhaps because he treated his landscapes and the human body in different ways. The background, with the light coming through the leaves, is spiritually closer to the aesthetic conventions of the age, while the figures in the foreground and the tufts of grass on which they are lying are closer to a photographic effect. The dis-

Alfred-Philippe Roll
Festival of Silenus, 1880
Oil on canvas, 362 x 306 cm (142½ x 120⅞")
Musée des Beaux-Arts, Ghent

harmony is not glaring, but it is real nevertheless. The disparity, moreover, is less obvious in contemporary photographs, where the individuals posing are often standing in front of a theatrical back-cloth. Everything derives from the peculiarities of the photographic technique. The camera lens of the time was incapable of capturing objects placed at different distances from it with the same sharpness, and so it gave a blurred image of anything outside its focal plane. In painting, by contrast, there is what is known as harmony between different planes, and elements of a picture placed at different distances from the artist are treated with the same precision. This does not mean, however, that they are given the same intensity; variations in intensity are necessary or desirable, as long as they come not from a mechanical process, as in photography, but from an artistic state of mind trained in natural observation.

In the picture we are discussing here, Chantron has done his best to match the background with the visual impact of the foreground without betraying his rational concept of the world. This effort seems to

Emile Bayard
Centaur Surrounded by Nymphs
Studio photograph published in
Le Nu esthétique, Paris, 1902–06

have prevented him giving free rein to his inspiration, but has pro-
cured other advantages. It is worth remembering that in our own time
the skilful artists of the Pop art school came up against the same
impasse as soon as they tried to give the elements of the background
the same standing as the real objects themselves. Later, the so-called
Hyper-Realists resolved the problem in their own particular way.
They gave themselves up to the all-powerful vision of photography,
and completely renounced any ambition to transpose to a work of
art the illusion given by the direct observation of nature. These recent
events in the aesthetic field have acted on our consciousness and
altered our conception of the past; they have made us realize that
even Chantron, like other painters of his time, posed problems which
are still very topical today.
An example of the problem of space being resolved in a different
way, through the use of photographic effects (sharpness of the fore-
ground and comparative fuzziness of the background), is given in the
Festival of Silenus by Alfred Roll. Roll found that he could not unite

the two planes, so he decided to contrast them. It must be made clear that this contrast in Roll's picture is totally different from the manner in which the Impressionists or Cézanne solved the problem, with a play of colours. In Roll the sharpness of the nearest objects slips imperceptibly towards the fuzziness of the background, without any variation of colour or tone, but through a skilful manipulation of the brush. In Cézanne, on the other hand, everything is turned into a subtle combination of shades, none of which has any meaning or value of its own within its own area except in a direct optical relationship with the adjacent surfaces. This is why it is not difficult to reproduce Roll's picture, and why the black-and-white photograph conveys the essentials of the original quite accurately. The situation is quite different with Cézanne. We never cease to be amazed at the richness and strength of his talents as a colourist, and we would be hard put to it to guess them from a mere reproduction.

Although Roll borrows his technique from photography, he entirely transposes what he borrows; so one can say that his work is original in conception and execution, and on no account a mere pirating of the photographic technique. The artist has created from his own resources what photography would not afford him. We would contend that its merit lies not simply in the fact that he has placed his easel rather than his camera before the group of gay and amusing nymphs in his picture: it lies also in the coherence of expression which he has managed to achieve through his experience as a painter, while remaining faithful to an accurate but retouched representation of reality. His oval-shaped composition becomes disengaged from the background and takes a very precise shape in the foreground, to revert gradually to fuzziness as it moves towards the background. We can measure the extent to which the artist's effort and inspiration remained an essential element of his work by comparing the *Festival of Silenus* with a photograph of the period which Roll might have used as easily as anybody else. In Roll's picture Bourgeois Realism fully achieved its aim, uniting *joie de vivre* and positivism in intimate harmony.

However, it would be wrong to bring all the aspirations and inclinations of Bourgeois Realism together under what might be called 'the art of happiness'. Here was a movement which set out, however cautiously, to interpret visible and palpable reality, with the firm intention of adapting it to the ideal image conditioning public and private life; such a movement could not elude the wealth and variety of themes and sources of inspiration that came direct from daily life. It showed itself in the expression of a religious feeling that had lost its force, in patriotic feeling, historical interpretation, the vicissitudes of family feeling and finally in an emphasis on the individual through portraiture. By examining these fundamental manifestations of the bourgeois spirit, it is possible to make a correct interpretation of the school of painting which most faithfully represented it.

The Subjects

Religion

A New Form of Piety

'It is impossible to have too great a fear of hell, or too great a desire for paradise,' said the Abbé de Saint-Pierre (1658–1743). 'The greater or lesser intensity of an individual's religious feeling consists in the greater or lesser tendency to fear the torments of life after death, and the greater or lesser tendency to hope for immense and eternal pleasures.'[9] This point of view marks the decline rather than advance of the Christian faith; and the impoverishment of the religious spirit, as Groethuisen has very rightly remarked, causes an evolution in its very nature, a regression and simplification of belief which manifests itself in the flowering of a new sort of Catholicism. A conception as simplistic as that of the contemporaries of the Abbé de Saint-Pierre inevitably engendered a new type of Catholic who professed a rather lukewarm faith – or at least one different from before.

This new type of believer did not like to be reminded of the existence of Hell, which he interpreted merely as a product of the popular imagination, and in dubious taste, he contrasted this with his own exclusive attachment to the highest and noblest ideals. The actions of daily life were no longer subject to the rules and regulations of the Church, and the need for religion now found its outlet in works of art and literature. In accordance with the secular education recently introduced, and the more or less avowed desire of the middle classes to adopt some of the usages of the aristocracy, the new lovers of art began to acquire a particular type of creation, a type that reconciled traditional forms – religious and otherwise – with the predilections of the period, both for physical beauty and in the choice of attitudes or costumes. This new brand of Christian inevitably came to admire one painter above almost all others: William Bouguereau.

The painting Bouguereau called *Regina angelorum* offers a vision of heavenly delights. The structure of the composition and the friendly expressions on the faces remind us of Raphael's Madonnas, though, when we look more closely, this very resemblance points up the fact that this artist is more inclined to idealization and sentimentality than his famous predecessor. If we examine the heads of the angels carefully, we can see that they are really young girls, except that they are not precise representations of the models they were presumably taken from; they fail to attain the status of individualized portraits, and in fact all the faces are of one single type. This uniformity is evident in the drawing of the angels' eyes, noses and mouths, as well as their very ingenuous poses, with their hands joined together and their heads gently leaning to one side or another, united in a sort of spiritual communion.

The Virgin herself, with her peaceful, dignified expression, communicates a feeling of remoteness, and one cannot help thinking that, rather than fulfilling the requirements of a creed, this picture is animated by religious inspiration in the widest sense of the word: a

purified, liberated expression of faith. The Virgin's face denotes adherence to the academic tradition, as well as an idealization of feminine beauty conforming to the accepted image of the day. The believers for whom the painting was done may have had only hesitant, tenuous links with religion; but everything the painter is offering them in this area needs nonetheless to be adapted to new habits and manifestations of religious feeling. The artist is, in a way, contributing to the Church's efforts to increase its flock. People were becoming less and less open to any form of belief; 'the Deity, for people to continue to believe at all, will have to be presented in an infinitely more human form than he appeared to those who sacrificed both

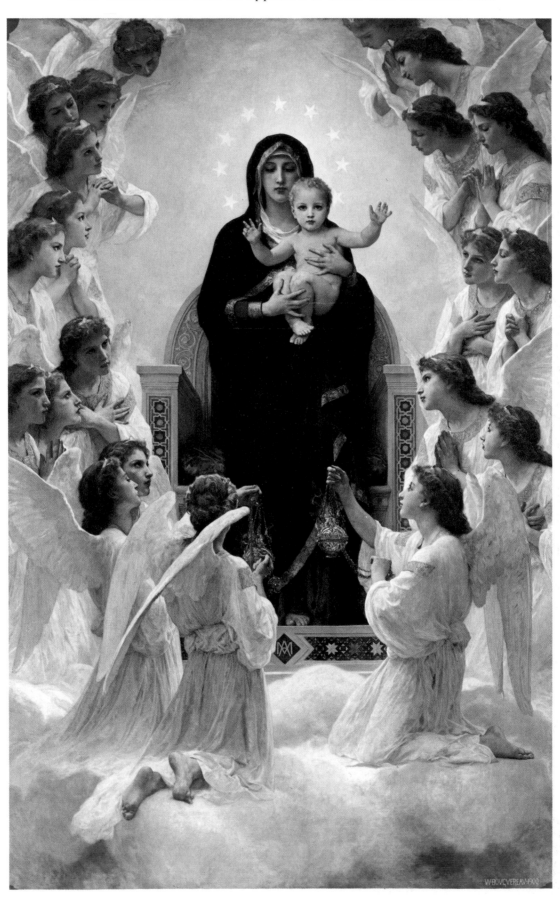

their reason and their secular sentiments to him in order to be able to believe in him with their whole hearts.'[10]

This sort of attitude of mind can be found again in a picture like Bouguereau's *Compassion*, where he displays all the resources of his realist talent. From the detail in which the saint's skin has been painted, it is evident that he was taken from a model. The feet with their blue veins and tired muscles, the head which belongs to some middle-class gentleman and displays every individual hair of the scalp and the beard: all these elements are rendered with a photographic precision, and at the same time co-ordinated. The same applies to the body of Christ. And yet there seems to be a sort of passiveness

William Bouguereau
Regina angelorum, 1900
Oil on canvas, length 180 cm (70⅞″)
Ch. Vincens Bouguereau, Paris

William Bouguereau
Compassion, 1897
Oil on canvas, length 120 cm (47¼″)
Ch. Vincens Bouguereau, Paris

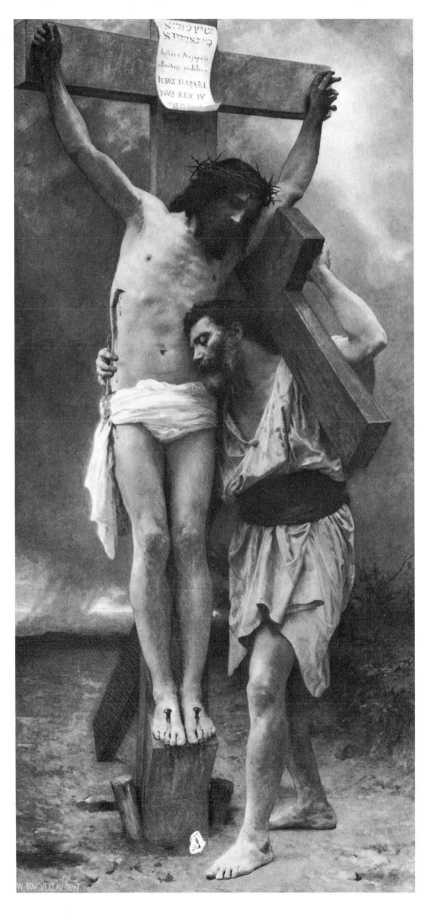

in the way this tragic moment in Christian history is treated, as if the artist had preserved a calm, placid attitude when painting the martyrdoms of St Peter and the Son of God, and failed to accord them the exceptional importance they merit in the eyes of any believer.

In order to have a better understanding of Bouguereau, it is helpful to relate a story that goes back to 1896.

'It was my first exhibition,' recalls the painter Lévy-Dhurmer, 'and one evening a grave old gentleman was waiting for me. He said: "I am Monsieur Bouguereau," and bowed; then, without more ado, he added: "Are you rich?" '"No," I said, "Quite the contrary." '"In that case, why do you put ideas into your work? With ideas you annoy your colleagues, your critics, your public...." As he came down the spiral staircase, the old painter wagged his forefinger and repeated sternly: "No ideas, above all no ideas." '[11]

The Influence of Positivism

As the strength of people's faith declined, the Church had to offer new kinds of arguments. When he was in voluntary captivity, Pope Pius IX would attack the materialistic bias of science, as well as all the other scourges of the period, such as pantheism, naturalism or total rationalism. The Pontiff said, of the supporters of these new ideas: 'They are led on by these unworthy and totally damnable principles to attribute a significance, forbidden by the Church, to the flesh rather than the spirit; they set it on a pinnacle, and endow it with natural qualities and rights that they feel Catholic doctrine has unjustly rejected; moreover they remain deaf to warnings, to the cries of St Paul: "If ye live after the flesh, ye shall die: but if ye through the Spirit do mortify the deeds of the body, ye shall live." '[12] Applied to the problems of art, this statement could mean that the faithful reproduction of the human body is wrong in cases where it is deprived of spiritual content. Due to this view, and also no doubt to its undeniable impact on the spectator, the realist style was also adopted for the portrayal of religious subjects. However, it was impossible to tell how at the same time religious painting could assimilate a rational or positive interpretation of the life of Christ. However much the Church might campaign against the works of Ernest Renan, it had no means of preventing artists embodying this philosopher's propositions in their work. For Renan was also a historian; urged on by his own religious feeling, and with a burning desire to save Christianity, he believed that it would be the role of historical science to interpret events according to the laws of common sense.

The influence exerted by Renan was largely due to the image of Christ which he presented, as Van Tieghem puts it, 'with reverence as well as deep and moving sympathy, responding precisely to the needs of an enormous public whose Christian feeling was incontestable, though fundamentally unresponsive to mystical thought'.[13] This idea found itself faithfully reflected in contemporary art, which fell in with the uncheckable process of change that affected the propositions of Christianity; this happened perhaps less freely where artistic commissions were concerned (new ideas always have more difficulty in destroying the prejudices of a hierarchical establishment), but more spontaneously and resolutely where the work in question was carried out on the personal initiative of the artist. The result of all this was a profound metamorphosis of religious art, characterized by a realistic creative process, an emphasis on the value of imitation and of movement and an interpretation of themes compatible with Renan's historicism.

People of the time were very sensitive to all these changes. They rightly saw in them the signs of a new orientation, and they considered them as necessary progress. When James Joyce, no more than eighteen years old, saw Munkácsy's picture *Ecce Homo* for the first time (it forms part of a series with *Christ Before Pilate* and *Christ on Mount Golgotha*), he marvelled at the exceptional richness of ideas this work offered. The record he left of it in one of his first literary essays is the more precious to us in that it offers a perfect comment on the spectators' reactions to these new and original creations of realism. Moreover, Joyce's opinion should not be regarded as something exceptional, for by that time Munkácsy's talent

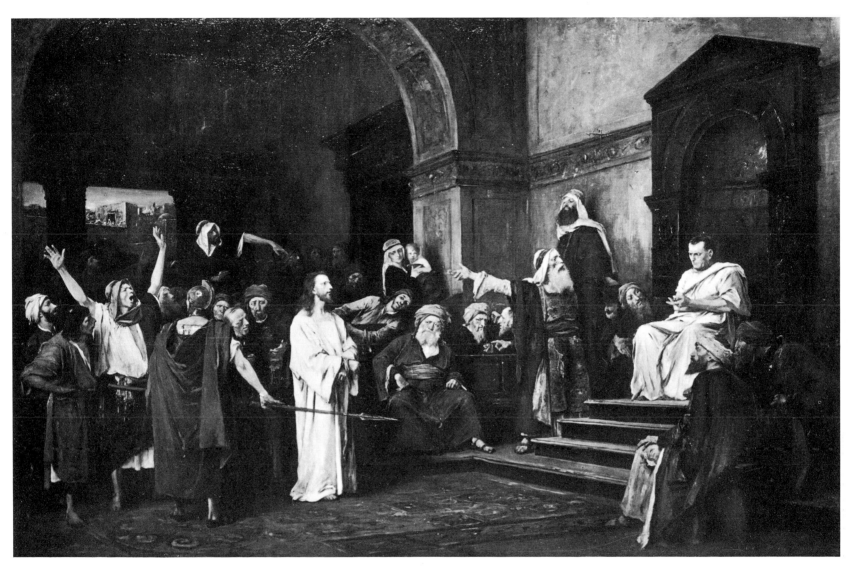

had already acquired an international reputation, founded even before Joyce was born.

Joyce was especially struck by the truth and psychological depth that emanated from the picture. He finds the treatment of the theme 'grand, noble, tragic'. The Founder of Christianity appears here as an incarnation of greatness and strength, and this is where the protagonist of a universal drama is born. As far as Joyce is concerned this protagonist has nothing the least superhuman about him, there is nothing divine in his features; and this was in no way a failing on the artist's part (according to the author of *Ulysses*, Munkácsy's virtuosity would not have been defeated by the biggest obstacles), but quite simply his artistic conception. The human passions expressed by the other characters are directly observed, without affectation, as if their personalities were vivisected. Pontius Pilate's interrogation is directed at himself, not at the defendant, while the faces of the crowd do not conceal the base instincts that motivate them – instincts which govern most human beings.

Mihály Munkácsy
Christ Before Pilate, 1880–81
Oil on canvas, 138 x 200 cm (54⅜ x 78¾")
Hungarian National Gallery, Budapest

In his analysis Joyce does not mention the inadequacies of the colours. He does not seem to realize that the canvas is coated over its whole surface with a dark tone illuminated here and there, in the absence of any source of light and as on a theatre stage, by patches of a whitish impasto – hence the impression of artificiality. Everything we have been accustomed since the Impressionists to call true painting is missing from this technique. As for the claim that Munkácsy's work can be related back to Rembrandt, this is nothing but a superficial view based on a first impression. It is quite wrong for respected modern critics, trying to draw attention to Munkácsy's talents, to dig up sketches and unfinished pictures with the object of proving that

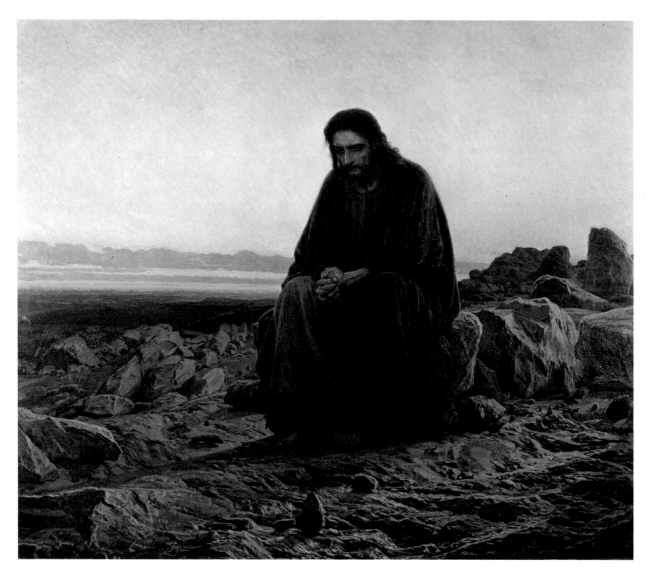

he too was a colourist with a fine sense of contrast. This is not to deny that he was a painter of considerable talent: with all the obstacles in his path, and a training which was inadequate to say the least, it took plenty of courage and will-power to achieve, as he did, a personal style and an international reputation. He painted a large number of admirable pictures in the course of a relatively brief career. But Munkácsy's essential character makes it impossible to integrate him into the currents of modern art. The significance of his work is based on a diametrically opposed set of principles. Munkácsy automatically reduced the visual to the dramatic; he always painstakingly avoided broadening his colour register, in direct contrast to the Impressionists and even to Delacroix, for whom it had been a primary concern.

Renan's ideas of a Christianity which from the beginning had developed around rational and profoundly human historical events had found an echo in the whole of Europe, exerting their influence even on religious art. In Russia, where the teaching of Christ had always

found followers who applied it to the letter, renouncing earthly consolations without a second thought, Renan's ideas contributed to the appearance of a movement which later took the name of 'Tolstoyism'. Inspired by this movement, Kramskoy's *Christ in the Desert* is the first picture in the 'historicist' genre, as well as a perfect illustration of it. It is striking to see how far this work continues the propositions of the French historian. Christ is depicted as a poor wretch, exhausted and desperate, sitting down to draw breath and reflect. 'His solitary shape dominates the vast silent expanse of the desert,' says S. N. Goldstein rather grandiloquently. 'Due to the low line of the horizon it stands out against the backcloth of a huge sky,

Ivan Nikolayevich Kramskoy
Christ in the Desert, 1872
Oil on canvas, 180 x 210 cm (85⅞ x 122½")
Tretyakov Gallery, Moscow

Luc-Olivier Merson
The Entry into Bethlehem, c. 1886
Oil on canvas, 81 x 54 cm (31⅞ x 21¼")
Musée de l'Impression sur Etoffes,
Mulhouse

which contributes to the monumental effect of the picture.'[14] Everything converges on the unique personality of Christ, but there is no indication of what he is thinking because there are no symbols.

It is quite natural for an artist to try and convey a message or a truth of more general significance in his work. In realism the relationship between what is expressed and what is understood is simpler than in other forms of painting. The concrete sign, the signifier, is identified with its semantic content, the signified, and the picture expresses no more than this allows. For Kramskoy, Christ was the personification of all the problems tormenting humanity. And the most ordinary of men was free to follow or reject the example of the Messiah. A letter from the painter to his friend Garshin expands on this idea. 'I can see quite clearly that in the life of every man, created however remotely in the image of God, there is a moment when he hesitates: should he turn to the left or to the right, will he confuse the Abyss with God, or will he refuse to yield to the power of evil? We all know the usual result of such hesitation.'[15]

But it was in France that Renan's influence turned out to be strongest. On the face of it, it is impossible to be a sincere believer, admitting the existence of miracles and therefore not afraid of confronting the irrational, and at the same time consider that everything can be explained, as the positivists do, so that faith itself is subject to empirical proof. Yet these two contradictory attitudes did coexist. Foremost among the painters who were both devout and susceptible to the new philosophical ideas was Luc-Olivier Merson.

The Entry into Bethlehem belongs to the category of works where everything seems to conform to a logical pattern. The scene takes place in a sizable Mediterranean village, and one's first reaction is that the landscape takes pride of place over the story, particularly as the latter is not immediately obvious to the spectator. The realism lies not simply in the absence of any idealization, but also in the way the painter has treated certain materials: the crumbling mortar of the house at which Joseph has just knocked, the desiccated earth on which Mary has sat down in the first pangs of labour. She is the only character who does not escape a certain stylization; perhaps because of her divine status, the painter has kept her free of commonplace detail, and thus set her apart from her surroundings. As for Joseph, he is dressed as a Roman peasant, and has rushed to get help, at the same time hurriedly explaining his story to the woman who has appeared at the window. It is not pure chance that the house he has chosen is not, like its neighbours, in the Arab style. In the meantime the first stars have appeared in the dusk. Devoid of its figures, this painting would have offered us no more than one of those Oriental landscapes of which there were plenty in European paintings of earlier periods: it might indeed have been even blander, as well as a little empty in its central part. Although the characters do not occupy a great deal of space, they impose their presence purely from being distributed according to a geometrical pattern which relates them to and integrates them into the landscape, creating a climate of dramatic tension unrelated to the theme itself.

St Francis of Assisi Preaching to the Fish shows us Merson in an entirely different light. The theme touches on those aspects of religion that the scientific doctrine of Renan endeavoured to repudiate: miracles and mysteries. That is why a difference of form is evident, suggesting a distinct feeling of innocence and modesty. One might say here that the semantic difference entailed formal differences. The artist makes no effort to retain a consistently logical position in relation to the religious problems of his time. He appears to draw a line between the privileged world in which St Francis could communicate with the animals and the purely historical one in which the entry to Bethlehem took place.

Merson himself has quite clearly explained his conceptions, and they are not always free of eclecticism. 'Religious painting,' he said, 'constitutes the highest level of the ideal. It embodies the most

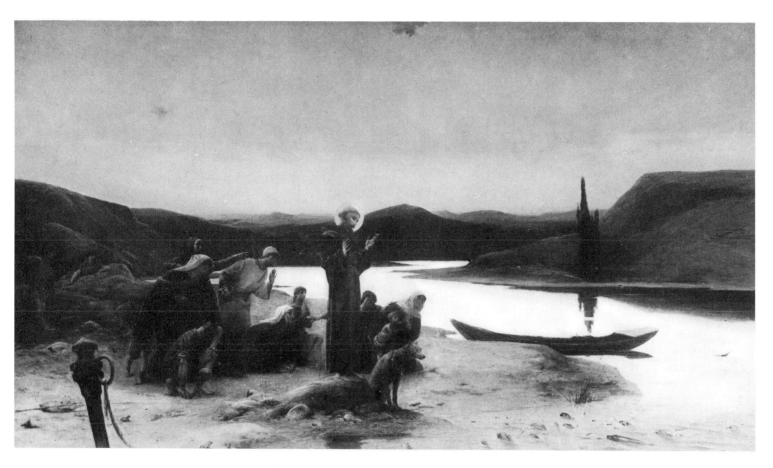

Luc-Olivier Merson
St Francis of Assisi Preaching to the Fish
Oil on canvas, 88 x 152 cm (34⅝ x 52¾")
Musée des Beaux-Arts, Nantes

sublime propensities, the most perfect types of beauty, the most noble characteristics of style, expression and thought. However, today, where Saints and Madonnas are concerned, the majority of artists seem to have forgotten the thousands of models left to us by the great masters, models in which the austere dignity of the art is so well adapted to the gravity of the subject... Some of the most able of today's painters, who no longer receive their inspiration from on high, are content with an exact imitation of nature.'[16]

Among those most skilled at imitating nature we should also mention Jean Béraud. An attentive chronicler of Parisian life, he appointed himself the interpreter of its obscure, fleeting delights: the young girls waiting at the factory gates; the old lady lurking in the wings of the Opera, passionately following the show; smart people out walking; high society gossiping in the salons. Detached from these worldly themes, his only religious picture, *St Mary Magdalene Before Christ*, is an exception that should not go unnoticed. At the centre of the table, with a napkin around his neck, Renan in person seems

Jean Béraud
St Mary Magdalene Before Christ, 1891
Oil on canvas, 97 x 130 cm (38¼ x 51⅛")
Walker collection, Paris

to be presiding at an official dinner, which is clearly almost at an end; we can see that they are already at the coffee stage. One of the guests is Christ. The expression on his face and the position of his hands indicate that he is making a speech. At his feet, in a white evening gown, fixed in an attitude of repentance, there is a woman who, it has been thought, is recognizable as Liane de Pougy, a famous courtesan who had risen from nothing to occupy an important position in Parisian society. Of most of the other guests almost nothing is known, although there are clearly important people among them: writers, scientists and perhaps even artists. The elderly man with glasses and greying whiskers is none other than the chemist Eugène Chevreul, who had already been dead two years at the time that Béraud was working on this canvas. At Christ's side, with his hand on the back of a chair, is Alexandre Dumas the younger. The high-minded moral could not be clearer: in the 'new society' based on positivism and finding its definitive form in the love and understanding of one's fellow creatures, the teaching of Christ retains its full force.

The Temptations of This World

While representations of the life and sufferings of Christ had to keep to the New Testament text, the vicissitudes of the lives of the saints offered infinite scope for the creative imagination. St Mary Magdalene had often been painted before the appearance of Bourgeois Realism, but it was the period of 'diminished piety' that allowed her a new lease of iconographical life. A penitent harlot, who became a faithful companion of Christ in the last stage of his stay on earth, the Magdalene is usually seen in art as a solitary ascetic; Bourgeois Realism re-endowed her with all her natural instincts. Her penitent retreat and her very long hair gave rise to unexpected effects which glorified feminine vulnerability, as in the famous picture *The Magdalene*, by Francesco Hayez (whose effigy stands in Milan opposite the Brera Academy over which he presided as absolute ruler). The saint's hair falls luxuriantly over her naked shoulders, while her hand rather limply clasps a crucifix. There is a very clear and striking contrast between the bare countryside, the pattern of the branches of the tree, and the vulnerable body of the woman. The Italian artist in his portrayal of this quality far surpasses his young French colleague, Paul Baudry, whose *Penitent Magdalene* caused Baudelaire to comment: 'a bit frivolous and slickly painted'.[17]

While the Magdalene had to a certain extent become the ideal personification of the woman who sins and repents, St Anthony embodied the man who avoids all the traps of the senses that society lays before him. This is a very old theme, but the period gave it a certain topicality by embellishing it with moralistic arguments. The current way of life helped to increase its relevance: the sources of

Francesco Hayez
The Magdalene
Oil on wood, 118 x 150 cm (46½ x 59″)
Civica Galleria d'Arte Moderna, Milan

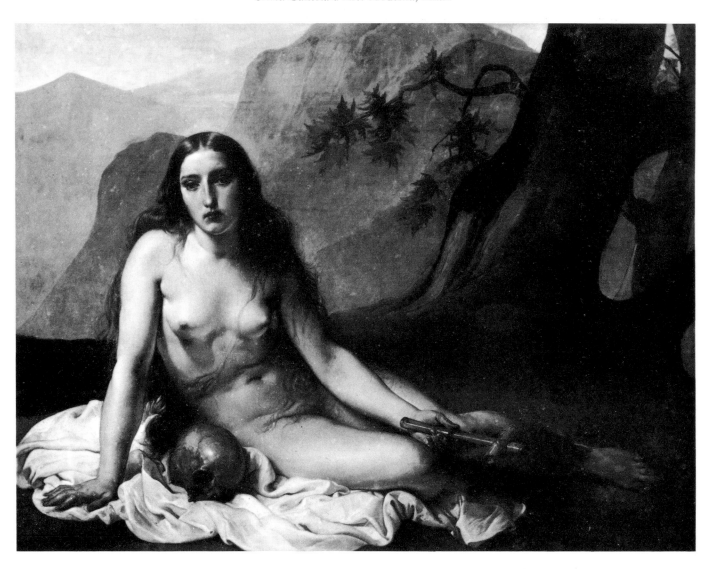

pleasure had continuously increased in number; at the same time, the economic and political foundations of society rested on a tight and solid family unit which these licentious temptations dangerously threatened. The danger in question was much more evident for the middle classes than the nobility, whose economic power and privilege had long made them fairly lax, especially as far as extra-marital relations were concerned.

Domenico Morelli makes his *Temptation of St Anthony* a sort of joke played on the hermit by a group of gay and smiling girls. Their charms are not really hidden by the mats of plaited reeds, and are so suggestive and palpable that the ascetic seems positively to fight for breath in his increasing torment, while he tries to turn his face away from the multiple temptation. There is a very clear-cut difference between this interpretation and those given in earlier art, with their swarming visions of fantastic creatures, heavy with symbolism. Morelli approaches his subject with the intention of showing a very real event; it may appear a little ridiculous to some spectators, but

Domenico Morelli
Temptation of St Anthony, 1878
Oil on canvas, 138 x 225 cm (54⅛ x 88¼")
Galleria Nazionale d'Arte Moderna,
Rome

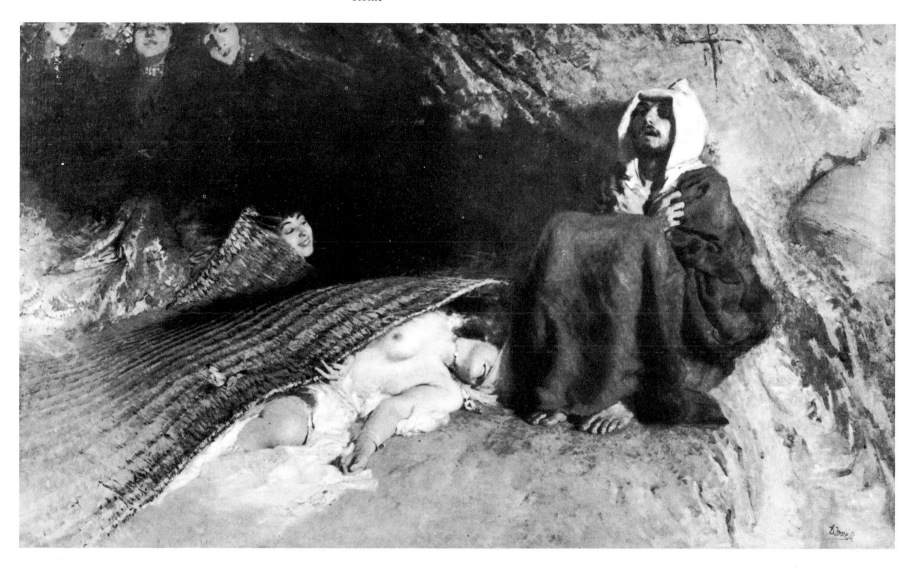

it does nonetheless represent an exceptional trial for the unfortunate
hermit. It is worth adding that as a young man the painter had been
destined for the priesthood and no doubt was only too conscious
of the agonizing problems which beset the majority of seminarists.
This picture, more than the historical subjects that he sometimes
tackled and even more than the portraits, is the one where we can
best admire his art of turning psychological processes into images.
This is particularly evident in the hunched figure of the saint
silhouetted against the semi-darkness of the cave (the cave, more-
over, can be subjected to psycho-analytical interpretation). For the
rest the rocky elements in the foreground, the brightly lit body
and the smiling face that emerges in the middle ground, are com-
bined in a masterly fashion. The group of unreal faces floating about
in the top left-hand corner adds a symbolic touch, yet does not
disturb the muted realism that envelops the whole scene; the author
has deliberately not held back from the absurd.

Devotional Pictures

Feminine charms are to be found in abundance in the religious painting of Bourgeois Realism, though the theme generally includes a moral lesson that to some extent compensates for the attractions of the female sinner. In art, as in daily life, concealed or repressed desires enter into conflict with morals and principles. In a painting by Moreau de Tours, *A Stigmatic of the Middle Ages*, the slumped and provocative position of the girl's body, as she exhibits her mystic wounds, seems so deliberate and premeditated that it is very hard to identify it with a state of religious exaltation; so the onlooker, like

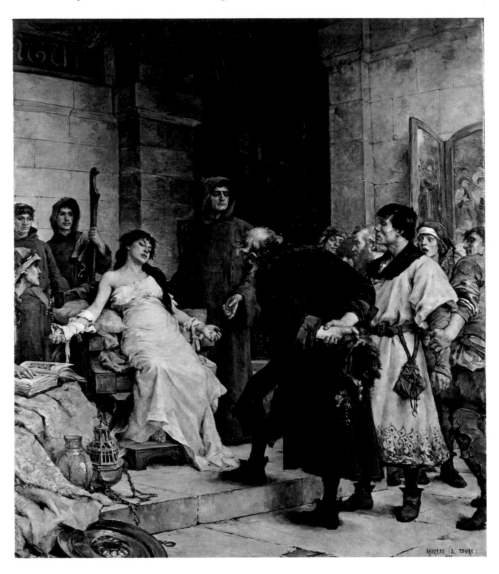

Georges Moreau de Tours
A Stigmatic of the Middle Ages,
Salon of 1885
Oil on canvas, 300 x 260 cm (118⅛ x 102⅜")
Musée des Beaux-Arts, Nantes

the incredulous burghers in the picture, is tempted to ask himself: 'What is she thinking? What is she up to with those monks behind her?' The artist's intentions are no less obscure; or else this is a real event of the past treated in the manner of his own period, as a sort of scandal story.

In the arresting realism of Moreau de Tours, colours play a primary role. They do not indicate a particular state of mind; they do not constitute the sort of aesthetic transposition that is always more or less present in painting: they serve the concrete elements of the narrative. To compare the colour values of the walls, the tiled floor, or the clothes and facial colouring, is to realize that the contrasts are flat, almost non-existent. A critic in *L'Illustration* was dazzled when he saw this picture in the Salon of 1885, and wrote: 'All the characters are carefully studied and painted with remarkable breadth; the head of the monk, among other things, is magnificent.'[18] We would disagree with this view: the colour would appear to have no role independent of the theme and cannot be considered in its own

right, for then it would lose all significance except that of remaining resolutely different from the experiments of Impressionism.

Liezen-Mayer offers us another type of feminine beauty in the person of *St Elizabeth*, the Hungarian queen who became the national heroine, and whose life was an uninterrupted succession of good deeds. She did not hesitate to give away a precious necklace in the course of her ministrations to the poor and needy. The velvet, ermine and silk, contrasting with the rags of the poor people, the bare stone and scattered straw of the little hut, have allowed the painter the opportunity to develop surprising contrasts of colour, while the theatrical gesture of the princess taking off her cloak, which it seems

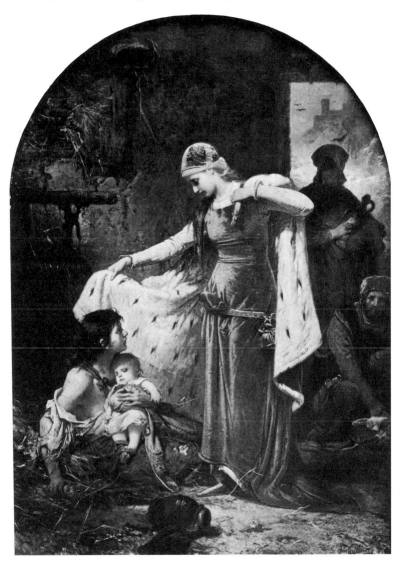

that no one could do at this period without majesty and grace, lets him reveal a still almost adolescent freshness beneath the splendid attire. So romantic an anecdote could not fail to appeal to the public, both from an aesthetic point of view (insofar as the beauty of the women and their sumptuous clothes are painted with realism) and from a thematic point of view (since charity was not only one of the cardinal virtues of the good Christian but had become for the middle classes an obligation that helped to mitigate the social contradictions which threatened their security). Far from the limited conception of alms that was current at a time when society divided into nobles and serfs, as the picture illustrated shows in its own way, the new social climate caused a revision of the very idea of charity. It was no longer a question of the privileged leading a life of pleasure, to redeem themselves later with generous gestures; here was a material prosperity in which effective social assistance was permanently available for the benefit of others. Since the liberality of Elizabeth in no way comes from a need for expiation, it can be seen that the moral

Sándor Liezen-Mayer
St Elizabeth, 1882
Oil on canvas, 262 x 182 cm (103¼ x 71⅝″)
Hungarian National Gallery, Budapest

61

Salvatore Postiglione
Peter Damian and Countess Adelaide of Savoy
Oil on canvas, 292 x 151 cm (115 x 59⅜")
Galleria Nazionale d'Arte Moderna,
Rome

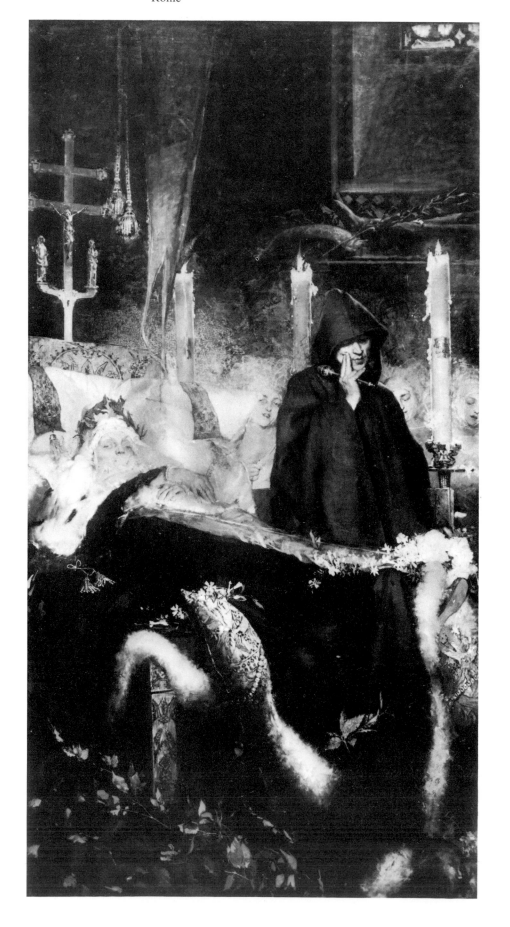

lesson is fully in accordance with the motivations of the class for which the picture was painted.

In all countries, the national saints of the Middle Ages took up service again on the basis of their political, social or moral antecedents. The appearance of these new criteria represented a weakening of the traditional ties of religion, and the beatification of certain historical figures ceased to be justified. In Postiglione's *Peter Damian and Countess Adelaide of Savoy*, we can admire the clever preacher and papal legate, famous for his moral austerity, caught in a meditative pose before the catafalque of Adelaide, whose marriage to Odo of Savoy enabled her husband's house to extend its possessions to the southern Alps and thus become a significant force in the Italian political arena. A choir of ethereal young nuns, in coifs of misty tulle, accompanies the final farewell with pious canticles. The candles burn down. On the funeral bier, in the foreground, lie the royal vestments. Thus the scene has a political and even prophetic significance as a meeting between the royal house and the representative of the Church; it evokes an event whereby it was hoped these traditional ties would be taken up by posterity at a time when Catholic countries were witnessing an ever widening gap between Church and State.

Torture and Mortification

There are many fewer depictions in Bourgeois Realism of sufferings of the body than those of the soul – unlike late Gothic art, where there is a plethora of images of speared saints, both male and female, beheadings, dismemberments, martyrs bound to stakes with the flames at their feet. The nineteenth century is not only more subtle in this area but quite different in kind. Even where suffering is portrayed, we feel that an allusion is being made to something else. José de Brito, the Portuguese painter of *A Victim of the Inquisition*, in the endeavour to develop a love of freedom among his compatriots, turns to the period of Spanish domination over Portugal. It would be a mistake, for all that, to underestimate the sadism with which the picture is filled. Like the heroes of the Marquis de Sade, who found their pleasures in endless discussions of whatever amazing excesses they could dream up before addressing themselves to the much briefer business of actual torture, so the Inquisitors pursue an interminable debate in front of their powerless victim, who will only later, after a shattering mental torment induced by the executioner's preparations, suffer the torment of the body. Clearly, the detail in which the cruelty is treated tends to push the painter's original intention into the background.

In works which deal with the religious practices of the past, masochism sometimes makes its appearance, as for example in the *Flagellation Scene* by Boleslaw Laszczynski.

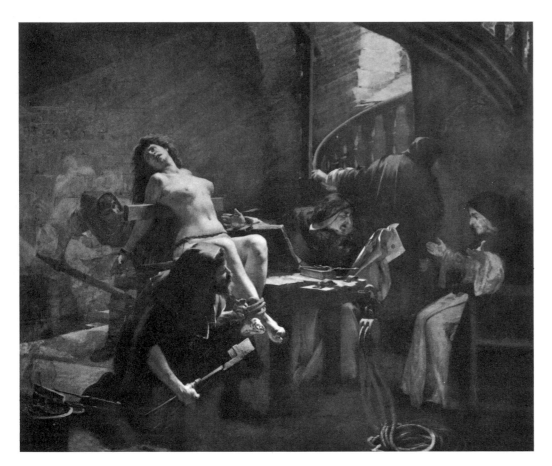

José de Brito
A Victim of the Inquisition, 1895
Oil on canvas, 240 x 295 cm (94½ x 116⅛″)
Museu Nacional de Arte Antiga, Lisbon

Here too the artist's ostensible intention is to laugh at, or to condemn, a repellent aspect of the lives of some of the nobles of the past. We are asked to witness a scene that is partly absurd, partly pitiful: the central character is allowing himself to be thrashed, without great conviction, while his manservant, armed with a towel, awaits the end of the scene. To give a precise picture of the social milieu, the background is reconstructed in full detail, representing a world of wealth and military tradition.

Boleslaw Laszczynski
Flagellation Scene, 1878
Oil on canvas, 63 x 48 cm (24¾ x 18⅞″)
National Museum, Warsaw

Religious Practice

As a complement to the historical role of the Church, and in contrast to its past severity and intransigence, the more skilful religious propaganda of the time exerted some influence by publicizing the good deeds of the Church. Principal among these were those which were useful to society as a whole and not simply to a handful of believers: consolation and hope imparted at difficult times, moral education, care for the sick, social assistance. It is remarkable that, in displaying these activities, painters concentrated nearly all their attention on women or girl children. As in the scenes from antiquity, there are virtually no *men* before the altars, at religious ceremonies or involved in charitable deeds. This applies, incidentally, to the majority of other themes adopted by Bourgeois Realism; established usage required it to be always the woman who embodied all the problems of humanity, and who personified all natural phenomena.

But this interest in the fair sex does not correspond to any desire for the emancipation of women. Although the idea had already been well received in certain English and French left-wing circles, the more frequent appearance of women in painting must be understood as a reflection of the morality and way of life of the middle classes, where the role of the woman was vital in looking after the family and in domestic economy. This role was not equal to that of a man, and the woman remained closely dependent on him, economically, emotionally and socially.

It is obvious that the piety of women went hand-in-hand with the application of a certain number of principles and practical arrangements, such as marital fidelity, devotion to children, thrift in domestic affairs. When we arrive at the shores of the Mediterranean, we can almost hear a voice coming from the picture suggesting: 'Let your wife go and seek her consolation from family conflicts and the other worries of life in the coolness of the churches. She will certainly find a solution to her problems there as she waits for divine benediction.'

Cercone's *Madonna* is drawn, with her whole being, towards the world above as an example to all other women. Her idealized face irresistibly recalls the style introduced by Bouguereau. The modern treatment of the folds in the garments in no way precludes our conscious recollections of Raphael and Murillo, and does not distract us from the painter's intention, which was to show the advantages of entrusting oneself to the force of destiny, a self-abandonment that can only adorn the conduct of any woman. The Italian painter seems to have been fascinated by the idea of a supernatural force to which everyone, but especially women, was obliged to submit.

Religion is distinct from magic in that priests and worshippers wait patiently for a response to the prayers they address to God. They do not use the sort of rites that obtain the requested favour by a sort of

coercion. Enrico Tarenghi's picture *In Church* shows the activity of prayer, which for Christians is the basic element of belonging to a religious community. The social divide between bourgeois and peasants, the psychological effects of faith on a young girl and an old woman, are all noted with consummate accuracy. While the young woman looks up at the nave vault after the manner of Cercone's *Madonna*, with an expression in which we can read hope and confidence in life, her neighbour (perhaps also her mother) seems more resigned and completely buries herself in prayer. Ordinary working people can be seen participating in the rite with much less fervour, but apparently in a far greater spirit of peace.

Ettore Cercone
Madonna
Oil on canvas, 145 x 75 cm (57⅛ x 29½″)
Galleria Nazionale d'Arte Moderna,
Rome

One often has the impression that true piety is reserved for the rich. In Bianchi's picture *Their Brothers are at War*, the three young women praying before the altar are exceptionally elegant. This picture owes its expressive character to the side-lit garments, and the light that delicately skims across them also gives particular value to the fabric, the marble, the silver and wood of the decor. And yet this strange scene has something constrained about it, perhaps because it has been created on the basis of conceptions which have nothing to do with religion and which, from a purely objective point of view, relate faith rather too often to the presence of young and pretty women. The attractions of worship are therefore indirectly linked to factors belonging to the secular world. When those present are exclusively young girls, the expression of reality becomes tendentious. The Realistic technique, however strict it may be, is then no longer a matter of documentary record but a response to the requirements of religious propaganda.

We reproduce two excellent examples of this deviation: Henri

Enrico Tarenghi
In Church
Watercolour, 68 x 100 cm (26¾ x 39⅜″)
Galleria Nazionale d'Arte Moderna,
Rome

Gervex's *The First Communion at the Church of the Trinity* and István Csók's *Communion*. Gervex's formula is generally to compose topical scenes on very large surfaces (unlike Béraud, who is also a faithful observer of the period). Gervex seems to have grasped that large formats gain in clarity of expression if they are given light backgrounds; this much he learned from his Impressionist friends. At the same time, he saw for himself that luminous, pure tones tend to lead the eye and the mind away towards gratuitous tricks of light which finally become an end in themselves, to such an extent that they can no longer serve to establish the characteristic elements of social life. This is why Gervex had recourse to neutral, light tones, using

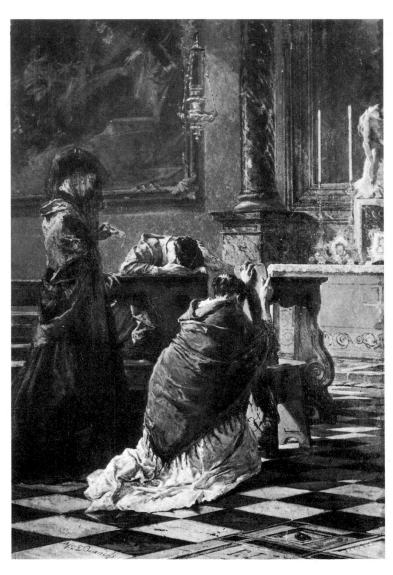

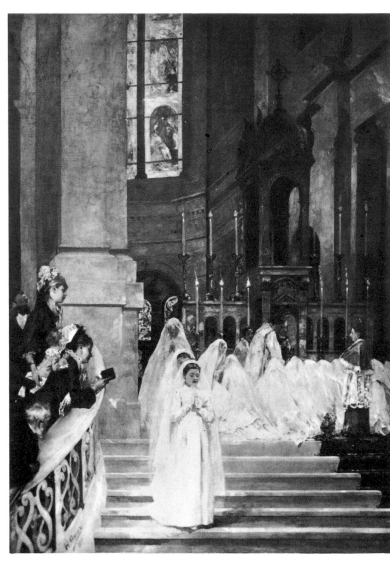

Mosè Bianchi
Their Brothers are at War
Oil on canvas, 149 x 104 cm (58⅝ x 42½")
Brera, Milan

Henri Gervex
The First Communion at the Church of the Trinity, 1877
Oil on canvas, 402 x 291 cm (157¼ x 114⅝")
Musée des Beaux-Arts, Dijon

scumble on the broad expanses of architecture, of the ground and even of the human figures, calling on a conventional solution to resolve the complex problem of colour in large-format pictures. Thanks to the even spread of colour across his canvas, and to his use of modulation in the warm-cold rather than the light-dark register, he has perfectly achieved his aim; this is demonstrated, even more than by the authenticity of the content, in his ability to communicate a feeling of peace and monumental majesty to the onlooker.

In his *Communion*, the Hungarian painter Csók is more concerned with directly expressing the psychology behind the appearance and attitude of his model than with unfolding an opulent tableau. The scene takes place in a village, judging from the dress and the modest, bashful expression of all the girls present. Whatever the case, even today this work radiates all the purity of its inspired lack of sophistication; this in no way diminishes our interest in the details and the unobtrusive aptness of the composition.

The following two works, devoted to the religious education of young

girls, are consistent with two different interpretations of the teaching role of the Church: the one is as gay as the other is austere. It is not by chance that the first comes from Italy and the second from Belgium. In the picture entitled *At the Nuns' School* Pennasilico's little girls knit and chatter, under the surveillance of a nun, as naturally as their mothers would have done. On the other hand, the *Catechism Lesson* by Henri de Braekeleer reminds us how dull and constrained this type of education can be; the children sit in a dark and miserable classroom repeating texts they do not understand. Both scenes take place under a crucifix, but the different fashions in which this detail is treated convey the differences in intention. Pennasilico gives it less

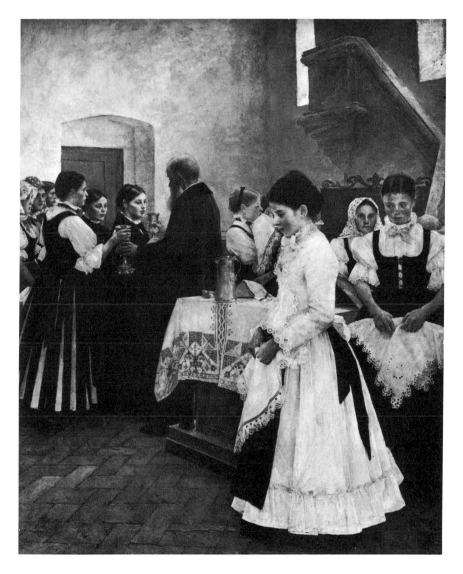

István Csók
Communion, 1890
Oil on canvas, 137 x 111 cm (54 x 43¾")
Hungarian National Gallery, Budapest

importance both in the position it occupies in the composition and the way it is lit. For de Braekeleer, on the other hand, the crucifix is the central element. The two are not even stylistically similar. The first crucifix supports a robust body that torture has not managed to break; on the other one, Christ hangs downwards with all his weight and every detail reminds the young pupils of the illusion and vanity of terrestrial things.

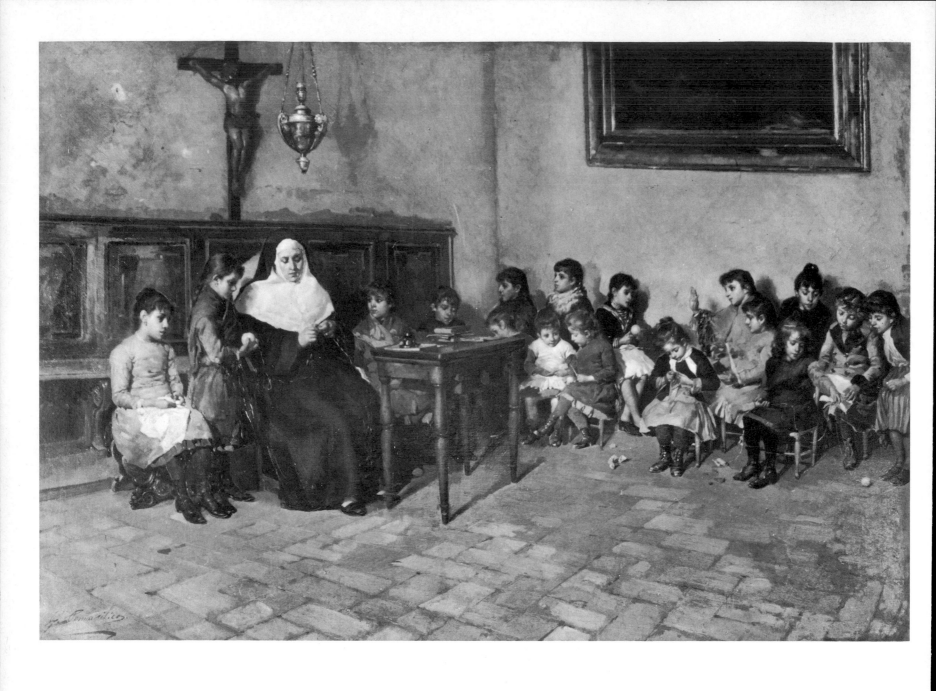

Giuseppe Pennasilico
At the Nuns' School
Oil on canvas, 100 x 146 cm (39⅜ x 57½″)
Civica Galleria d'Arte Moderna, Milan

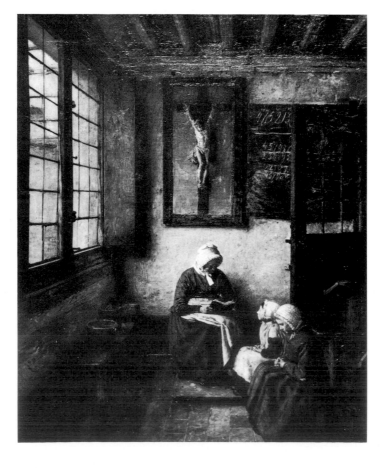

Henri de Braekeleer
Catechism Lesson, 1872
Oil on canvas, 90 x 74 cm (35½ x 29⅛″)
Musées Royaux des Beaux-Arts de
Belgique, Brussels

The Cult of the Dead

Religious and familial emotion tend to combine in mourning and the cult of the dead. There is no situation in which attachment and sorrow are expressed with greater force. What could be more moving than a child who has lost its parents? This is the subject that Uroš Predić has chosen for his picture *An Orphan on his Mother's Grave*; and he has treated it with a rare professionalism, in a wintry countryside in perfect harmony with the spirit of the work. Another of the finest examples of paintings devoted to family life in its dealings with religion is unquestionably Friant's *All Saints' Day*, which was

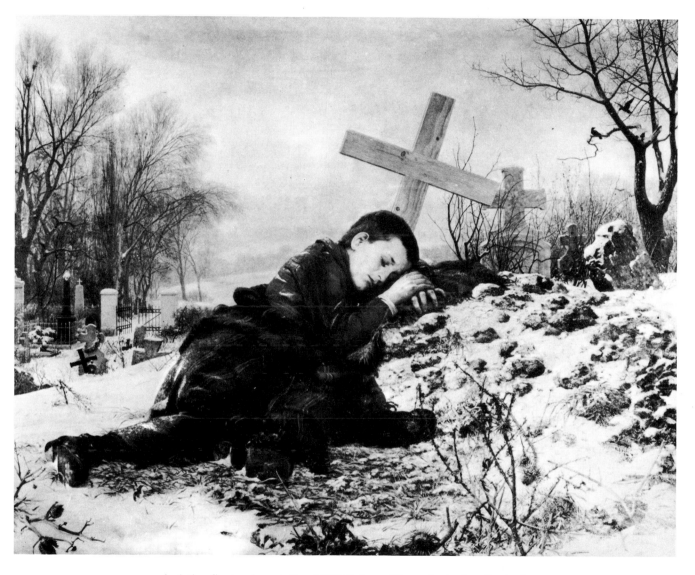

awarded the first prize at the 1880 Salon. The whole family in heavy mourning, decidedly middle class if we are to judge by the attitudes and external appearances, is visiting the grave of some close relative, recently deceased. There is every reason to suppose that the dead person was the husband of the lady with the bouquet, and no doubt the father of the two girls: the younger one rushes to place her offering in the poor man's bowl, while the elder one is weighed down with a large pot of chrysanthemums. A middle-aged woman, perhaps the aunt of the little girls, looks benevolently on the gesture of the younger girl, while the gentleman guiding the whole group moves forward without paying the slightest attention.

The central idea is expressed here in every detail of the composition, and its intention is to convey the physical as well as moral aspects of family solidarity. The calm rhythm which governs the movement of the group, just as much as the uniform black which the painter has used so skilfully to blend his figures together, expresses to perfection the almost physical nature of this alliance. The same element can

Uroš Predić
An Orphan on his Mother's Grave, 1888
Oil on canvas, 100 x 123 cm (39⅜ x 48⅜")
National Museum, Belgrade

71

also be found in the preoccupied air of the characters, as well as their evident haste, not to speak of the atmosphere of sadness which overlies the whole picture. It would be difficult to find a work which better illustrates the position of the middle classes regarding religion, on a philosophical and social level. Within one picture we find a portrayal of their respect for the discipline of the ceremony; the distance kept from the poor by the practice of almsgiving; and finally the correct upbringing of the young. The fact that this work is very close to Degas, or even the Nabi painters, Bonnard and Vuillard, simply confirms that Bourgeois Realism was first and foremost the expression of a way of living and a system of thought to which the

Gabriel Cornelius von Max
In Prayer
Oil on canvas, 58 x 43 cm (22⅞ x 17")
Bayerische Staatsgemäldesammlungen,
Munich

Emile Friant
All Saints' Day, 1888
Oil on canvas, 254 x 325 cm (69⅝ x 128")
Musée des Beaux-Arts, Nancy

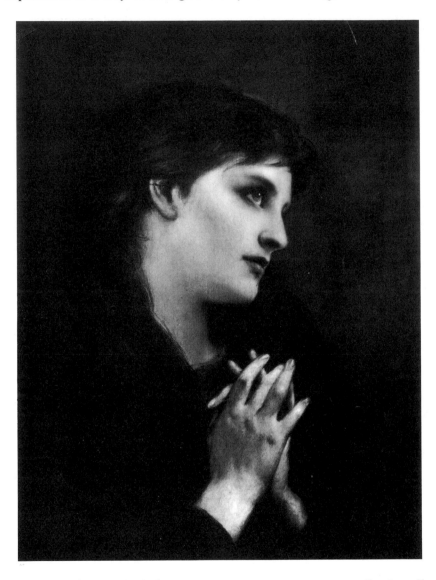

Impressionists and their successors were not necessarily hostile, though they felt no obligation to defend it. To return to Friant's picture, the elements that separate it from the Impressionists carry more weight than those which link it to them. These are, above all, the accurate observation of the facial expressions, of the clothes and also of the character of the blind man. It then becomes easier to understand the story of Vuillard expatiating one day on the beauty of the bouquet of flowers present in the picture. The pioneers of modern art did not merely wish to devote themselves to optical experiences tied to sensory perception, but also to divest themselves of the moralistic yoke imposed on them by the Académie and official painting.

Man's contact with supernatural forces had, in the thematic development of Bourgeois Realism, undergone the same vicissitudes as other religious themes. This phenomenon was the main preoccupation of the German painter Gabriel von Max. Essentially mystical by nature, he had all the qualities needed to provide a visual exposition of it. His

picture *In Prayer* is a work dealing with the German version of the sincerely devout young woman; of particular note is the opulence of her physique. In Neureuther's *The Nun*, which is an earlier picture, religious ecstasy is treated in a slightly more complex way. While the execution of the picture links it to the Romantic school, the cloister is painted with a realism that proclaims the new style; and in the attitude of this woman, whom the invisible presence of an angel has almost reduced to a state of collapse, there are unquestionable references to late Baroque. It was only in the strictest Bourgeois Realist works that religious painting ever became completely detached from the traditional manner.

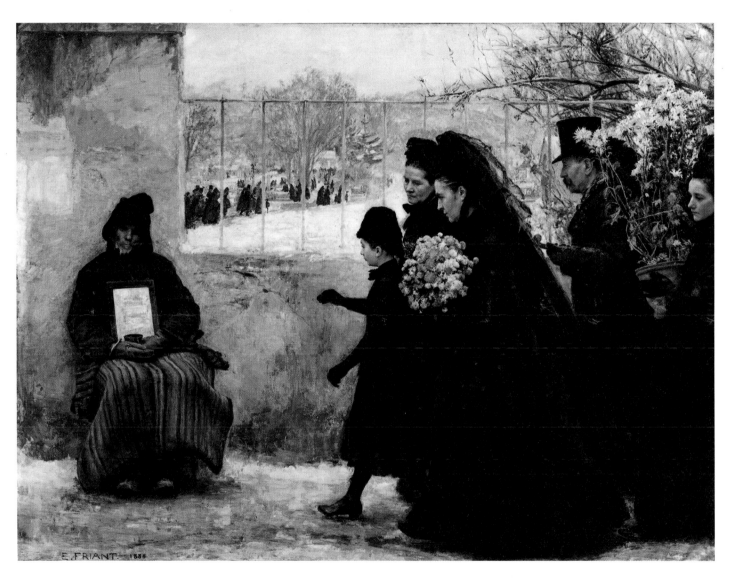

A fine example of the rationalist frame of mind, even though the appearance of a ghost is involved, is provided by the Russian painter Nesterov, who at an early stage quite often expressed his interest in themes concerning religion and its ritual. It is easy to feel that *The Vision of the Young Bartholemew* is entirely motivated by the desire to draw attention to the charm of the gently rolling Russian countryside, with its meadows and woods – and accurately to depict the personality of an innocent little peasant boy. The old man facing him has all the appearance of an itinerant monk. The picture overall is treated in light tones which never step outside the scrupulous reproduction of reality; the shades of colour superficially relate this work to the Impressionists, but in fact the patently realistic use of these tints completely divorces them from that school.

Contact in Russia between clergy and believers, religious and civil life, characteristically took the form of pilgrimages to monasteries, which enjoyed the reputation of being warmly hospitable. As we are assured by the numerous testimonies to be found in literature,

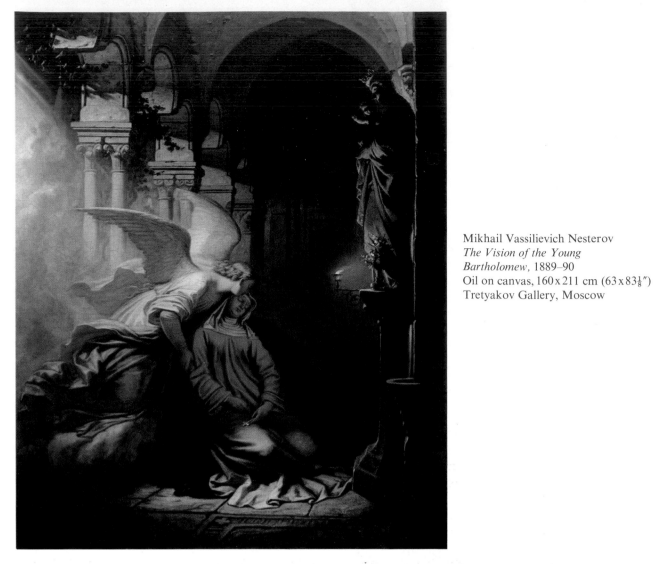

Eugen Napoleon Neureuther
The Nun, 1862
Oil on canvas, 104 x 84 cm (41⅜ x 33⅛")
Schackgalerie, Munich

Mikhail Vassilievich Nesterov
*The Vision of the Young
Bartholomew,* 1889–90
Oil on canvas, 160 x 211 cm (63 x 83⅛")
Tretyakov Gallery, Moscow

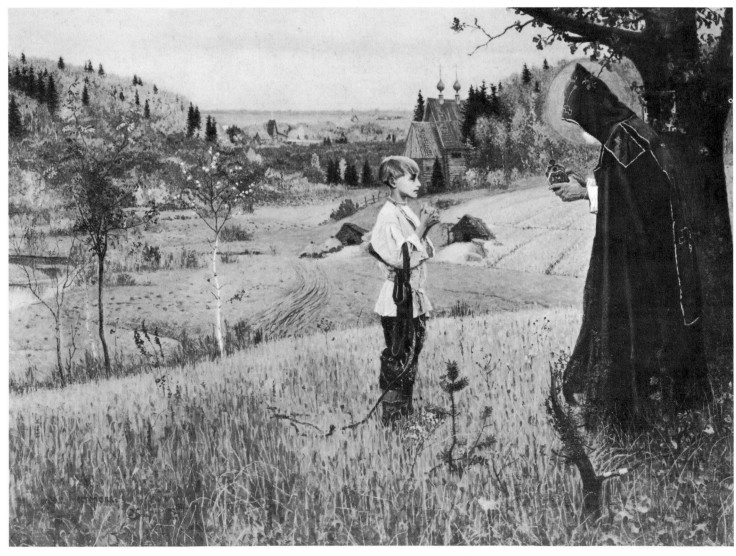

the poor assembled around the monastery buildings, waiting to be given charity; on the other hand, the more prosperous visitors, and, more to the point, potential donors, had the right to lodgings that were often very comfortable. Korzukhin has provided us with a lively and amusing picture which recalls this aspect of the monastic life. *The Monastery Hospice* is painted with freshness; its drawing is lively, and this work is indubitably the fruit of direct experience. The manifold psychological observations, far from overloading the picture, offer a total image of the theme such as was fairly uncommon at this time.

Through the prism of Bourgeois Realist painting, religious subjects

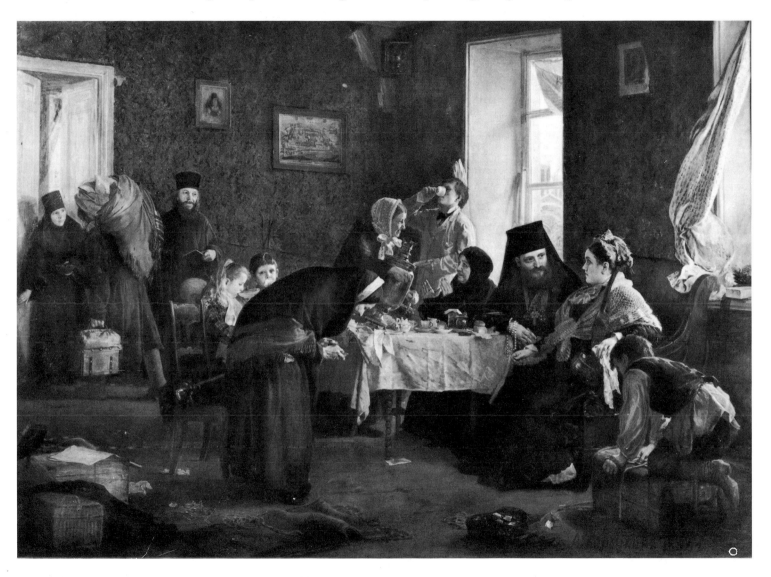

Alexei Ivanovich Korzukhin
The Monastery Hospice, 1882
Oil on canvas, 107 x 150 cm (41⅛ x 59″)
Tretyakov Gallery, Moscow

and public reactions to them show how the bourgeois world, while not rejecting the role of the Church in daily life, gave it an original interpretation and adapted it quite naturally to its own needs. It can also be seen that the artists themselves did not allow materialist and positivist trends to turn them aside from using religious themes in their work; otherwise they would have turned to landscapes and still-lifes. On the contrary, they used their virtuosity and enthusiasm to try and express the dilemmas and compromises that the nature and practice of religion posed for their time.

Mythology and Antiquity

From the time of the Renaissance, mythology and ancient history had provided a multitude of subjects for painting. In the Neoclassical period these generally served to illustrate an edifying lesson, and the artists sought them for preference in Greek and Roman history of the classical period; they were fascinated by the idea that human feelings at that time were infinitely purer, and that the behaviour of many a character in antiquity constituted the perfect expression of infallible virtue. The allegories devoted to these figures, and to precise historical episodes, subsequently gave way to more and more direct allusions to the needs of society and above all to the demands of the State; these took the form of examples reminding one that it is the duty of every man, and not merely of a chosen handful, to struggle ceaselessly, to the extent of self-sacrifice if need be, in order to safeguard that virtue.

Objective and Subjective Realism

At a later stage, and especially thanks to the role of the Académie des Beaux-Arts in France and similar institutions everywhere else, antiquity established itself firmly as a source of traditional inspiration, even if the spirit behind it was noticeably less tendentious than before. Contrary to the very widely held view that realism has particular affinities with the social aspects of contemporary life, it played just as decisive a role in the interpretation of historical themes, including those dealing with antiquity. G.M. Ackerman, talking of the work of Léon Gérôme, who liked to use this type of theme, makes an interesting distinction: on the one hand there was the 'objective' realist who used scientific techniques, perspective and photography, and concerned himself with historical facts and details of the dimensions of the reproduced object; and on the other hand there was the 'subjective' or 'optical' realist who trusted in his own observations, rather than a methodical or rational approach, or any sort of mechanical device. Precise as it is, this form of contrast can certainly be applied equally well to other movements in the history of painting. But Ackerman's observation serves to underline the close links between positivist philosophers and artists in the second half of the nineteenth century.

When Gérôme (whose attention to precise detail induced him to carry out elaborate studies into archaeology and ethnography) worked on a theme from antiquity, he endeavoured to be completely accurate, and to conform to all the available scientific knowledge. Anatomy and the functional dynamics of movement, as well as objective data on the details of dress or architecture, not to mention ingenious theories on lighting and atmosphere – all this helped to play a role in his evocation of the typical real-life scenes that had actually taken place in those distant times.

Understandably, success came readily. *The Gladiators* was not long in

Jean-Léon Gérôme
The Gladiators, c. 1859
Oil on canvas, 97 x 149 cm (38⅛ x 58⅝″)
Collection of the Phoenix Art Museum

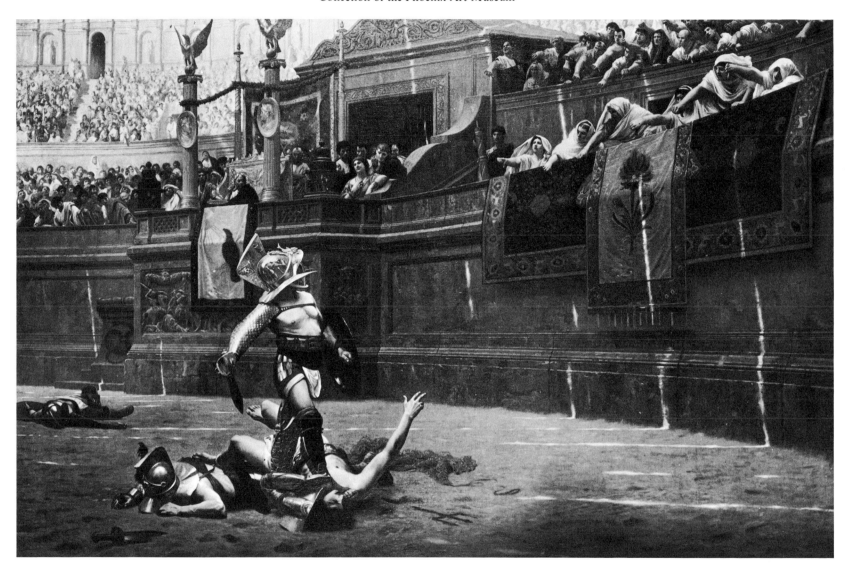

becoming much better known on both sides of the ocean than the esoteric tomes of Dezobry and Barthélemy, which, according to Baudelaire, served as elementary source-books for painters who dealt with themes from antiquity. We should notice that the winning gladiator in the foreground of the picture is a middle-aged man, a little plump, whose victory, since he cannot avail himself either of youthful agility or of brute strength, can only be due to his technique and experience. He is a professional; his work, however repellent, is nonetheless dealt with in a business-like manner. Similarly, neither the crowd on the terraces, expressing its verdict with so much vehemence, nor the group of women in the box on Caesar's left (certainly Vestal Virgins), express the dignified and noble poise that the supporters of Neoclassicism liked to visualize in the Romans of both sexes.

This way of seeing things relates more closely to St Augustine's famous account of the effect that arenas produced on the crowd than to the perverse curiosity of a frivolous modern society. Con-

temporary taste is much more faithfully reflected in the light, engaging interpretation of a similar theme, given us by Henryk Siemiradzki in his picture known as *A Christian Dirce*. The comparison of these two pictures of circus games points to the essential differences between the two types of Bourgeois Realism, the objective in Gérôme and the subjective in Siemiradzki. The latter shows neither the implacable cruelty of the crowd, nor the terrible vacuum that surrounds the gladiator and concentrates the full power of the dramatic tension on him. The centre of the composition swarms with characters, each reacting in his own way to the sight of the body of the victim: the Emperor shows an expression of contempt, while his

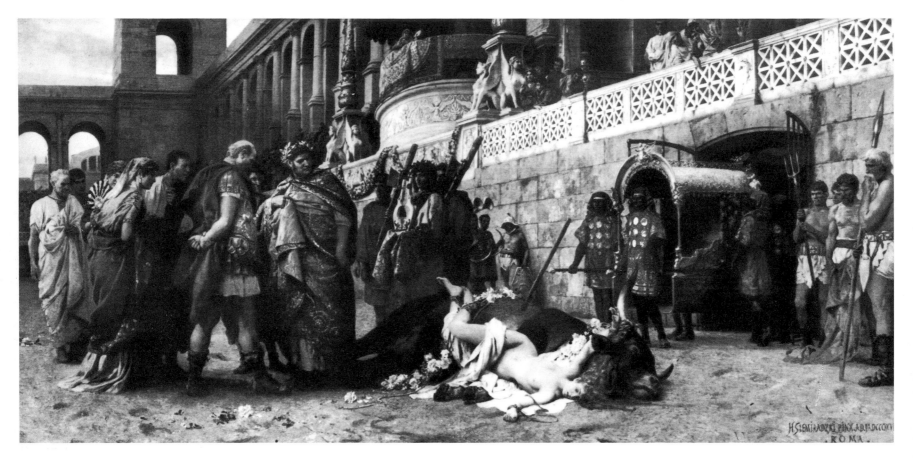

Henryk Siemiradzki
A Christian Dirce, 1897
Oil on canvas, 263 x 534 cm (103½ x 210¼")
National Museum, Warsaw

entourage displays, in spite of itself, a little curiosity at this unusual spectacle; slaves and *retiarii* find it difficult to hide their pity, one of them even going so far as to hold a handkerchief to his face; the Egyptians in the middle ground, like the good mercenaries they are, remain imperturbable and impassive.

The architecture of the arena is just as authentic as in Gérôme's picture; and yet there is no way of seeing the vast dimensions of the building or the swarming, delirious crowds. The artist has put all the emphasis on the harmoniousness of the female body, the sensuous whiteness of the flesh, the luxury of the vestments of the Emperor and his entourage, stressing the force and opulence that are inseparable from power. Whereas Gérôme recounts an episode which could only have aroused horror among his contemporaries, Siemiradzki, on the other hand, expresses more warmth and compassion, even if these sentiments only appear in the attitude of one of the slaves. Lygia from Henryk Sienkiewicz's novel *Quo vadis?* (for it is she) seems simply to have slipped out of her soft garment; her wrist and

ankles, tied to the horns of the bull, have held the body as it falls and offer it up to the gaze of the spectators in its nakedness, and, furthermore, in a provocative pose. There is no allusion in Sienkiewicz's text to this type of detail, which are the products of a creative imagination desirous of pleasing the public; it is the same desire that has led the artist to bring the Emperor down into the arena, to let him have a good look.

Phryne at the Festival of Poseidon, God of the Seas is the title of another work by Siemiradzki which invites comparison with Gérôme. Phryne, celebrated courtesan of the fourth century BC, makes her appearance at the end of a search for new themes to please an al-

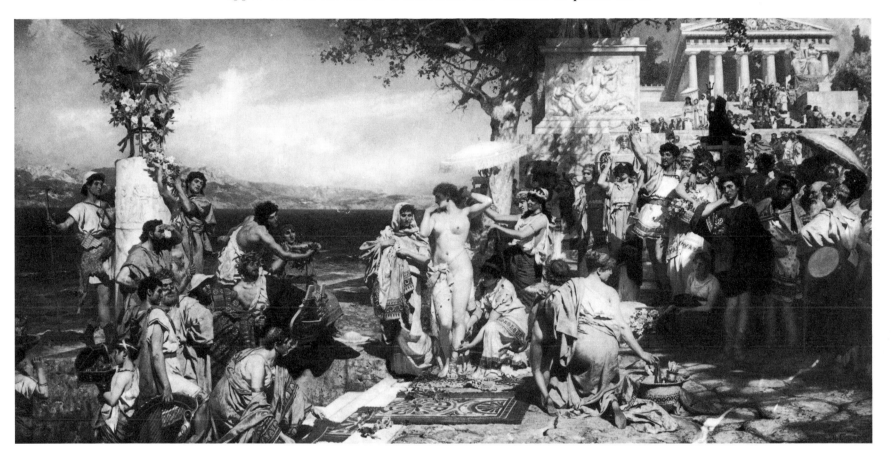

Henryk Siemiradzki
Phryne at the Festival of Poseidon,
God of the Seas, 1889
Oil on canvas, 390 x 763 cm (153⅝ x 301⅜")
Russian Museum, Leningrad

ready blasé bourgeois public, and replace the boring portrayal of the virtues of antiquity with which they were familiar. Gérôme has chosen to depict her appearance before the Areopagus, which tried her for immorality and ended by acquitting her; Siemiradzki, however, gives us a surprising scene in which she displays herself to the crowd in a state of undress.

Both pictures are steeped in eroticism, but, whereas the historical setting and the apparent gravity of the judges manages to temper the real intentions of the first one, the creator of the second aims at a greater frankness which only makes the picture appear duller and more superficial. Here, too, Siemiradzki has included a mass of figures reminding us of the motley chorus of an operetta, while Gérôme puts the emphasis on the principal character. There are twenty-eight years between these two works. In between a frivolous sensationalism had eliminated from painting, at the same time as any interest in historical objectivity, the unappealing picture that objectivity gives of the life of past centuries.

Gesture and Eroticism

The treatment of movement and the scrupulous observation of captured attitudes provide a sure indication of a further step taken in the search for objectivity and scientific exactitude, but they also result from the desire to obtain the participation of the spectator. When the characters in a picture or sculpture are caught between two positions of balance, for example standing on tiptoe, they look like puppets to the spectator who has not followed the action in his mind's eye. Today, strip cartoons produce a similar impression. The pictures we are discussing in this section are also reminiscent of the publicity stills outside some of the cinemas which, not so very long ago, used to show the films of Cecil B. De Mille. It is quite reasonable to suppose that Bourgeois Realist painting paved the way for the cinema, actually becoming the interpreter of a hidden need which it had been technically impossible to satisfy. This sort of painting responded to two basic principles of Bourgeois Realism: art should never be dull, and, far from being just a game for the mind or senses, was closely attached to life itself. The life of these times may have been dominated by pragmatic, individualistic ideas, and inspired by the most second-rate ideals, but this was not the fault of the artist, rather the product of historical circumstances. The bustle of life, entertainment, luxury and eroticism invade the majority of those works of art that have a classical content. The skill of the painter, his erudition and his capacity for pandering to the tastes and inclinations of a rich clientele, took precedence over the desire to deal with problems of more general interest in painting.

In *The Temple of Bacchus* by Giovanni Muzzioli, which represents the last act of some pagan mystery, one of the participants, drunk and exhausted, is slumped against an enormous bowl of wine; in front of him a young priestess pursues her diabolical bacchanale, as if inciting him to take his place again in the whirl of the festival. The real ritual is being celebrated in the background; animated men and women, arms around each other or holding hands, dance around the altar on which a brimming chalice is placed. The Bacchante in the foreground occupies the centre of the composition. Her shape stands out very clearly, and the impetuous movement of her body is visually checked by the immediate proximity of the great wine-vessel.

This compositional contrast is foreign to Giulio Bargellini. In his picture *Pygmalion*, the eponymous character stands out against a wall of smooth marble, whose role is to emphasize the unusual attitude in which his first shock of amazement has caught him. Straight as a column, the statue, which no longer bears any relation to classical sculpture, changes into a flesh-and-blood woman who offers him a flower. On the ground, a hammer fallen from the sculptor's hands, and a wrinkled carpet, underline the movement of Pygmalion, stunned at the product of his labours, and help the specta-

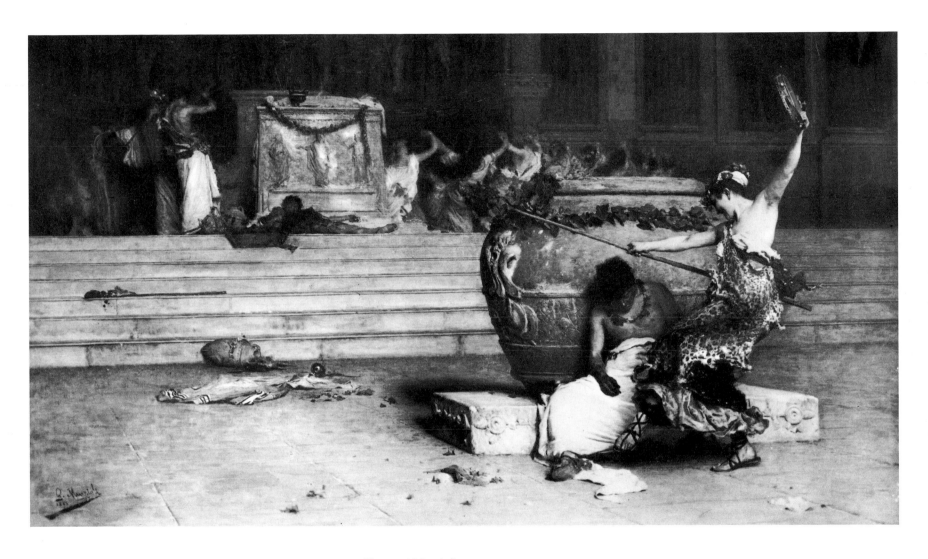

Giovanni Muzzioli
The Temple of Bacchus
Oil on canvas, 85 x 145 cm (33½ x 57⅛″)
Galleria Nazionale d'Arte Moderna,
Rome

tor to reconstruct in his mind the moving picture of all the movements
and gestures that have preceded the instant fixed by the artist.
Movement and nudity are found together again in *The Oreads* by
Bouguereau. A swarm of female bodies intertwine, and, as if carried
off by a whirlwind, soar into the sky before the bewildered eyes of
three satyrs. There is no longer any trace here of the kind of
message which had once been implicit in mythological subject matter;
all that remains is the desire to glorify the body and its charms.

Giulio Bargellini
Pygmalion, 1896
Oil on canvas, 91 x 130 cm (35⅞ x 50⅛")
Galleria Nazionale d'Arte Moderna,
Rome

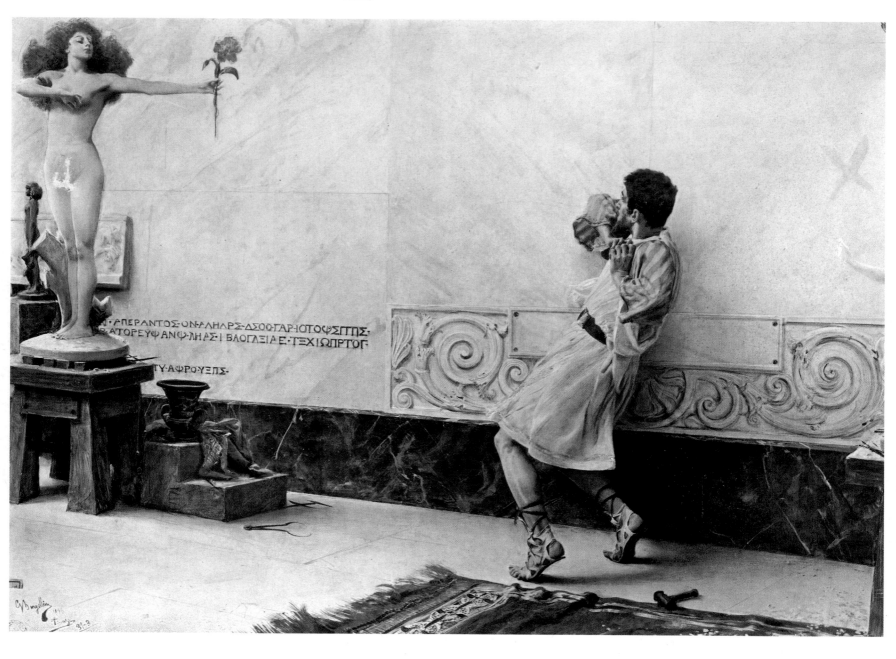

William Bouguereau
The Oreads, 1902
Oil on canvas, length 180 cm (81⅝")
Ch. Vincens Bouguereau, Paris

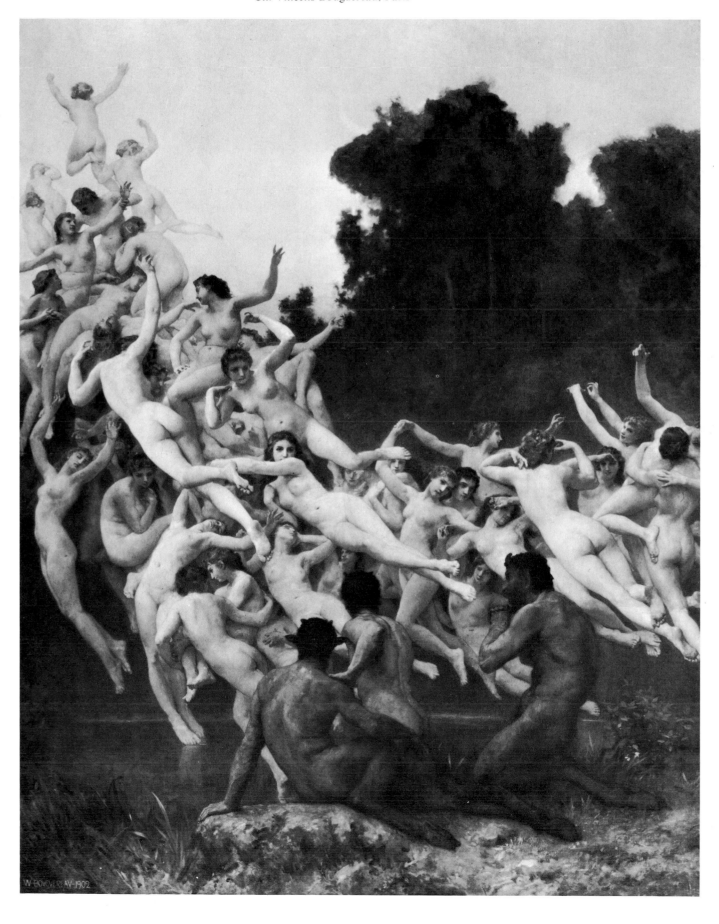

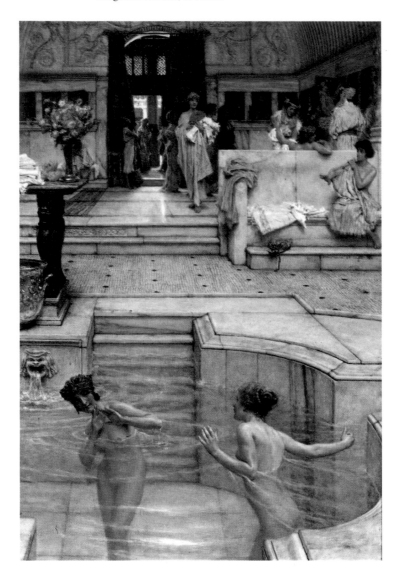

Reconstruction of the Life of Antiquity

Yet painters at the end of the nineteenth century did not all abuse
the portrayal of movement in their paintings of themes from
mythology and antiquity. Sir Lawrence Alma-Tadema, the great
master of the genre, used great economy of movement, as prescribed
by academic tradition; an example is *A Favourite Custom,* where
the movements of the bathers do not disturb the serene atmosphere
of the picture. On the solid framework of the sketch, the artist has
with great precision disposed a whole mass of descriptive detail, en-
riching the tried and tested technique of Bourgeois Realism with a
new method of expression. Unlike Munkácsy, whose violent contrasts
of light and shade forced him to melt the different elements into a
single mass, Alma-Tadema, through the lightness of his shadows, the
subtle deployment of contrasting warm and cold tones, and the use
he makes of sky-blue to bring surfaces of different colours into
harmony, manages to give balance to the complex structure of the

Károly Lotz
After the Bath
Oil on canvas, 180 x 70 cm (70¼ x 27½")
Hungarian National Gallery, Budapest

Frederick, Lord Leighton
The Bath of Psyche, 1890
Oil on canvas, 189 x 62 cm (74½ x 24½")
Leighton House, London

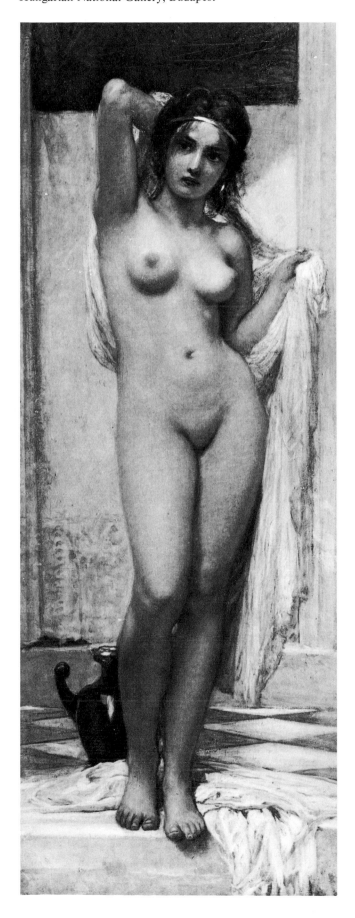

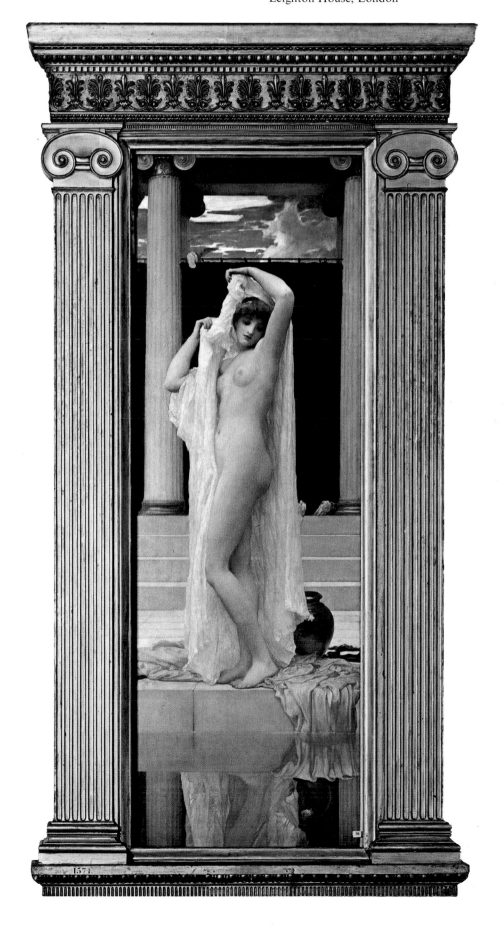

Federico Maldarelli
The Pompeiian Girl
Oil on canvas, 49 x 73 cm (19¼ x 28¾")
Galleria Nazionale d'Arte Moderna,
Rome

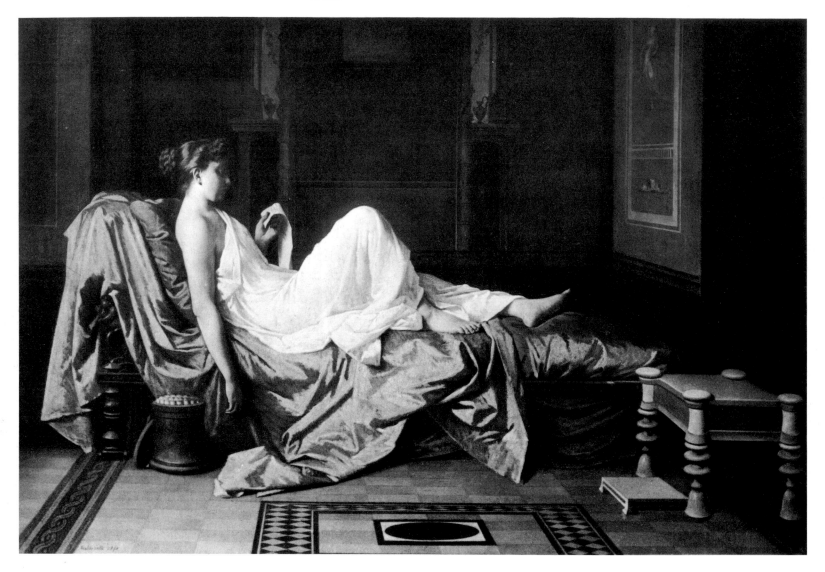

composition. Even when, as in some of the pictures of his next period, the secondary areas are enriched with stylized decorations in the Art Nouveau style, the central section always maintains this equilibrium, due to his strict and exact technique.

Nor is Alma-Tadema sparing with the titillating frivolities that his contemporaries loved. He emphasizes the slenderness of his figures, the graceful feminity of their gestures, the care that these women took in doing their hair and adorning themselves, as if he wished to gather together all the secret longings of his bourgeois public. Members of the stronger sex, if rich, could enjoy the most varied of pleasures, and Alma-Tadema offered them all that their hearts could desire. The heroines of his pictures, clothed as Roman women and transported to a setting in antiquity, retain the bearing and the manners of their class and their time.

The reconstruction of Roman scenes could not avoid taking account of the knowledge acquired from the excavations at Pompeii and Herculaneum, which had begun to stimulate minds from the middle

Louis-Hector Leroux
Herculaneum, 23 August AD 79, 1881
Oil on canvas,190 x 303 cm (74¾ x 119¼")
Musée des Beaux-Arts, Dijon

of the eighteenth century. Federico Maldarelli's *The Pompeiian Girl* shows a young patrician woman quietly reading a letter in her bedroom. The title alone gives one a glimpse of the imminent tragedy, in which this ravishing creature will perish (she is incidentally more Neapolitan than classical in type). But for the moment she gives herself up to a quiet moment of daydreaming.

Hector Leroux, in his *Herculaneum*, reveals a different aspect of the same drama. Herculaneum is further from Vesuvius than Pompeii. The experts therefore reckoned that the flow of lava took more time to submerge the town, gradually invading the lower parts first and then the heights. This inspired the idea of presenting a group of women waiting for the appalling end. Their wealth, at this moment, has lost all meaning, and while some accept their fate others seek salvation by praying to the gods. At the sight of this scene the spectator is entitled to ask: what has happened to the men? Were Herculaneum and the whole of antiquity exclusively populated by young and beautiful women?

The Empire of the Night

It might be supposed that the night and its magic powers provide a heaven-sent opportunity for the portrayal of ethereal, youthful creatures in melancholy mood. Yet in a picture by Ernst von Liphart, appropriately called *Night*, we are shown a well-endowed woman of a pronounced Mediterranean type, possibly Spanish. The movement of her right arm has something ambiguous about it; since we cannot refer back to the original model, it is difficult to tell whether the gesture is meant to be lascivious or imperious. The detailed rendering of the hair, eyelashes, misty eyes and lips, like the smoke-like

Ernst Friedrich von Liphart
Night, 1884
Oil on canvas, 100 x 75 cm (39¾ x 29½″)
Schackgalerie, Munich

Albert Edouard
Night
Oil on canvas, 82 x 54 cm (32¼ x 21½″)
Gérard Lévy, Paris

material of her veils, tends to evoke sensuality rather than remind us of the philosophical symbolism that is found in the same theme when treated by Michelangelo.

Faced with the same public, Albert Edouard was more subtle. He too chose a young person brimming with health as a symbol of Night, but he gave her face a serious, distant, unattainable expression, as if she was attending the celebration of a secret cult, or acting in some esoteric play.

The quest for woman, gay or sad, complaisant or untouchable like the nymphs of Mallarmé – remember also Bouguereau's *Oreads* – forms the background to all the Bourgeois Realist works inspired by

antiquity. The central figure in Giacomotti's *The Rape of Amymone*, whose pose reminds us yet again of Bouguereau's *Venus*, has fallen into the clutches of sea-monsters. Due to the buffeting of the wind and partly to the firmness of the gesture with which she repels them, she must seem to her ravishers the perfect incarnation of femininity. But the resistance betokened by the movement of the head and arms is not matched by the position of the lower part of the body, which is pressed tenderly against the shoulder of one of the tritons. One is drawn to the regrettable conclusion that the daughter of Danaus is not very convincing in her resistance to the overtures being made to her.

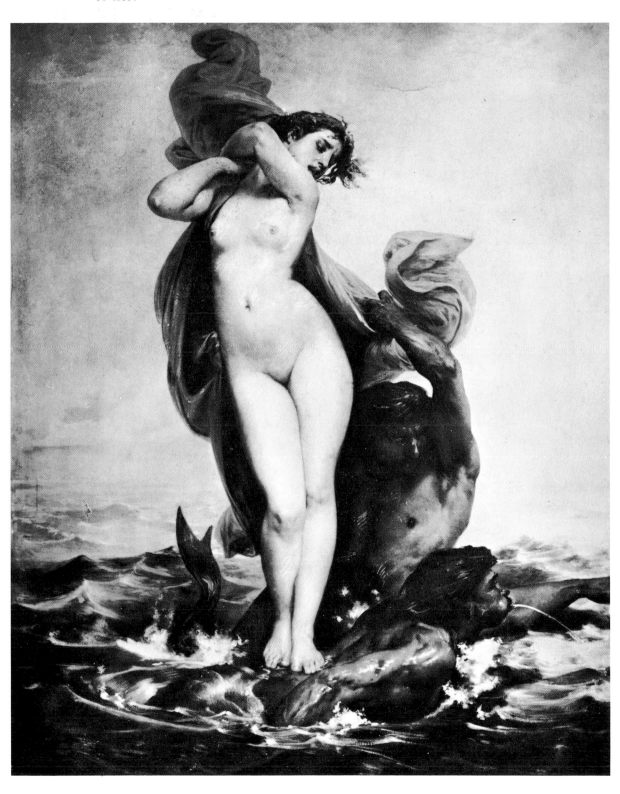

Félix-Henri Giacomotti
The Rape of Amymone
Oil on canvas, 225 x 162 cm (88⅝ x 63¾")
Musée Raimond Lafage, Lisle-sur-Tarn

Victor-Julien Giraud
The Slave Merchant, Salon of 1867
Oil on canvas, 238 x 445 cm (93¾ x 168¼″)
Hôtel de Ville, Sermaise-les-Bains
(Marne)

The Trade in Women

Another theme which delighted artists of the period was the market for female charms, which prospered within the framework of organized prostitution, while causing a few anxieties in respectable circles. The Bourgeois Realists did not treat this scourge of society with the rather crude, even vulgar candour which is to be found later in Toulouse-Lautrec; they introduced it in an underhand sort of way under the cover of motifs from antiquity or the East. Once the problem had been transposed into a different social milieu and century, the artist was at liberty to undress his models at will or dress them suggestively, with the inevitable delight in the salacious, and allow himself sly allusions to the morals of the day. If the great age of antiquity, which had inspired all subsequent struggles for the equality of human rights, had allowed this sort of trafficking to be carried on quite openly, how could modern times fail to tolerate it in a disguised form?

A whole series of small paintings by Gérôme exploits these themes, using exotic settings or calling on the distant past. They were executed with the delicacy and attention to detail that distinguish this painter, and they are not without a titillating detail or two; they were intended for the fashionable salons, to provide a talking-point when the occasion arose.

But there are also large formal pictures, like Victor Giraud's majestic *Slave Merchant*, which exist in a dramatic climate, and thus contrast with somebody like Gérôme, who takes this class of subject matter for granted. The apparently documentary intention of Giraud's work allows him to be more intense in his erotic content. We can see the same differences between these two painters as we can between Gérôme and Siemiradzki. The observation of psychological characteristics through the characters' reactions, the expression of joy or sadness, constitute a sort of commentary, but they eradicate the distance between the work and what it suggests, destroying the implicit content, the power of suggestion, that can be found in paintings of all periods. The youthful, thoughtful and reserved Roman who in Giraud is somewhat contemptuously contemplating the young, naked slave-women; the young girl bowing before him with a submissive air; and the old Levantine merchant selling his wares: all these figures seem to us naive and transparent, no doubt because their sentiments and desires are spelled out in gestures and attitudes. Nevertheless, far from sharing our opinion, the public of the day really appreciated these works. Art at that time had the role of encompassing all the stimulating social problems, without taking sides. This was how even so negative a phenomenon as prostitution could become socially acceptable and adopt the title of 'the world's oldest profession'.

Legend and History

The Vitalist Aesthetic

Together with religious painting, history painting was long accepted as the fullest artistic experience. This opinion was based on the traditional hierarchy of themes, which neither the naturalist aesthetic of the second half of the nineteenth century nor even the 'vitalism' of theorists such as Guyau managed to break. Bourgeois realism did no more than renew the form of historical painting and give it more solid motivations than it had until then been given by theology.

'The great aesthetic emotions,' said Guyau, 'are in general very closely allied, both to the strongest and most fundamental sensations of physical existence and to the noblest sentiments of moral consciousness.'[19] This twofold connection found its confirmation in artistic experience. Bourgeois Realist paintings provide either the description of objects and people in the minutest detail, or the detailed exposition of a conception of life in which moral and political considerations were counterbalanced by a coherent idea of material gratification. This complex relationship with the external world – at one and the same time physical, or even physiological, since Guyau associated beauty with sensuality, and moral, in that he assigned art an active role in the propagation of exalted ideas – this relationship created a scale of values which could be applied to works of art. The purpose and the merits of a work are therefore ultimately based on the functions and relationships of its various components.

In accordance with Guyau's theories, Bourgeois Realism produced historical paintings of works which, by their content, emanate from one or other of the two tendencies mentioned above. History served either as the backcloth on which the inclinations of contemporary society were expressed, or else as an approach to the intellectual and political motivations of the present, coloured as they frequently were by nationalism.

While the themes of antiquity induced painters to paint frivolous scenes, or to reconstruct the past like archaeologists, the period which followed the great invasions of the Dark Ages, and to an even greater extent the history of the centuries in which new states and their dynasties were formed, often served as a pretext for the exposition of political doctrines. Every European nation, and even the national centres of peoples who had not yet acquired their independence, produced historical painting of one kind or another, preferably large in format. The works in question acted as assertions of national identity, although very often, as Francis Jourdain points out, they presented an image of history not so very different from the rudimentary idea that children have. Moreover, sensual gratification and political aspiration were very often closely linked, and it is not rare for the two to be found side by side in the same picture. Guyau himself was not unaware of the dangers such a confusion entailed for an art that was obedient to reality – the art in which he

was a convinced believer – and he affirmed that the truly authentic realism was one which 'consisted of borrowing from the representations of daily life all the force inherent in the distinctness of the contours, but stripping them of their vulgar, tedious and sometimes repugnant associations'.[20] This approach tended to be rather too intellectual for the painters to follow.

Paul-Joseph Jamin
Brenn and his Share of the Plunder,
Salon of 1893
Oil on canvas, 162 x 118 cm (63¾ x 46½")
Musée des Beaux-Arts, La Rochelle

The Pleasure of the Senses

In *Brenn and his Share of the Plunder* by Paul Jamin, there is a superb example of an erotic scene that the author transposes into a past sufficiently alien not to incur the censure of respectable people. We get the impression that the splendid fellow standing framed in the doorway, dressed up as a Gallic warrior, is about to cross the threshold of a brothel which has a particularly promising bill of fare. To attain his end, the painter has used all the most effective means: a detailed inventory of the physique of all the models, especially those in the foreground who claim the most attention, and a deliberately ingratiating choice of colours. Pink and pale blue are dominant, supported by the gleaming bronze of the sculpture on its stele, and by the neutral grey tones that academic painters tended to use to avoid the too-vivid contrasts that might arouse emotions unsuitable to the subject of the picture.

Medieval Legend

Legends, too, encouraged painters to embroider on the past. The Bourgeois Realists took this legacy of the Romantic movement and gave it the same credibility as their other themes. So legend was embodied in a succession of carefully observed personal idiosyncrasies and spectacular scenes born of the collective imagination.

Alionushka is the heroine of a popular Russian tale; Vaznetsov shows her as a young peasant woman sitting beside the water with her hair down, looking pensive and a little melancholic. The young girl does not claim any less of our attention than the countryside, but it is

Viktor Mikhailovich Vaznetsov
Alionushka, 1881
Oil on canvas, 173 x 121 cm (68⅛ x 47⅝″)
Tretyakov Gallery, Moscow

Albert Maignan
The Meeting of Dante and Matilda, 1881
Oil on canvas, 320 x 240 cm (126 x 94½″)
Musée de Picardie, Amiens

the latter especially that creates the lyrical atmosphere. Vaznetsov, who treats nature in his own very realistic manner, creates all the conditions for the mythical figure of Alionushka to be as tangible as an ordinary being, using an artistic approach contrary to that of the Symbolists.

Maignan's picture *The Meeting of Dante and Matilda* shows us a scene which appears in the Purgatory of the *Divine Comedy*. The two parts of the picture constructed around one diagonal are treated without any recourse to the fantastic, but mark a very clear difference in colour and lighting. One critic, who deplored the presence of Dante and Virgil, pleaded in favour of a simpler composition; a picture in which nothing would detract from the visual enjoyment. The creator, for his part, had tried faithfully to express the emotion produced in the poet by the spectre, and to integrate it into the composition. After the manner of Gleize, he tried to show the ambivalence of the situation. On the first level we have the object of the poet's admiration, then the feelings that she arouses in Virgil and in Dante – feelings

John William Waterhouse
The Lady of Shalott, 1888
Oil on canvas, 153 x 200 cm (60¼ x 78¾″)
Tate Gallery, London

that derive from the similarity of their views: they look as if they have suddenly come upon a perfect work of art. We must recognize that the Bourgeois Realist painters, following the theoreticians of their own time, were capable of asking themselves subtler questions than art historians have hitherto been prepared to admit.

In his visual transposition of Tennyson's 'The Lady of Shalott', Waterhouse, like Vaznetsov, has made nature very beautiful, with its shining waters and its trees and plants, without neglecting, however, details like the boat and the embroidered material that drapes the Lady. Within his rich setting, treated in the realistic manner, he has placed an unreal figure with a poignant expression and a hieratic stance. If it were not for the setting, and the medieval atmosphere, the way this picture is composed would be in no way distinguishable from the productions of Alma-Tadema, Waterhouse's master. The delight in detail and the rationalist conceptions of Bourgeois Realism intermingle here with the Romantic fascination with remote and indefinable psychic states.

Philip Hermogenes Calderon
Going with the Stream, 1869
Oil on canvas, 111 x 190 cm (44¾ x 75¾")
Hamburger Kunsthalle

Life in Fancy Dress

Whereas the Lady of Shalott, under the spell of an enchantment, accepts her destiny and is carried away by the current of the river towards the unknown, the young woman in medieval costume in Calderon's painting *Going with the Stream* gives herself up to her desire for life. Her companion contemplates her without great enthusiasm, as if he were thinking of something else. If they were not both in fourteenth-century costume, one might think this was a bourgeois couple from a story by Maupassant, relaxing one Sunday afternoon with a little boating. There is no longer any trace of Romanticism, but simply a situation which passes for 'Romantic' in bourgeois terms, that is, one that is picturesque and sentimental.

The atmosphere of the Middle Ages thus did not always dispose painters to Romantic frames of mind. *The Court Jester* by Karl Gehrts reconstructs the atmosphere of a castle at a time when the whole household is enjoying the musical and poetic skills of a troupe of

Karl Gehrts
The Court Jester, 1878
Oil on canvas, 102 x 190 cm (40¼ x 75¾")
Hamburger Kunsthalle

mountebanks. The room is richly furnished with carved wood and brocade; the walls and the floor are covered with carpets and animal skins. Everything proclaims the immoderate passion of the lord of the manor for surrounding himself with a profusion of goods, a typical preoccupation of the middle classes at this time. In painting the various elements of the decor, the artist has been intent on conveying a climate of wealth and opulence. The pale, anxious faces of one section of those present do not detract from the general impression one has of a room in which family life flows smoothly, one such as the honest bourgeois might imagine and dream of within the confines of his narrow ideal.

Political Trends

The spectacle of the life of certain monarchs of the past sometimes has as its object the awakening of the national consciousness and the illustration of the political aspirations or territorial claims of a

people; an example is the picture *Laszló V and Ulrich de Cilli* by the Hungarian, Bertalan Székely. It is easy in all parts of this work to detect an application, albeit a little simplistic, of Guyau's criteria for an authentic work of art. He defined beauty as perception from the point of view of the public and as action from the point of view of the artist. Perception and action stimulate our spiritual life by renovating it. They act at the same time on three components: sensibility, intelligence and will. In the present instance the group of dancers is attempting to excite our sensibilities; the reconstruction of an eleventh-century interior is working on our intelligence; and the treacherous counsellor who is trying to make the King sign the fatal

Bertalan Székely
Laszló V and Ulrich de Cilli, 1870
Oil on canvas, 123 x 222 cm (48⅜ x 86⅜")
Hungarian National Gallery, Budapest

Sándor Wagner
Queen Isabella Leaves Transylvania, 1863
Oil on canvas, 135 x 171 cm (53⅛ x 67⅜")
Hungarian National Gallery, Budapest

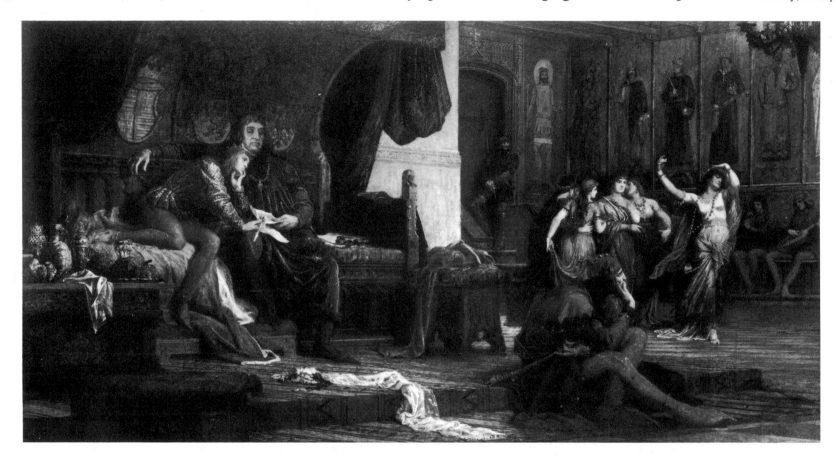

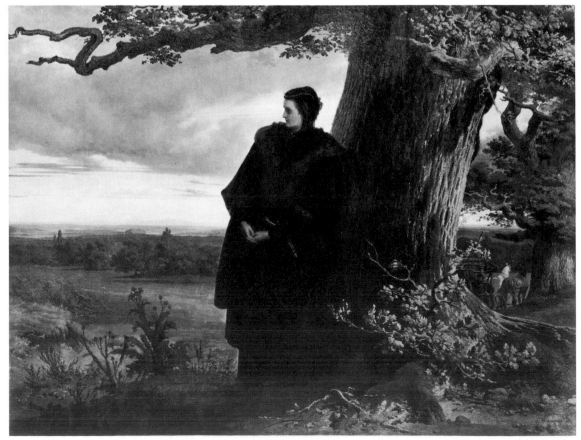

document arouses the desire in us to see the guilty man punished and the innocent boy vindicated. It remains to be known whether the painter consciously wanted to convey Guyau's aesthetic idea, or whether it was so intimately associated with his art that it imposed itself on successive moments of the creative process.

It often happens that the political intention of a work is apparent only to initiates. That is what seems to happen in the picture by Sándor Wagner, *Queen Isabella Leaves Transylvania*. The gracious young woman in Renaissance costume, meditating with her back against a tree while the harnessed horses are champing at their bits, symbolizes a nationalist craving for revenge. The allusion can be

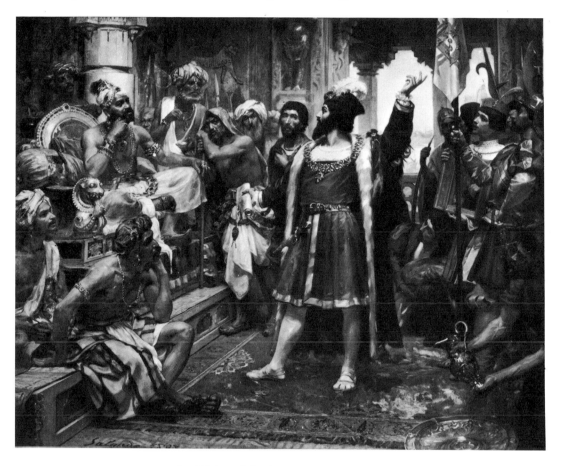

José Veloso-Salgado
Vasco de Gama Before the Prince of Calicut, 1898
Oil on canvas, 240 x 295 cm (94½ x 116⅛")
Geographical Society, Lisbon

understood only by those who know that Transylvania is a rich province, now in Romania, which the Hungarians have lost several times in the course of their history. It might just be possible for someone with local knowledge to identify it from the components of the landscape: the majestic trunk of the oak, like those that grow on the slopes of the Carpathians; the vast plain which stretches into the background; and the river which makes its meandering way across it. It is only with this knowledge that the spectator can be aware of the Queen's feelings, and her regret at leaving the lost territory.

The Portuguese painter Veloso-Salgado was also inspired by the history of his country, and immortalized its colonizing spirit in a scene which again is set in the Renaissance. Be that as it may, what strikes us above all in *Vasco da Gama Before the Prince of Calicut* is the sartorial elegance of Portuguese and natives alike.

Influence of Official History and Literature

The Russian Surikov painted *The Morning of the Execution of the Streltsy* as a true historian. This work appeared in the middle of the political and intellectual upsurge that Russia was witnessing around 1880. This was the time when people began to reconsider Peter the Great's reforms and to regard in a new light such episodes as his persecution of the traditionalist sect of the Streltsy, which ended in wholesale killing. Instead of unreservedly glorifying the authority of the monarchy by pointing to the reforms the Tsar had made, the intelligentsia acquired a more complex vision of history

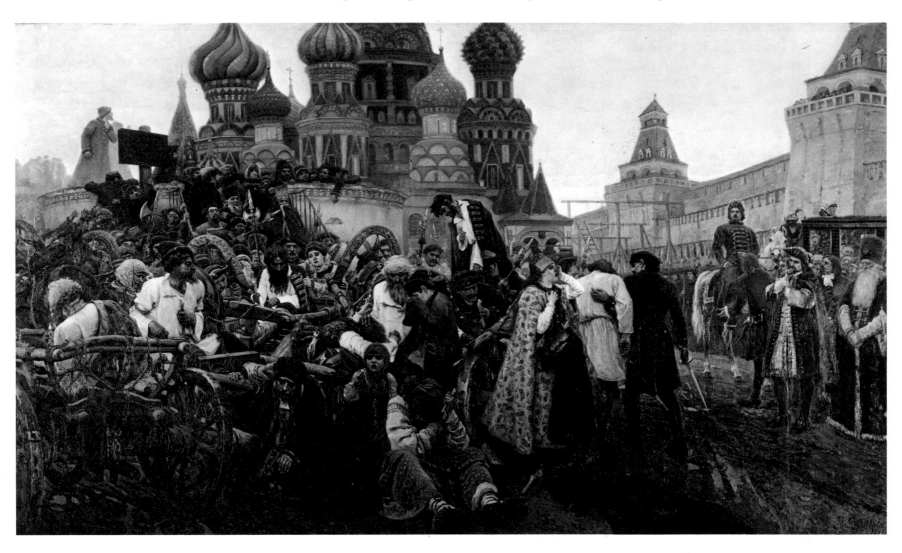

Vassily Ivanovich Surikov
The Morning of the Execution of the Streltsy, 1881
Oil on canvas, 218 x 379 cm (85⅞ x 149⅜")
Tretyakov Gallery, Moscow

and formed a clear image for itself of the sufferings imposed on the people by brutal and authoritarian measures. At the time when Surikov was working on his canvas, the public had already realized that at the same time as liberating the peasants the abolition of serfdom had deprived them of the land that was their livelihood. Furthermore, science and art began to insist more and more every day on the historical role of the people, its patriotism and the moral values it preserved. It is not for nothing that the episode evoked by Surikov is echoed in the passionate music of Moussorgsky's *Khovanshchina*; this too dealt with the suffering of those fighting against the reforming monarch to maintain their traditions.

The crowd is the principal actor in Surikov's drama. It is moving forward towards the troops drawn up in front of the walls of the Kremlin. It gives an immediate impression of chaos, in spite of the mass of picturesque costumes. The dramatic tension is first and foremost concentrated on two of the condemned, black beard and red beard, then on the members of their families who accompany them

to their execution. In this way the artist has to some extent corrected the apparent confusion of the whole, although the narrative unfolds chiefly through the use of psychological details: the attitudes of the different characters and the expressions on their faces are drawn with particular care. Close to literature and the theatre, this picture, because of its narrative content and the image it gives of the people and their attitudes in a Tsarist regime, has never ceased to inspire endless disquisitions on the way in which an artist can become a spokesman for social aspirations.

In their evocation of past events, certain artists were directly inspired by the theatre, while trying to adapt their subjects to the require-

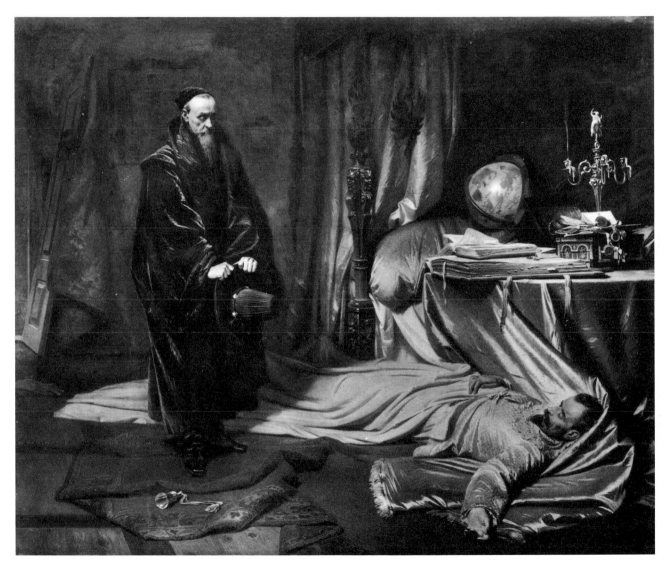

ments of their own art. This is true of Karl von Piloty, who paints imaginary celebrations reminiscent of opera, or transposes fragments of dramatic works, such as *Seni Before the Body of Wallenstein*. The artist takes characters from Schiller and alters their role in the drama, to the point of giving the general's astrologer finding his dead master the meditative appearance of a philosopher. Instead of the expression of horror indicated in the stage directions, just before the line: *O blutige, entsetzensvolle Tat!*, ('O bloody, horrible deed'), the character in the picture hangs his head as if the *dénouement* came as no surprise to him. Scenes of this kind could not awaken interest in their content, because they depend too much on works of purely literary value, and because they illustrate neither the ideals nor the characteristic features of the life of a society. All that is left here is the superficial imprint of the theatre.

Karl Theodor von Piloty
Seni Before the Body of Wallenstein, 1855
Oil on canvas, 312 x 365 cm (122¾ x 143¾")
Bayerische Staatsgemäldesammlungen,
Munich

Gallantry

People are supposed to be more tolerant of erotic scenes in period
costume. Those set in the eighteenth century lend themselves quite
naturally to suggestions of licentiousness, the secret aspiration of so
many bourgeois. This is not to say that the time-shift was used by
Bourgeois Realists to gloss over risqué or improbable situations: the
artists' choice in eighteenth-century scenes was for the more moderate
entertainments of the nobility, which consisted in innocent little parties
and outings to country taverns.

It is significant that Meissonier, one of the most popular artists of

Jean-Louis-Ernest Meissonier
The Roadside Inn, 1865
Oil on panel, 24 x 20 cm (9½ x 7⅞")
Reproduced by permission of the
Trustees of the Wallace Collection,
London

Jean-Louis-Ernest Meissonier
*Napoleon III at the Battle of Solferino –
24 June 1859*, 1863
Oil on canvas, 44 x 76 cm (17⅜ x 29⅞")
Louvre, Paris

his time, was one of the illustrators of this way of life. His success
was entirely based on an incomparable technique. Nobody before him
had managed to reconstruct the past so minutely and vividly. Men
and horses are caught in their natural movements, as later a profes-
sional photographer using a perfected and easily handled camera
could have done. Meissonier can render all details of costume,
movements, furniture and vegetation according to where the scene is
set, and without sacrificing the unity and balance of the painting.
Meissonier was world-famous, and his works fetched astronomical
prices; their small size, conforming to the technique of Romantic
vignettes, enabled them to be easily transported and hung in a
moderate-sized apartment. Meissonier fulfilled the requirements of a
clientele who desired to amass a great quantity of works of art in a
relatively small area, and at the same time to make the maximum
concentration of a part of their capital. So the acquisition of Meis-
sonier's works became the same sort of habit as the purchase of
valuable objects like pieces of jewellery.

One of the finest of Meissonier's works chronicles the history of his own time; *Napoleon III at the Battle of Solferino – 24 June 1859* appeared only a few years after the event itself. It exploits all the resources of the realistic technique, applied to a collection of real facts that the painter could still verify, whether they related to the progress of the battle, the site where it happened, or the men who took part in it. Even the choice of the scene is a mark of the artist's stubborn pursuit of objectivity. He avoids bombast (which was at the time very much in vogue), and he comes upon his subject as if by surprise, viewing it from near the high command, in a place where nothing heroic is happening. The picture was

purchased in 1864 at the same time as *The Emperor Surrounded by his General Staff,* by the Direction des Arts charged with purchasing the works of living artists for the Imperial family. These two paintings brought Meissonier 50,000 francs. The government was able to pay such a high price because there had been since 1849 a special fund for the purchase of this painter's works.

When *Napoleon III at the Battle of Solferino* was hung in the Luxembourg, it was almost universally admired, by the general public as well as by connoisseurs and acquaintances of the artist. Degas, with great care, copied several of the horses, which later served him for his own work. Theodore Reff has recently established that there are in existence four examples of details copied by Degas in his book of sketches; one of them is identical to the original, and shares its 'meticulous surface realism'.[21] He adds that the two painters, whose friendship went back to their stay in Rome at the time of their youth, had recourse to photography to study the horses' movements with precision; they were especially interested in the photo-

graphs published around 1880 by the English photographer Eadweard Muybridge.

The Impressionists themselves – or at least some of them – gave the researches of Meissonier their due; they appreciated his perseverance in painting an animal in movement, and trying to capture the fleeting moment on his canvas. Moreover, his use of colour was by no means lacking in spirit, even if the best of his personality is expressed in his forms. All these qualities of the painter can be found together in *Napoleon III at the Battle of Solferino*. This is a perfect example of a consistent application of the principles of Bourgeois Realism; it is a model of its kind. It is also free of eclecticism. This concept could

Aleksander Gierymski
The Arbour, 1882
Oil on canvas, 136 x 148 cm (53½ x 57¾″)
National Museum, Warsaw

Gyula Benczúr
Louis XV and Madame du Barry, 1874
Oil on canvas, 79 x 65 cm (31⅛ x 25⅝″)
Hungarian National Gallery, Budapest

never be applied to Meissonier, except insofar as he bridged the gap between painting and photography, and so demonstrated the close affinity between the achievements of modern science and the traditional artistic creative process. He gave an ever-increasing importance to the reconciliation of photography and painting; he becomes daily more topical with the appearance of Pop art and Hyper-Realism.

His desire to keep up with technical advances might easily have led to the work falling apart under the pressure of too many objective elements; that it did not do so is a tribute to Meissonier's unity of visual perception. This unity is apparent in the priority given to the picture as a whole, rather than to details relating to the countryside or to the horsemen, so that nothing obstructs a general vision of the picture. The details themselves are there for anyone who looks for them; they have a great deal more sharpness and persuasive force than even one of the most modern of photographic shots.

Under the influence of Meissonier, and due to the eternal desire of the bourgeoisie to ape everything the aristocracy did, the great

European centres witnessed the birth of a great number of works. Gyula Benczúr, the Hungarian painter, in his picture *Louis XV and Madame du Barry*, conveys an overblown eroticism that was foreign to the French master. In this sense, and also because of his more relaxed technique, he is more reminiscent even of certain works painted at the time of 'Louis the Beloved' himself. *The Arbour*, by the Polish painter Gierymski, presents us with a more bourgeois atmosphere, and a sharper sense of social relations.

Street scenes set at the end of the eighteenth century or the beginning of the nineteenth were common enough, and this is the genre that Storey gives us an example of in *The Old Soldier*; it is an excellent

illustration of the attitude of the middle classes to the army. The first glance reveals nothing of particular interest. In the charming setting of a street in which only wealthy families would be able to live, a war veteran is bowing respectfully to a young woman about to give him alms. The two actors smile at each other, and the passers-by flash them a benevolent look; yet we have the impression that the order and peace so dear to the middle-class heart deliberately hide something that the work has managed to capture. At first sight we might think the artist was commenting on social injustice and class differentials, but there is more to it: the old soldier's face speaks eloquently of the discredit attached to a career in arms. It is true that throughout the whole of the nineteenth century the State tried to appear concerned to glorify the noble deeds of the defenders of the fatherland in any way possible, as for example in the famous picture by Nils Forsberg, *Death of a Hero*. The State was not sparing with honours and rewards of all kinds; but deep down the bourgeoisie and the businessmen had no love for the army. Middle-class youths

George Adolphus Storey
The Old Soldier, 1869
Oil on canvas, 112 x 87 cm (44$\frac{1}{8}$ x 34$\frac{1}{4}$")
Hamburger Kunsthalle

had little interest in a military career, and the military academies were full of the scions of a nobility that had become frustrated by its loss of power. The situation was no different in England. What is meaningful in Storey's picture is not simply the account of a random incident, or the tale of an injustice corrected by charity, but above all a warning and a lesson for those preparing to enter life.

Nils Forsberg
Death of a Hero, 1888
Oil on canvas, 300 x 450 cm (118⅛ x 177⅛″)
National Museum, Stockholm

Warlike Patriotism

When they reproduced events in contemporary history, artists willingly succumbed to a climate of patriotic eloquence, whether or not they had actually seen the events with their own eyes, as had Anton von Werner during the Franco-Prussian war of 1870. Cammarano's *The Battle of Dogali* shows us the manipulation of historical fact in the course of its transposition into art. This was a battle the Italians lost in 1885 during the last Ethiopian war. Of course, nobody would claim that heroism is always in the camp of the winners; it is no less present in the ranks of those on whom fortune has failed to smile.

All the same, there is a big gap between an illustration of individual courage and the picture of a battle being won – a gap which Cammarano sets out to bridge. His Italian soldiers, in their white colonial uniforms, led by their intrepid officers, are irresistibly carving a path through a rabble of natives armed with bows and spears.

The problem which Cammarano managed to solve with real virtuosity was also one that faced the Russian painter Vereshchagin. In *The Surprise Attack* his soldiers in white are also in a difficult situation, somewhere in the mountains of Central Asia, assailed by a large horde who have overrun the valley. The men surprised outside the camp have already fallen back and split up in disorder, while the

Anton von Werner
Billeted in Paris, 1894
Oil on canvas, 120 x 158 cm (47¼ x 64⅛")
Staatliche Museen, Berlin

others are hurriedly regrouping to form a square, which is the only way to break the charge of the enemy, at whatever cost. The disposition of the battle lines; the bare, flat space between the Russians and their assailants; these remind one of scenes from the later films of Eisenstein. The documentary aspect of the picture is not fortuitous. Besides the numerous and picturesque Oriental scenes he left behind, Vereshchagin bequeathed to posterity works which bear witness to his sense of historical reality. We should not be surprised by this; as an official army painter, he went to the scene of operations, as war correspondents do today, and was killed at Port Arthur during the Russo-Japanese war of 1905.

Michele Cammarano
The Battle of Dogali
Oil on canvas, 445 x 748 cm (175⅛ x 294½″)
Galleria Nazionale d'Arte Moderna,
Rome

Vassily Vassilievich Vereshchagin
The Surprise Attack, 1871
Oil on canvas, 82 x 207 cm (32¼ x 81½″)
Tretyakov Gallery, Moscow

Ilya Efimovich Repin
Zaporozhets Cossacks Write to the Sultan
Oil, 67 x 87 cm (26⅜ x 34¼")
Tretyakov Gallery, Moscow

Panache and Jingoism

Patriotism did not only find expression in conflicts with enemies from outside one's country's frontiers. Within a country, it nourished the aspirations common to citizens of all countries. The property of Bourgeois Realism is that it did not associate patriotic sentiment with a particular outstanding personality or action, as did the painters of the Romantic school. Democratic habits, and the right to vote, exert a constant influence in society, and modify the very nature of national feeling. The notion of heroism loses its individualist character and can then be extended to a group, a complete collectivity.

Repin's *Zaporozhets Cossacks Write to the Sultan* refers to Gogol's *Taras Bulba*, and to a free and proud people living on the banks of the Dnieper; the Russian painter has depicted several members of the community laughing and joking at the words dreamt up by the village letter-writer. Only the title of the picture tells us what has brought these men together. The Turks claimed the levy of a tribute

on territory occupied by the Cossacks which rightfully belonged to the Turkish government. Hence the fury and the immediate response from these people, who obeyed no one but themselves, and saw the Sultan's ambitions only as an insolent provocation. The Russians later had to perform miracles of diplomacy in order to make these people recognize the sovereignty of the Tsar. By the time Repin tackled this subject – and he dedicated some ten years of his life to working on it – the Zaporozhtsi had long since capitulated. This detail leaves the artist free to express an unreserved sympathy for those he looks on as blood brothers.

The method adopted by Repin consists of accenting the character and

Alfred-Philippe Roll
Sketch for 'The Fourteenth of July'
Oil on canvas, 165 x 265 cm (65 x 143¾″)
Musée du Petit-Palais, Paris

mood of each personality. None of them is silent, and none of them expresses sentiments or opinions contrary to the collective state of mind, so that the creator is constrained to provide variations on the same psychological theme as it manifests itself in each of the faces. Instead of looking at the whole, the spectator is required to carry out an examination of each detail. The eye moves from one face to another until it has managed to penetrate the general meaning of the composition.

When Roll a few years later painted the celebrations of *The Fourteenth of July*, his aim was to show us the unanimity of the French people as it showed itself in the rejoicing shared by all layers

of society. This is why the general view of the participants is more important here than the expressions on their faces. These people may be different in their dress and behaviour, but their sentiments are identical and they share in the general mood. One sharp character is taking advantage of the jostling to pick up a girl. In the background we can see a military march-past, while on a specially erected podium a band is playing fit to burst.

If we put side by side the early sketches and a reproduction of the final painting (for it is impossible to see the original, since it has been relegated for many years to the vaults of one of the Paris museums) we have no trouble in seeing the direction the artist's work

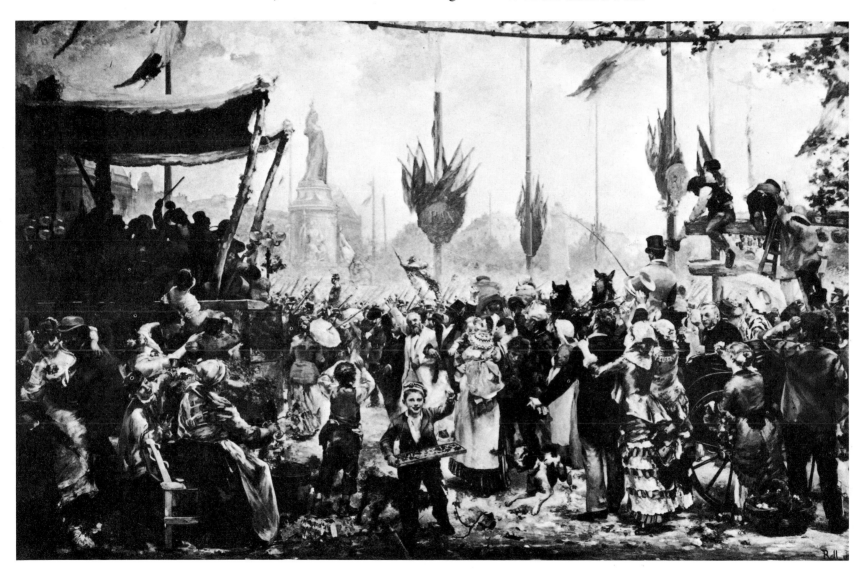

Alfred-Philippe Roll
The Fourteenth of July
Oil on canvas, 645 x 980 cm (253⅞ x 385⅞")
Musée du Petit-Palais, Paris

was taking. The plastic and decorative values are already present in the sketches. Careful not to modify them, Roll cautiously added details which could define the social position of each character. The old fellow in the carriage, who shows all the signs of belonging to the high commercial bourgeoisie, the intellectual in the centre whose gesture betrays patriotic emotion, the families of shopkeepers, craftsmen and workers, everyone down to the little rosette-seller occupies his place in the general harmony. With the image of the statue of the Republic which can be glimpsed through a light haze, the work symbolizes the very ideal of a liberal and democratic France.

Orientalism

The last thirty years of the nineteenth century are marked by political struggles between the great powers – England, Germany, France, Russia – for a new distribution of spheres of influence outside the boundaries of Europe. In the course of this competition, new candidates appeared on the international scene; first of all the United States and Japan, then states of lesser importance, such as Belgium, Italy and Portugal, some of which had received their constitution or unity only a little while before. Each nation tried to take possession of parts of Africa and Asia which until that time had only been of relative importance to their interests. So the digging of the Suez Canal and the colonization of Indo-China, not to speak of the reinforcement of its positions in North Africa, corresponded to the relatively recent national ambitions of French policy. At the same time, the assumption by Queen Victoria of the title of Empress of India and the purchase by Britain of shares in the Suez company is evidence of the increasing involvement of the British in overseas regions. England and France came into conflict with the German penetration of the African continent, while Austria-Hungary concentrated its efforts on the Balkan Peninsula. Russia, taking advantage of the immense and sparsely populated territories on its doorstep, and using modern technology, especially in transport, extended its possessions in the Far East. But one region in the world excited the interest and covetousness of everyone – the Middle East, then as now.

Just as painting followed the evolution of religious or social themes, it reflected and adopted political aspirations; and so it turned towards subjects of an Oriental nature. It is true that these themes were already present in the works of the Romantics, but they were viewed differently and from a different perspective. Apart from the fact that Bourgeois Realism offered very clear-cut differences of style, it was also nourished by new ideas. When Delacroix and Fromentin happily painted Arab horsemen, it was because they were fascinated by the almost legendary existence of these men, an existence that they imagined packed with dangers and excitements long unknown in Europe. The Bourgeois Realist painters offered a vision of the East which put it within the reach of the public and showed its desirability and, by implication, the profits that could be made from it. Their canvases presented two distinct varieties of theme. The first was quite superficial and gave a glimpse of the wealth of these countries, by showing the architecture, costumes and traditional scenes; the other was more subtle in aim, and attempted to unveil to the eyes of the curious the secret life of these people of the East, including anything that might be seductive for the real or armchair traveller: the latter was promised, heavily laced with eroticism, all sorts of pleasures forbidden in the West. Moreover, as Crespelle has rightly noted apropos of Rochegrosse's picture, *Morocco – The Twitter of Birds,* any client of certain Parisian establishments would find the atmosphere in these works familiar.

Félix Ziem
View of an Island in the Venetian Lagoon, after 1890
Oil on canvas, 44 x 75 cm (17¼ x 29½")
Louvre, Paris

Almost any voyage to the Middle East still passes through Venice. Bathed by the same sea and splashed by the same sun as Istanbul or Alexandria, Venice breathes the sensual warmth that is the hallmark of these distant lands. Its sumptuous gondola-borne festivals have the exotic charm of a world lost forever, remote from a Europe that has been turned upside down by the rapid advances of industry and technology. The canvases of Ziem invite a privileged audience to enjoy cultural escapades, far from the smoky cities, in picturesque and sunny spots. Although literature is not his only source of inspiration, his sunsets over the Venetian lagoon, or over the minarets and cupolas of the Bosphorus, may be compared with certain descriptions by the French writer Pierre Loti. We cannot arrive at a better definition of his work than by comparing it with the Impressionists, not only with Monet but also with the solitary Boudin, who was nearer to him in age.

Let us think back to the Monet of the 1870s. Like him, Ziem naturalistically painted the water, the sky and the reflections of the

Konstantin Makovsky
The Holy Carpet Being Transferred from
Mecca to Cairo, 1876
Oil on canvas, 214 x 315 cm (84¼ x 124")
Russian Museum, Leningrad

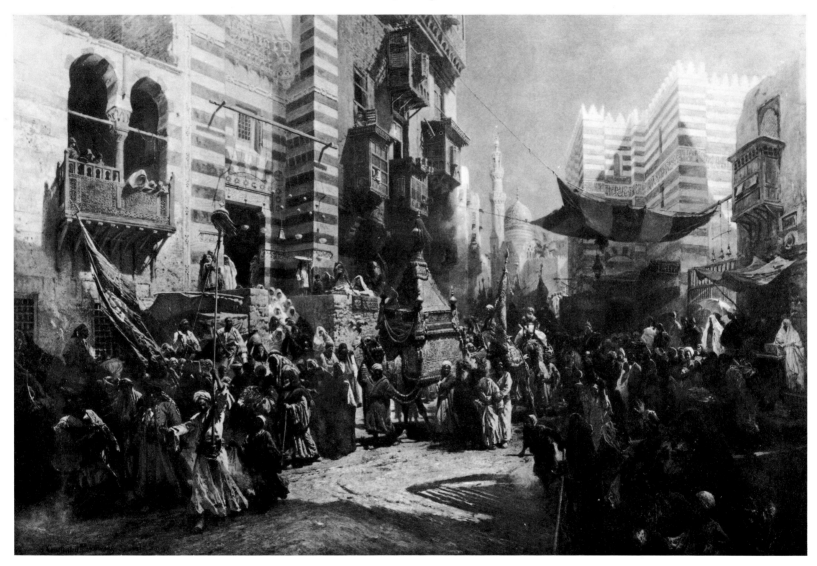

light in dazzling colours: see his *View of an Island in the Venetian Lagoon*. With his warm, earthy tones, his ochres and pinks, which are much in evidence even under a deep and vivid blue sky, he ensures that these colours are always harmonious and never have the starkness that one notices with Monet. If we compare Ziem's pictures with Boudin's, where the harmony is made through the gamut of greys, the difference is even more striking. Ziem does not show the objectivity of his less commercially successful colleague. In Boudin a woman's hat or parasol on the beach carries as little weight as the edge of a chair or the roof of a bathing cabin, while Ziem takes certain details of architecture or costume and accentuates their colouring, to the detriment of the structural balance of the picture. This process aims to evoke a preconceived experience, without relating it to the immediate vision of the external world; it is a response to an aesthetic ideal or a sense of beauty which are based on a profound attachment to material goods and physical enjoyment.

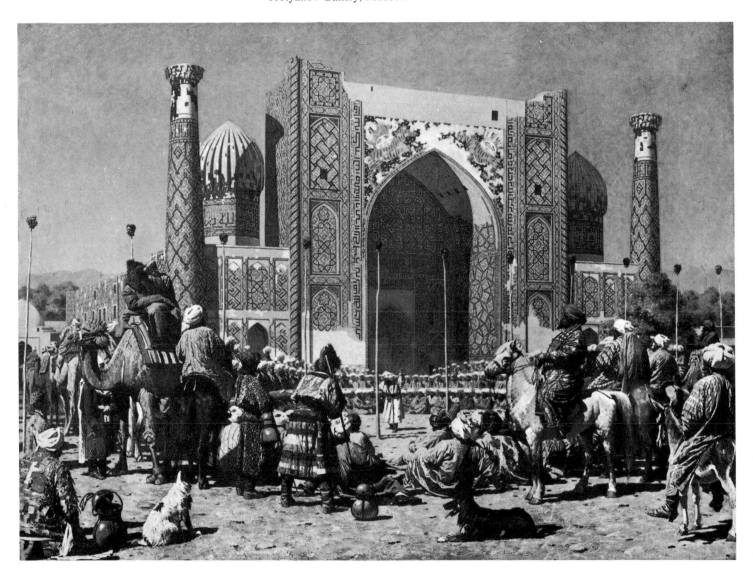

The Holy Carpet Being Transferred from Mecca to Cairo, by the Russian painter Makovsky, shows that the painter's interest in the Middle East led him to collect documents for subsequent use in works of a narrative character. More than just a picturesque display, this canvas attempts to show the ostentation in which the religious fervour of the crowd finds its expression, the rituals whose exotic nature compels our curiosity. Everything here is painted from travel sketches, with a fine sense of detail and using colours like those Ziem used, by someone who knows the Arab world intimately.

Vereshchagin, whom we already know as a military painter and an indefatigable traveller, has in *The Song of Victory* not only given us a faithful replica of the Religious School of Chir-Dar Madrasah and a rendering of the splendour of the ceremony taking place under his eyes, but also portrayed the cruelty of the customs which Russian observers could not help frequently witnessing. What the artist thought of war, though he himself was a soldier, is evident in another picture in which a pyramid of skulls stands in the desert

outside an Oriental town. A tireless researcher, Vereshchagin puts his talent and his virtuosity to the service of information. Apart from his war scenes, he has provided us with a faithful picture of the places he visited, reproducing with the same scrupulous precision the costumes, dwellings and historical monuments.

In spite of the interest which was aroused by Eastern cities, their wealth and traditions, the public tended to be more interested in depictions of Eastern private life and its pleasures. In this field the projection of the artist's own tastes took priority over the documentary aspects. We can distinguish two series of associated themes which corresponded to the intimate preoccupations of the prosperous

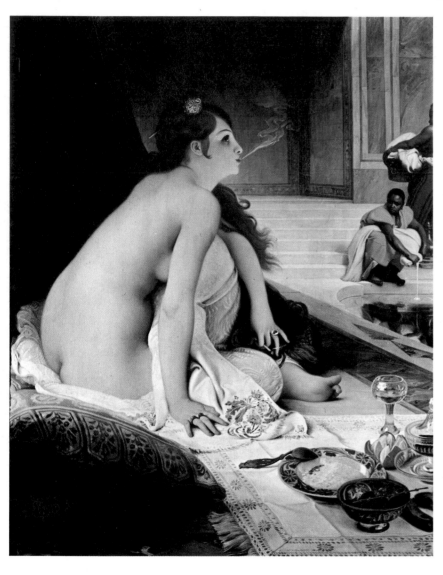

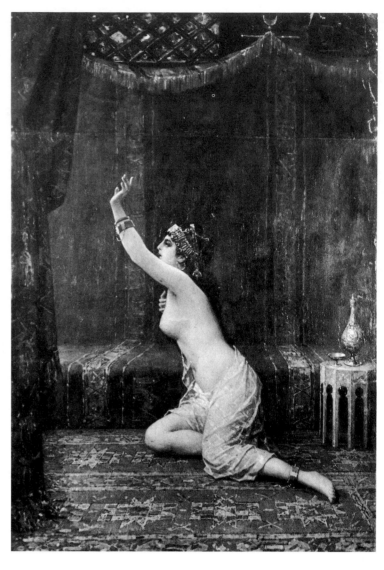

Jules-Jean-Antoine Lecomte du Noüy
The White Slave-Girl, 1888
Oil on canvas, 146 x 118 cm (57½ x 46½")
Musée des Beaux-Arts, Nantes

Pantaleon Szyndler
Odalisque
Oil on canvas, 83 x 55 cm (32⅝ x 21⅝")
Private collection, Warsaw

middle class. The first of these dealt with the situation of the married woman, while the second described extra-marital life.

It is to the East and to its way of life, too, that the unclothed slave-girls and dreamy beauties of the harem belong. Gérôme had perfected his method of treating such subjects, without Romantic idealization, without over- or underplaying his themes; which does not mean to say that he applied his realism to the representation of actual scenes. One of his Oriental merchants is sitting in his shop while the slaves on display stand in a line before him in the street. The scene is dull, devoid of grace or fantasy. The *Odalisque* by the Polish painter Szyndler, with bracelets on her wrists and ankles, is the result of a totally different inspiration. A solitary captive, she nevertheless exudes a trembling sensuality. In the heavy silence of the room in which carpets and hangings must absorb all noise, her raised hand seems to be trying to grasp a ray of light.

The example of *The White Slave-Girl* by Lecomte du Noüy is even more eloquent. It is no accident that this canvas was contemporary

with the scenes in café-concerts and houses of ill-fame painted by Toulouse-Lautrec. Noüy's model, too, reminds us of a prostitute, but a prostitute as the public or the artist might have wished her to be: well-groomed, good-humoured, without problems of conscience, and with thoughts only for pleasure. Unfortunately painters like Toulouse-Lautrec or writers like Zola, who found their inspiration in the real life of the daughters of the night, left us a totally different image. This is why this delightful idealization is transported to a mythical Orient, where the appetites of a new and vast clientele can be satisfied, if only in their imaginations. The drawing and the colours appeal to the tastes of these people. The plastic qualities of the

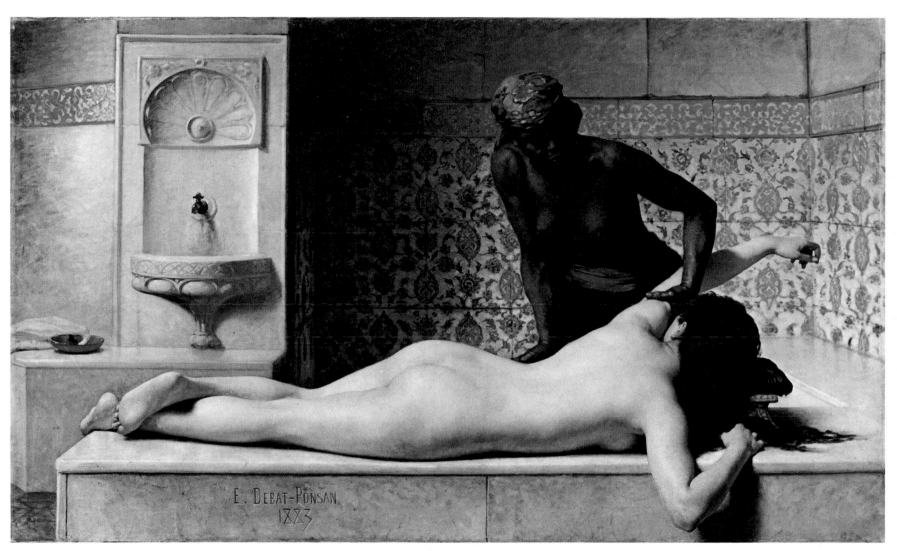

body are not emphasized any more than in Cabanel or Bouguereau. The forms are dulled by an artificial illumination which recalls the effect of the lighting used for cabaret acts, and the combination of colours is at the very least bizarre, and touching on the vulgar. The result is clear: the artist has worked to emphasize the sensual aspect of the theme, at the expense of what the eye would normally see.

Debat-Ponsan, in *The Massage*, has qualities all his own. In the contrast of the two bodies, one white and the other black, the author shows an unconstrained confidence in resolving a problem that painters had rarely tackled. The rendering of the skin surface is astonishingly realistic. The body of the patient bears the red marks of the masseuse's fingers. Elsewhere one can detect the bluish network of veins under the skin, and even the feet still show the faint marks left by the shoes. Debat-Ponson has been just as meticulous and professionally conscientious about the tiling of the wall, not forgetting the cracks in the glaze.

What can one say of the artistic value of such an enterprise? One

Edouard-Bernard Debat-Ponsan
The Massage: Turkish Bath Scene, 1883
Oil on canvas, 127 x 210 cm (50 x 82¾")
Musée des Augustins, Toulouse

117

John Frederick Lewis
The Siesta, 1876
Oil on canvas, 89 x 111 cm (34⅞ x 43¾")
Tate Gallery, London

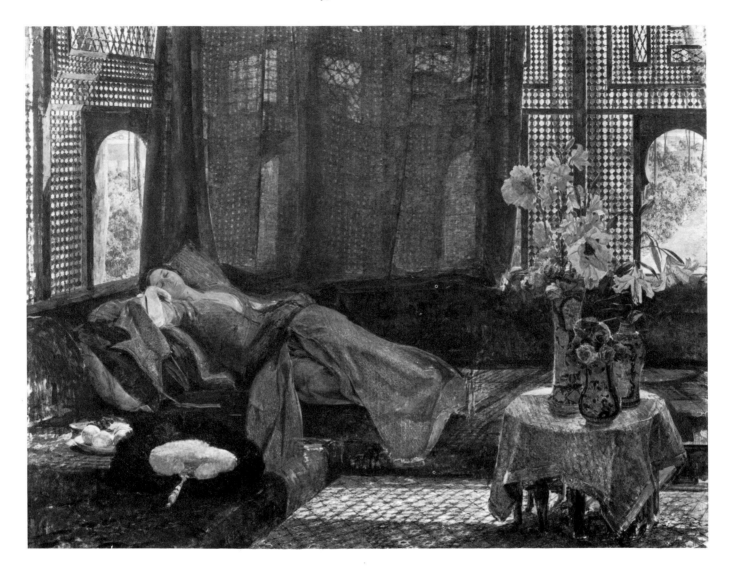

can only judge it by taking account of the conception of life of the milieu that produced it. It was a question of attaining what Taine considered the highest form of artistic creation; as he put it, 'one must have one's eyes fixed on nature in order to imitate it as faithfully as possible'.[22]

Lewis's *Siesta*, in its minutest details, evokes the abandon, the sense of expectation, even the prostration, of a hot summer afternoon. A woman dozes on an ottoman, the fine curtains waft softly about in the draught let through by the open windows and lattice-work. In the shady room the flowers in their vases and the fruits on the plate give out their perfumes. Through this idealized picture, the painter seems to have set out to show the framework within which any married woman ought to live. The bourgeois world liked to treat woman as a tender and fragile creature, a sort of precious object – though this treatment was evident more in theory than in practice.

Bourgeois Realist painters occasionally went further afield than the

John Evan Hodgson
*Chinese Ladies Looking at European
Curiosities,* 1868
Oil on canvas, 71 x 92 cm (28 x 36¼")
Laing Art Gallery and Museum,
Newcastle-upon-Tyne

Middle East, but this was rare, for the Far East was not well known.
Jeremy Maas has given this sort of documentary painting the generic
term: 'Painters Abroad'.[23] The English artist J. E. Hodgson, not
without humour, informed the European public that the process could
work in the opposite direction. In *Chinese Ladies Looking at European
Curiosities,* a group of Chinese women, visibly interested, examine a
dancing shoe from the West as presented to them by a shopkeeper,
with a smile on their lips. The occasion is no less attractive for the
pleasant display it makes of the silks and screens then in fashion,
and it is clearly intended as a reminder of the obvious fact that
Oriental girls bear comparison with anyone as far as looks are
concerned.

Social and Family Life

Adolf von Menzel
Pause Between Dances, 1875
Oil on canvas, 32 x 40 cm (12⅝ x 15¾″)
Bayerische Staatsgemäldesammlungen,
Munich

Social and family life was perhaps the favourite territory of Bourgeois Realist painting, the one in which its expressive resources are seen to the best advantage. Cosy domestic scenes, social festivities, official celebrations – there was no occasion of public or private life which artists did not delight in putting on canvas. There are even occasions when Bourgeois Realist painters passed beyond class prejudice and became witnesses of the political and social conflicts of their time. Certain English, Belgian, German and Russian artists, and more rarely French ones, present scenes evoking the discontent of the masses, the workers' struggle, the inequality of conditions and the great list of injustices and hardships. Such works could not be left out of a complete panorama of realist painting; however we are not dealing with them in this exposition, since they in no way help to provide a picture of the life of the leisured classes, or illustrate their tastes and aspirations. Only the themes which in one way or another reflect bourgeois ideology will claim our attention here.

What counted most in the eyes of this bourgeoisie, if not day-to-day

existence in its most down-to-earth aspects? In the family budget, the famous heading 'Sundry Expenses' indicates special funds allocated to the various social and cultural activities, naturally including those required to set up a wardrobe appropriate to all these occasions. But contact with the outside world was not an end in itself. The unanimous interest in home life and the family manifests itself in many ways, in themes in which daughters and wives appear in their successive roles as laid down by the traditional order of things: candidates for marriage, lovers, housewives and spouses, loving and devoted mothers.

Formal Parties

Receptions and big dinners were not particularly frequent, and invariably led to heavy expenditure. Not only were the sumptuous evening dresses very expensive but it was also necessary to decorate them with jewellery made of precious metals and set with pearls or fine stones. It must be added that it was unthinkable to sport the same outfit several times in succession; luckily the habit of sending out invitations several weeks in advance permitted women to alter their dresses to give them an air of novelty. Men's attire posed fewer problems. Exempt from unavoidable extravagances, male fashion, just as in the twentieth century, hardly varied, so that the stronger sex had far less difficulty in keeping its investment of clothes to a reasonable level.

A little picture, *Pause Between Dances*, by Menzel, invites us to a party for German high society. Although the male guests are mostly elderly individuals – senior officers and diplomats – they hold

Sébastien-Charles Giraud
The Dining Room of Princess Matilde, 1854
Oil on canvas, 56 x 81 cm (22 x 31⅞")
Musée du Château, Compiègne

121

themselves erect. The only seated figures are the ladies, who appear to be exchanging witty remarks. They are provided with refreshing drinks, while the gentlemen stand round them. It was unthinkable in the circumstances for a gentleman to sit down among ladies, and absolutely forbidden for him to take his seat on the same sofa. Observed with the most punctilious precision, the social colouring and the attitude of the guests faithfully reproduces the atmosphere of an evening of dancing in the 1870s. But the great achievement of the artist is to have been able to render, with the appropriate use of light, the composite impression of dazzling luxury and trivial conversation that is the hallmark of Menzel's work.

Jean Béraud
The Soirée, 1875–85
Oil on canvas, 37 x 27 cm (14½ x 10⅝")
Musée Carnavalet, Paris

Under the Second Empire and after its fall, Parisian high society was accustomed to giving formal dinners in which a less elaborate dress was worn than at the balls, though just as costly. An interior scene by Giraud invites us to admire *The Dining Room of Princess Matilde*, cousin of Napoleon III, in her mansion in the Rue de Courcelles. On the richly decorated table, the hot dishes are waiting under their silver covers, engraved with the arms of the Imperial House. From the back of the room, according to the custom of the period, a procession advances with the gentlemen offering their left arms to their partners. Since officers wore their sabres on the left, they were the only ones allowed to infringe this rule. There is an astonishing profusion of lavish decorative plants arranged along the walls. It was at this very time that conservatories became fashionable. The scene has certainly been painted from memory; we know that the painter of the picture used to give the Princess painting lessons, and often attended her receptions, where the list of guests included not only high society but also writers, scientists and famous artists.

These evenings were sometimes embellished with musical interludes and recitals. The guests would gather together on these occasions in the most spacious room where the ladies would be allowed to sit on graceful chairs of gilt canework. Jean Béraud has chosen to paint the exact moment when the company gathered, just before the artist's recital. It is not known at what date the artist executed *The Soirée*, or who the personalities present are. Only the manner of dress can serve as a guide. It is reasonable to suppose that the original models frequented these gatherings; Béraud, who had the *entrée* to Parisian high society, is a faithful witness of this period, and the scene that he represents corresponds, without doubt, to a particular occasion.

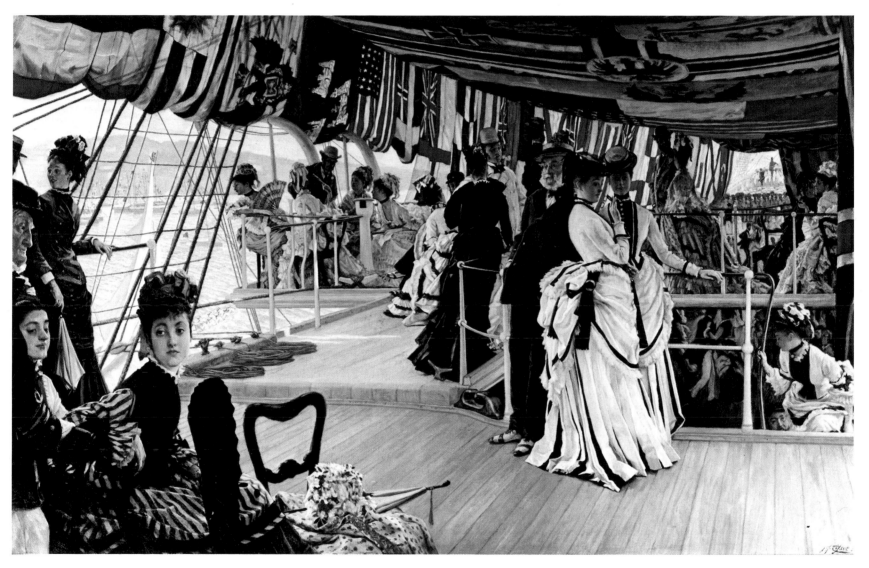

It is odd that the author has avoided using artificial light to illuminate his subject. The lamps only light up the back of the scene whereas all the rest is bathed in a brightness coming from an unseen source, as in a studio. The very simple composition presents three successive planes which obey the laws of perspective and give the impression of a crowd significantly more numerous than it actually is. The ladies, and especially their dresses, claim all the spectator's attention.

James Tissot, a Frenchman who lived in London, provides an inspired and anything but conventional view of high society life in England. *The Ball on Shipboard* takes us to a daytime party on board a boat anchored no doubt on the Thames somewhere near Greenwich. Tissot knew the works of the Impressionists, and it is not impossible that they influenced him in his use of lighter tones. He was not tempted, however, by their interpretation of reality, which gave priority to the effects of distance, to the texture of the air, as well as to the shimmering effects of light and colours. Characters and

James Tissot
The Ball on Shipboard, 1874
Oil on canvas, 84 x 130 cm (33⅛ x 51″)
Tate Gallery, London

settings in his paintings lose nothing by comparison with tangible reality, and thus they assert their autonomy. Ruskin's remark that Tissot's paintings looked like 'coloured photographs' is acceptable only if one admits that in certain conditions photography can also become an art form. *The Ball on Shipboard* is not just a slice of reality; it is also proof of an intimate relationship between this very reality and the internal universe of the artist.

Louise Abbéma
Luncheon in the Conservatory, 1877
Oil on canvas. 194 x 308 cm (76⅜ x 121¼")
Musée Bernadotte, Pau

Select Gatherings

Select and informal gatherings were much more frequent than they are today. Their intimate climate was popular with professional people and artists, who took the opportunity to talk shop.

The Luncheon in the Conservatory by Louise Abbéma allows us to experience this privileged ambiance. The figures form a wide-based triangle which is somewhat reminiscent of the pediment of a Greek temple. One is struck by the way the characters are spaced out, which helps to place an emphasis on each one of them individually. The plants and the curtains in the foreground produce an imposing, almost monumental effect, while the sparse, sombre background concentrates all one's attention on the personalities assembled. These are from left to right: the dramatist Emile de Najac; Madame Abbéma, the artist's mother; Monsieur Abbéma, her father; Sarah Bernhardt in a greay dress and probably Louise, Bernhardt's sister.

At a later date, *Conversation Piece* by the English painter Solomon

evokes a totally different atmosphere. While the mistress of the house is idly playing the piano, the couple in the foreground seem absorbed in the contemplation of a valuable *objet d'art*. Their intimate relationship is symbolized by the position they have chosen for their *tête-à-tête*. They have seated themselves on a comfortable sofa, and the girl has thrown back her head against it in a relaxed pose. The characters' attitude, the style of furniture and the profusion of knick-knacks, even the lighting of the whole setting, manage to reconstruct very accurately and in great detail the artist's youth, and the scene exudes the nostalgia in which people liked to indulge.

Painting at night has always posed theoretical problems to artists of

Solomon Joseph Solomon
Conversation Piece, 1884
Oil on canvas, 102 x 127 cm (40 x 50″)
By permission of Kensington & Chelsea
Borough Council
Leighton House, London

all periods. Given that darkness theoretically abolishes light and colour, one might say that it plays a role in painting analogous to that of rests in music or of the interval between the responses in a literary dialogue. *The Pré Catelan* by Gervex certainly owes a debt to the studies of the Impressionists. The artist has conveyed the diffusion of electric light into the surrounding night by combining two dominant tones, grey-blue and grey-pink. These tones undeniably add an atmosphere of poetry to the picture, which is strictly, almost photographically, realistic in composition and drawing. Through the glass we can recognize certain characters from Parisian high society: among them are the Prince and the Princess de Sagan, the Marquis de Dion, Liane de Pougy and the well-known journalist Arthur Meyer.

Young ladies' gatherings were the favourite occasion for painters to pay tribute, at one and the same time, to their seductiveness, grace and good manners. Millais went much further in his picture *Hearts Are Trumps*, where, in the opinion of his biographer and friend,

Henri Gervex
The Pré Catelan, 1909
Oil on canvas, 214 x 324 cm (84¼ x 127⅝")
Gérard Seligman, Paris

Walter Armstrong, he achieved a genuine 'bravura in the execution', combining 'breadth of hand' with 'respect for the minutest vagaries of fashion'.[24] The writer, whose daughters had been Millais' models, credits him with 'a unity of results which has never been excelled since the days of Don Diego Velasquez'.[25] It was said that the work appeared in unusual circumstances in response to the sarcastic comments of a critic who threw doubt on the ability of Millais to create something comparable to the *Ladies of the Waldegrave Family,* a group portrait by Reynolds. This is why the artist seems to have voluntarily taken on a number of problems by assembling in the same composition objects and models overloaded with a wealth of minute details, which he set himself the task of reproducing with the utmost precision. Observe, for example, the marquetry of the little Oriental-style table in the left foreground, the decoration of the gaming table, the cards, and the innumerable folds, lacework and ribbons that decorate the dresses of the young girls. At the back is the inevitable Chinese screen, as well as a richly decorated panel of plant motifs. This wealth of detail does not, however, detract from the expression of the faces: the one on the right has deep, vivid, burning eyes, the middle one is tinged with a certain nostalgia, while the girl on the left has her eyes lowered in a sort of resignation.

Girls used to go to their first balls at eighteen, escorted by their families or under the supervision of a watchful chaperone, whose

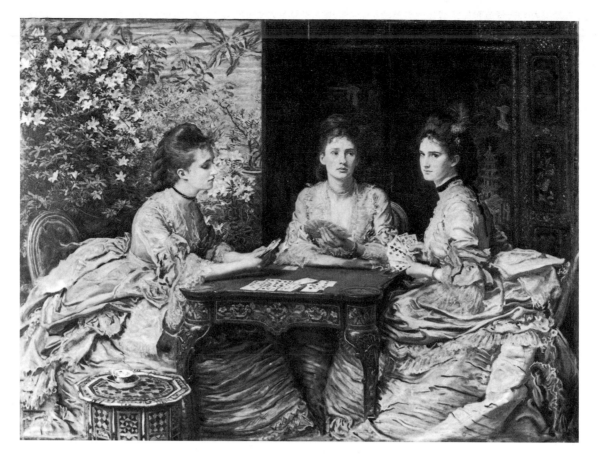

Sir John Everett Millais
Hearts Are Trumps, 1889
Oil on canvas, 166 x 220 cm (65¼ x 86½″)
By permission of Kensington & Chelsea
Borough Council
Leighton House, London

Marius-Joseph Avy
Bal blanc, 1903
Oil on canvas, 139 x 217 cm (54¾ x 85½″)
Musée du Petit-Palais, Paris

mission was to watch over the good behaviour of her protégée and of the protégée's suitors. For girls who had not yet 'come out' into society, *bals blancs* were given in which they were initiated into the various dance steps. Thus, Avy has left us a *Bal blanc* full of charm and poetry. The composition is bold: the piano, a great dark stain, cuts the painting in two diagonally, and contrasts with the filmy whiteness of the dancers. It is worth noticing that the artist has not rejected the influences of the moderns: witness his use of colours to convey the white whirlwind of the dresses.

Those of a more modest station in life, like civil servants and soldiers, led a much more humdrum life, especially in the provinces. Sándor

José Malhoa
The Fado, 1910
Oil on canvas, 150 x 185 cm (59 x 72⅞")
City Museum, Lisbon

Bihari, in his *Sunday Afternoon,* using light colours and in a firm and precise hand, gives us an accurate example of the existence of the *petits bourgeois* in a town in Hungary. The only remedies for boredom were playing cards and drinking tea.

The working classes were more spirited in their amusements. From time to time, there is a tendency, already present in the genre painting of the seventeenth century, to contrast popular entertainments with the decorum of bourgeois social occasions. In *The Fado,* José Malhoa apparently takes a disapproving view of the spontaneity of simple people and their passionate excesses.

As for the military life, which in times of peace tended to revolve around the barracks and the bar, Régamey has provided one of its most expressive documents in *The Cuirassiers,* in which he demonstrates considerable powers of formal creation. The uniforms painted with bold strokes, the shining cuirasses, the open and decisive face of the woman serving the drinks, the neutral background: together these lean towards aesthetic ends not so very distinct from those of a Manet.

Guillaume Urbain Régamey
The Cuirassiers, 1874
Oil on canvas, 73 x 92 cm (28¾ x 36¼")
Louvre, Paris

Sándor Bihari
Sunday Afternoon, 1893
Oil on canvas, 112 x 157 cm (44⅛ x 62⅛")
Museum of Fine Arts, Budapest
Corvina Archives, Budapest

Love and Marriage

The essential difference between Bourgeois Realism and the schools preceding it was the way the artists treated their models every time they wanted to concentrate on emotion. Declarations of love and religious fervour were manifested in particular poses and gestures instead of being simply suggested. It might be supposed that the reason was that artists were unable to pinpoint and convey emotion through the much more subtle and telling signs of internal tension. On the contrary, however, all they were doing was to represent their own experience – it was life itself that determined the way they saw it.

For middle-class families, love and marriage were always subordinate to financial considerations, and in principle they were meant to be a sort of investment or merger of capital. Marriages were made by mutual agreement between the parents as contracting parties, according to closely defined economic criteria; religious, national and political prejudices certainly played a role in this procedure, but romantic feelings were very definitely relegated to the background. This conception of marriage and the family, which had become consolidated in the course of the social and political ascent of the middle class, explains the firm resolve to limit the education of girls to a low and highly specific level of scholastic achievement. But, as

129

in all periods, artists from time to time presented in their work aspects of life that contradicted the current usages. This is what Gervex did in his famous *Rolla*, and Makart in *The Plague in Florence*. Already Romanticism, especially in literature, offered a measure of compensation for the obstacles that prevented lovers uniting, by glorifying those ill-starred lovers whose memory had been perpetuated since the Middle Ages by an essentially aristocratic literary trend. The Bourgeois Realists themselves sometimes turned towards the past, but gave it a quite different interpretation, according to their own criteria. At least this is the only explanation one can give for a picture like *The Declaration of Love* by Henri Leys, where the

Henri Leys
The Declaration of Love, 1863
Oil on canvas, 124 x 96 cm (48⅞ x 37¾")
Musées Royaux des Beaux-Arts de Belgique, Brussels

Karl Heinrich Hoff
The Eavesdropper, 1868
Oil on canvas, 75 x 58 cm (29½ x 22⅞")
Hamburger Kunsthalle

characters are in seventeenth-century costume; thus attired, the suitor with his outdated manner of paying his court, and the girl who receives his advances with an expression of indifference, are there to raise a smile.

Love letters were subject to the strict control of the family circle, at the same time as benefiting from that circle's good advice. Here was a source of inspiration that certain artists of the time did not fail to exploit. In *The Pair of Lovers* by Pál Szinyei Merse, the casualness of the attitudes is almost daring for the period. Anxious to find an excuse for them, the artist has transported his hero and heroine to the open countryside, using the argument no doubt that Mother Nature encourages us to give free rein to our instincts. The freedom of interpretation is especially apparent on the level of colours; frank and vivid, they free us from the humdrum daily round and open the gates of the imagination.

Although the Church had lost its secular control over the institution of marriage and the family, society nevertheless found a way to bridge

this gap and impose its own system of constraint on people. These new regulations, tacit or explicit, were even more logical, and so stricter than the old ones, though their severity was greater with regard to women. In the *Histoire du peuple français*, we read that 'it was the bourgeoisie that instituted civil marriage, in which the mayor played a part, and soldered together virtue and marriage, making marriage socially honourable, respectable and highly regarded'.[26]
England in its social changes had since the eighteenth century shown a certain advance over France, and it provides the best examples of painting dedicated to bourgeois marriage. So, in his *A Wedding Morning*, Bacon observes certain features that perfectly reflect the

aspirations of the middle classes. The impeccable dress of the bride, which is being given its final touches, contrasts with the unpretentiousness of the setting. The bride's friends, whose attitude betrays stunned admiration, certainly also belonged to a modest social class, if one may judge from their dress and bearing. Everything seems to indicate that this marriage is equivalent to a social promotion, or at least that the family is determined to give this impression. A sober realism based on a skilful hand and adroit use of colours, especially in the foreground, is combined with the narrative style that was popular at the time.

Stanhope Forbes goes even further in his apportionment of narrative elements and accurate realistic facts. In *The Health of the Bride* the characters are also the unpretentious people who form the material and moral backbone of bourgeois society. The composition is understated and subtle in its total effect as well as in the details, and the characters present attitudes which are not forced and which provide an idea of the close relations between them.

Pál Szinyei Merse
The Pair of Lovers, 1870
Oil on canvas, 53 x 63 cm (20⅞ x 24¾")
Hungarian National Gallery, Budapest

131

Unfortunately, marriage is not only a source of joy. Disappointment is never out of the question, especially if the horizons aimed for are too ambitious. Sometimes too, the bride is not the one who hoped to be chosen. It is this latter theme that is to be found in Giudici's canvas *Betrayed*.

Marriages lightly entered into, between spouses of disparate age, have always been the object of sarcastic reproof. Orchardson's *Le Mariage de convenance* gives us a specimen of this sort of union, between people of the prosperous classes. The painter devoted a whole series of paintings to this theme of the disappointments of marriage. They provide food for thought without being completely negative, which

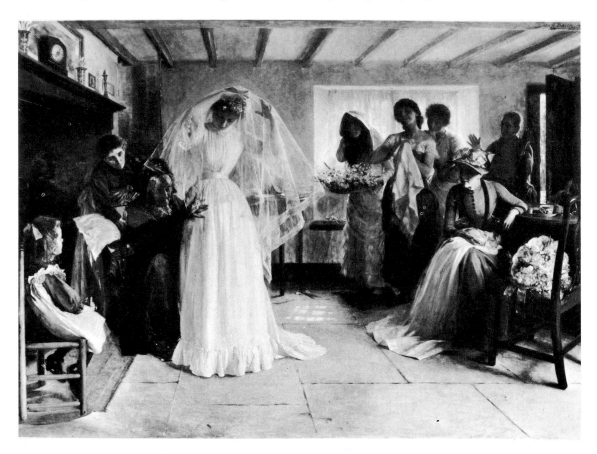

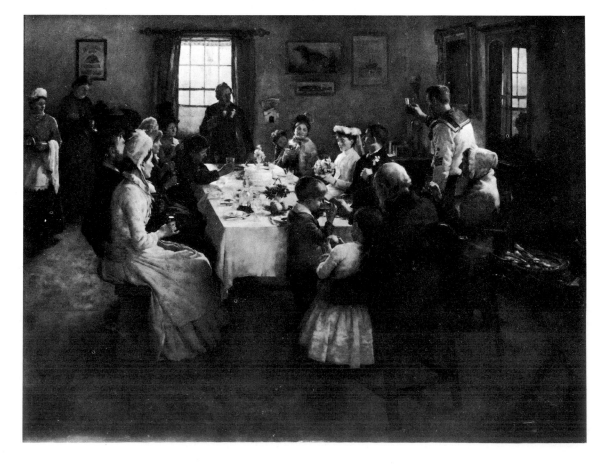

Rinaldo Giudici
Betrayed
Oil on canvas, 160 x 112 cm (63 x 44⅛")
Galleria Nazionale d'Arte Moderna,
Rome

Sir William Quiller Orchardson
Le Mariage de convenance, 1883
Oil on canvas, 105 x 154 cm (41¼ x 60¾")
City Art Gallery and Museum, Glasgow

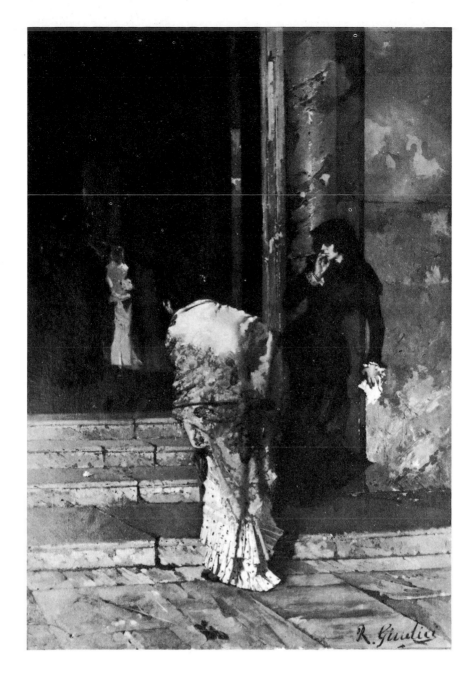

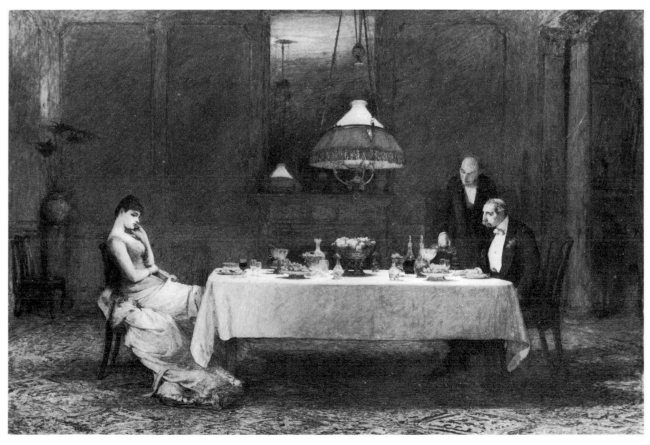

133

would run the risk of making them disagreeable. This is why, in this case, everything in the bride's appearance denotes freshness and health, instead of indicating her feelings of repulsion towards her old husband. Her pose, and the distance the painter has placed between husband and wife at the table, serve to emphasize the spiritual loneliness of the young woman.

In the Romantic period, in the wake of Goethe's *Werther*, ill-fated love afflicted many young people even to the extent of sometimes making them choose suicide; the Realist period, by contrast, sets out to shed light on the social aspects of relations between man and woman. This step was not unmotivated by didactic considerations.

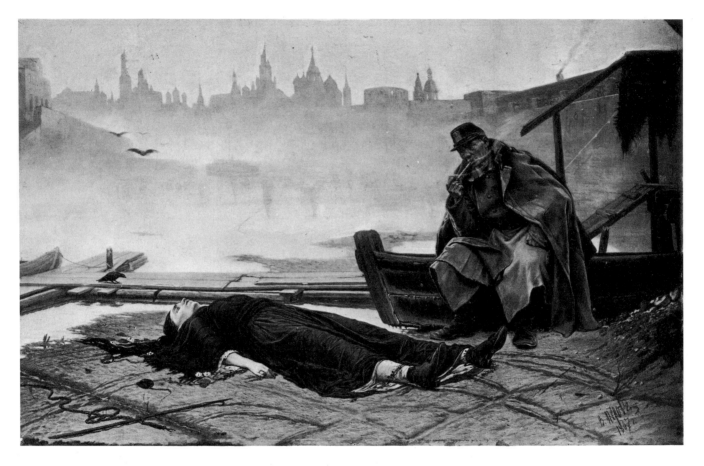

Vassily Grigorievich Perov
The Drowned Woman, 1867
Oil on canvas, 68 x 106 cm (26¾ x 42¾")
Tretyakov Gallery, Moscow

Any imprudent or unfortunate liaison exposed the girl or wife to public opprobrium. Perov's *The Drowned Woman* gives us a feeling of the tragic circumstances which could have led this young working-class woman to such a frightful end. Whatever her motive may have been, society has neither pity nor indulgence for her. Having dragged her from the river, the constable has seated himself beside her body, and is quietly smoking his pipe as if he saw nothing out of the ordinary in her fate.

Woman in the Home

In the tranquil intimacy of her house, woman personifies well-being, stability, conjugal and family happiness. Her boudoir is no longer the coquettish little salon that it was in the aristocratic abodes of the eighteenth century. It has become very much a room to dress in, and the furniture includes a large mirror and an even more imposing cupboard in solid wood with numerous shelves. In the more modest dwellings, this treasury of new and old dresses, perhaps ribbons, artificial flowers, buttons and in general, everything which might come in useful one day – all this, together with the adjustable mirror,

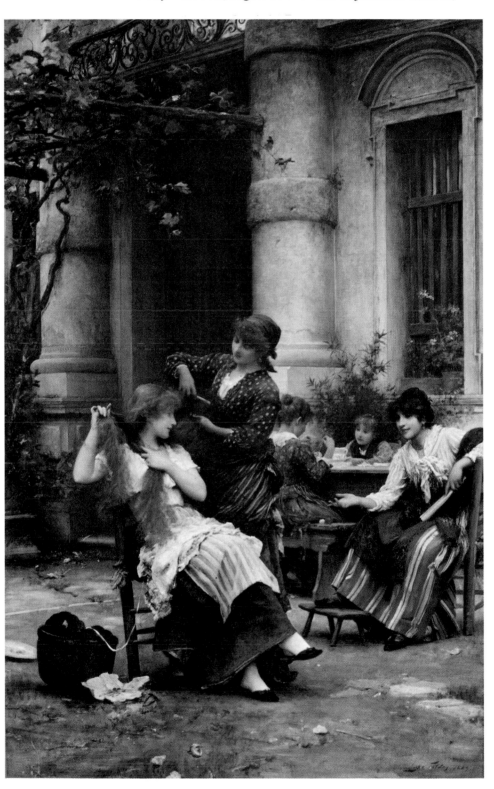

Sir Luke Fildes
An Alfresco Toilet, 1889
Oil on canvas, 167 x 104 cm (68 x 42½″)
By courtesy of the Trustees of
The Lady Lever Art Gallery, Port
Sunlight

sets of combs and tortoiseshell-backed brushes, is relegated to the bedroom, standing near the enormous bed and occupying almost all the available space. The wife reigns with absolute power over this empire, which also includes the drawing-room piano, the flowers and house plants. As mistress of the house, she sees to the maintenance of all this herself, just as she is the only person who can open her wardrobe or sit at her piano, having previously cleared all her ornaments off it. The young daughter of the house, when there is one, becomes initiated into these rites with a view to one day having her own home and family to look after.

An Alfresco Toilet is an indirect reference to this way of life. The

Umberto Coromaldi
Vanity, 1901
Oil on canvas, 135 x 48 cm (53⅛ x 18⅞")
Galleria Nazionale d'Arte Moderna, Rome

Raymond (Raimundo) de Madrazo
Female Nude
Oil on canvas, 184 x 110 cm (72½ x 43⅜")
Prado, Madrid

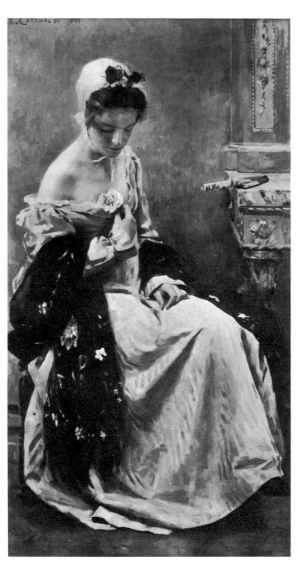

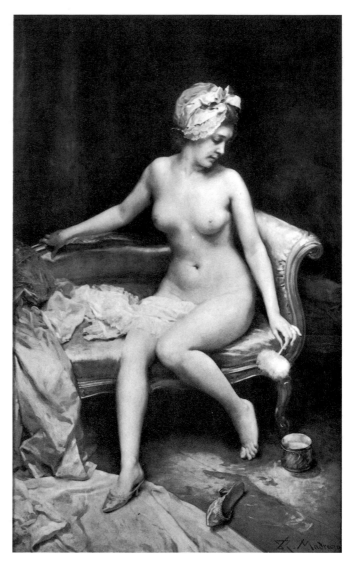

painter, Sir Luke Fildes, has achieved his aim by using a tried and tested Bourgeois Realist technique. We have a clear idea of the prosperity of the inhabitants from what we can see of the interior courtyard, which certainly belongs to an imposing bourgeois residence. A woman who looks like a servant helps her young mistress to do her hair, while other children play near by. In spite of the almost photographic imitation of nature, and the rather over-smooth aspect of the picture, the artist has managed accurately to define the relations between the colours, and to endow a really rather banal episode with an exceptional truth to life.

It only needs a woman more or less in a state of undress to be caught at her toilet, behind closed doors, for the theme to be tinged with a certain salaciousness. Fildes managed to avoid this trap by placing his scene under an open sky. The same device can be found in Coromaldi's *Vanity* and Madrazo's *Female Nude*. The subjects are no different: aware of her attractions, the young woman devotes her efforts to putting them carefully to the best effect. Each time the

artist has used his talent to depict the behaviour, mentality and tastes of human beings of this period, by means of passing observations and an insignificant anecdotal situation.

Lady in Lilac Dress with Flowers by Czachorski, and *Young Girl Resting* by Masriera, are works in a similar vein, although produced in very different countries. In both cases the numerous objects reproduced add all the weight of their presence, and create an impression of luxury comparable to the feeling inspired in the *nouveaux riches* by the display of their opulence. And yet this impression is stronger in the picture of the woman arranging flowers in the vase with rather an awkward movement than in the other one where she smokes and

Wladyslaw Czachorski
Lady in Lilac Dress with Flowers
Oil on canvas, 55 x 78 cm (21⅝ x 30¾″)
National Museum, Warsaw

Francisco Masriera
Young Girl Resting, 1894
Oil on wood, 42 x 55 cm (16½ x 21⅝″)
Prado, Madrid

fans herself, with a relaxed and natural attitude that is inseparable from an emancipated and modern way of life.

Flowers have always been a decorative element as well as a symbol. In John White Alexander, they support an allegorical theme which goes back to Boccaccio's *Decameron* and which Keats himself used in his poem 'Isabella; or the Pot of Basil'. This title is also that of the picture, which seems to us a good example of collusion between styles. The Symbolist and Art Nouveau elements combined in it are more strongly in evidence than the Bourgeois Realist elements. The latter are, however, dominant in the upper part of the composition, where the impassioned and rather theatrical gesture of the woman

John White Alexander
Isabella and the Pot of Basil, 1897
Oil on canvas, 185 x 88 cm (75½ x 35¾")
Gift of Ernest Wadsworth Longfellow,
Courtesy Museum of Fine Arts, Boston

Mihály Munkácsy
Parisian Interior, 1877
Oil on canvas, 70 x 102 cm (27½ x 40⅛")
Museum of Fine Arts, Budapest
Corvina Archives, Budapest

denotes a somewhat fiery temperament. The lighting itself, which is theatrical in its effect, is treated realistically, while the lower part of the painting is stylized after the manner of Art Nouveau.

The symbolic character of realistic flowers can also be found in the Hungarian painter Simon Hollosy. When he was working on his *Deep in her Thoughts,* was the painter making an association with the French word for pansies (*pensées,* also meaning 'thoughts'), or had they simply been chosen as a symbol of remembrance? One might say that the young woman lost in her dreams, and the pale violet-coloured flowers, have changed roles: the flowers are identified with the state of mind of the model, whose velvet dress and serene mood

one associates in turn with the visual and tactile properties of the flower. Within the logic of his proposition, the painter has tried faithfully to render the material of which the objects are made, arranging them on a background of grey tones.

Leslie's little daughter is also lost in her thoughts, but in the simple manner of children, in a painting with a very pretty title, *Rose Time.* The simple indoor dress and the lace mittens are used to emphasize her perfect and almost unreal beauty. The freshly cut flowers that she delightedly holds to her nose seem to have lost none of their perfume. However meticulous the drawing, the originality of the work lies especially in its composition, based on the rhythmic alternation of complex minutely observed details and planes of peaceful simplicity. This contrast is found further accentuated by the dark repetitive lines on a light background decorating the Japanese vase, the weave of the lacework, the hair raised up on the nape of the neck, and finally the internal edging on the frame of the round mirror.

The woman in Munkácsy's *Parisian Interior* has adopted a pose

139

reminiscent of the little girl in *Rose Time*. But while Leslie pays his tribute to the feminine virtues of modesty and reserve, Munkácsy gives a great deal of importance to the precious objects which surround his model. A woman portrayed in her home setting, surrounded by flowers and reading a letter, was one of the favourite subjects of those wishing to immortalize the simple well-being and harmoniousness of family life. It is this quality that we find again in Munkácsy's *Interior* full of furniture and knick-knacks; this is one of his best paintings.

Music was one of the favourite pastimes among women, and even more among marriageable girls. Albert von Keller has represented

Simon Hollosy
Deep in her Thoughts, 1886
Oil on canvas, 81 x 64 cm (31⅞ x 25¼″)
Hungarian National Gallery, Budapest

George Dunlop Leslie
Rose Time
Oil on canvas, 46 x 61 cm (18⅛ x 24″)
Hamburger Kunsthalle

one of these in his picture entitled *Chopin*. Since he was unable to render the language of music in painting, he has provided his music lovers with a profusion of physical details and psychological observations. The cut and elegance of the clothes indicate that these are people who belong to a reasonably prosperous class at the very least; the lacquer screen was an obligatory piece of *chinoiserie* around the 1880s in apartments furnished to contemporary taste. Keller's picture seems much less concerned with the music than with the practical aspects of family life; but probably people at the time interpreted it in a different way, since all these objects were for them nothing but the framework within which the life of the mind could flourish.

Albert von Keller
Chopin, 1873
Oil on wood, 41 x 24 cm (16⅛ x 9″)
Bayerische Staatsgemäldesammlungen,
Munich

John George Brown
The Music Lesson, 1870
Oil on canvas, 59 x 49 cm (24 x 20″)
Gift of Colonel Charles A. Fowler, 1921
Metropolitan Museum of Art,
New York

Supervised piano practice and accompanied pieces were fertile soil for amorous relationships to grow on; that is why young male accompanists and music teachers were the object of constant surveillance on the part of families. When Brown exhibited his *The Music Lesson* it was triumphantly successful, and served as a model for an engraving called *A Game Two Can Play At*. Surrounded by Victorian furniture and communicating through their love of music, two young people sit side by side near a harp decorated with pseudo-Greek motifs. A certain didactic intent is combined with the desire to tell a story. The artist's conception of his own personal art is summed up in a phrase he used himself: 'Art should express contemporaneous truth, which will be of interest to posterity.'[27]

Far from the opulence and luxury in which the upper middle classes lived, Ludwig Knaus retraces the daily vicissitudes of a nomadic life, that of the circus artiste. *Behind the Curtain* reconstructs the precarious intimacy of a makeshift camp in which the parents look after the children and the children look after the animals. Only the young

woman on the right, with her easy manner and her volatile air, leaves an impression of freedom from care, especially compared with the husband who is occupied in feeding the youngest of the children. The impression is of the humdrum day-to-day existence of a family who only experience their few moments of excitement during the show itself.

The Love of Children

One of the great achievements of the nineteenth century, and of bourgeois society, was the recognition that children had the right to their own particular world. The literary works of Dickens, Twain and Hugo, denouncing retrogressive ideas in education and the injustices and cruelties that children suffered, only confirmed the appearance of a new awareness and of a different attitude to the youngest members of society, and to the most important years in the life of each human being. In *The Visit*, Defregger tries to express the tenderness working-class people have for their children, and he is not afraid of theatricality. Later, we find other works that depict children and show no desire to tell a story. Most of the time they subtly reflect the universe of childhood and the joy that adults find in it. Middle-class homes generally included one or more nurseries. These were light rooms without the great morass of useless objects which cluttered the rest of the household. Inviting visitors to look in on

the nursery from time to time was interpreted as a gesture of friendship and confidence. Sometimes painters too enjoyed this privilege.

With the exception of eighteenth-century masters like Chardin and Fragonard, we very rarely in pre-realist painting find scenes that demonstrate an intimacy with children comparable to that in *The Painter's Family* by Johansen or *The Nursery* by Uhde. These two works already herald the trend towards intimacy in Post-Impressionist art. Both these paintings use effects of light to convey the very special atmosphere in which the individual features of the characters become blurred, yet at the same time great attention is paid to those lightly sketched gestures that make the scene lively and spontaneous.

Ludwig Knaus
Behind the Curtain, 1880
Oil on mahogany, 81 x 110 cm (31⅞ x 43⅜″)
Staatliche Kunstsammlungen Dresden,
Gemäldegalerie Neue Meister

Franz von Defregger
The Visit
Oil on canvas, 93 x 71 cm (36⅝ x 28″)
Bayerische Staatsgemäldesammlungen,
Munich

The love of children as a symbol of family solidarity inspired a number of group portraits. These attempted to capture children's faces at a given age in a larger format and a more elaborate form than in photography. This genre was accessible only to the better-off. Portraits like *The Colard Children* by Agneessens, *Young Girl with Cat* by Chaplin, Khnopff's *Portrait of a Child*, and *The Trubetskoy Children* by Ranzoni, show the image of the well brought-up family.

The maternal instinct was also a popular theme with painters; when they tackled it they took care to dispose of any reference to the traditional metaphor of the Virgin and Child, an example being Cremona's *Motherly Love.* But sometimes an outdated symbol crept into these paintings, and the real child gave way to the cherub of flattering allegory. This sort of painting was wildly successful, and people took oleographs and designs for tapestry motifs from them which were used to decorate drawing-room cushions or framed to be hung on the wall. An example is Martens' *Dream of Love.*

Sometimes the children were even used to act out the adults' desires.

Anything adults did not have the courage to do, they could enjoy vicariously through the young. Poynter's *Outward Bound* is a picture which invites us on a trip. The quality of the composition lies entirely in the exceptional precision of the drawing, which is in perfect harmony with the sternness of the surrounding rocks and which relieves, to some extent, the insipidity of the tale.

Fritz Karl Hermann von Uhde
The Nursery, 1889
Oil on canvas, 111 x 138 cm (43¾ x 54⅜″)
Hamburger Kunsthalle

Viggo Johansen
The Painter's Family, 1895
Oil on canvas, 84 x 90 cm (33⅛ x 35½″)
Hamburger Kunsthalle

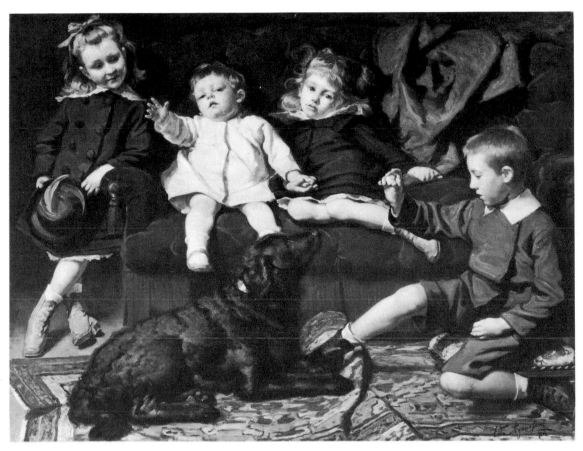

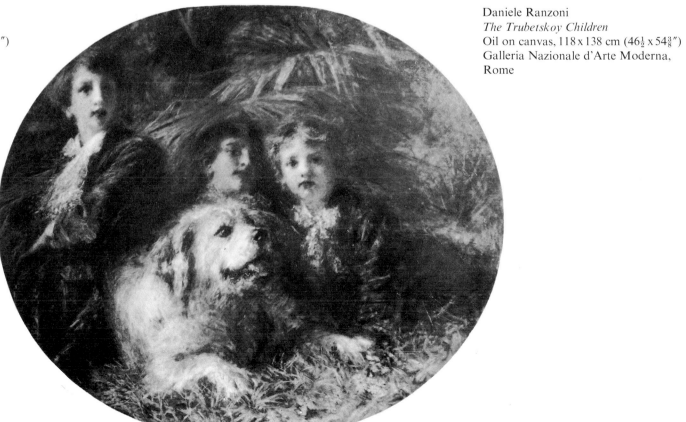

Edouard Agneessens
The Colard Children
Oil on canvas, 127 x 170 cm (50⅝ x 66⅞")
Musées Royaux des Beaux-Arts de
Belgique, Brussels

Daniele Ranzoni
The Trubetskoy Children
Oil on canvas, 118 x 138 cm (46½ x 54⅜")
Galleria Nazionale d'Arte Moderna,
Rome

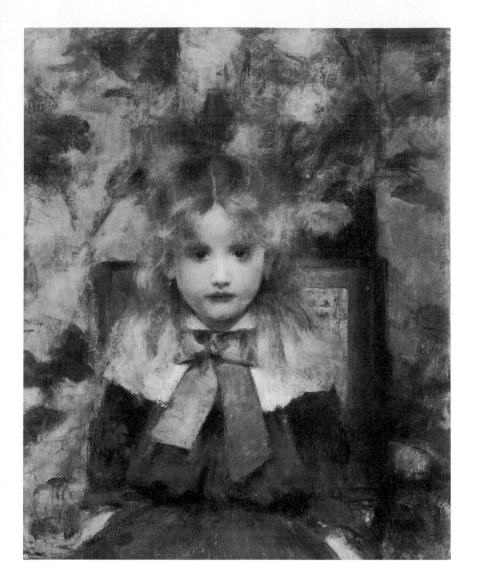

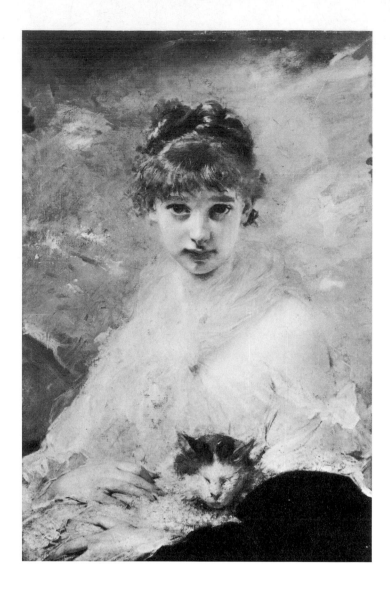

Fernand Khnopff
*Portrait of a Child – Mademoiselle
van der Hecht,* 1883
Oil on canvas, 37 x 29 cm (14 x 11⅜")
Musées Royaux des Beaux-Arts de
Belgique, Brussels

Charles Chaplin
Young Girl with Cat, 1869
Oil on canvas, 78 x 50 cm (30¾ x 19⅝")
Musée du Château, Compiègne

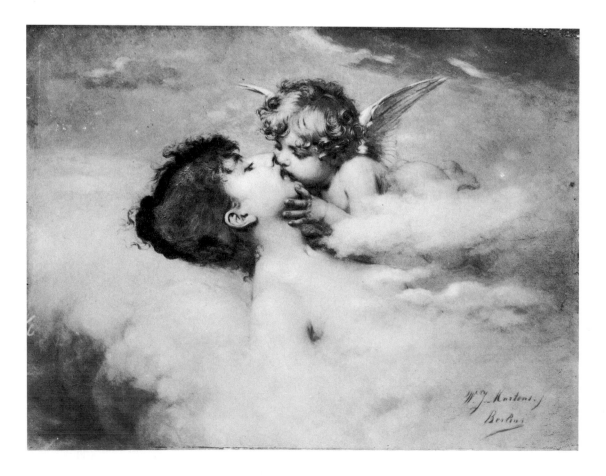

Tranquillo Cremona
Motherly Love
Oil on canvas, 67 x 56 cm (26⅜ x 22″)
Civica Galleria d'Arte Moderna, Milan

Willem Martens
Dream of Love
Oil on canvas, 37 x 49 cm (14½ x 19¼″)
Stedelijk Museum, Amsterdam

Sir Edward John Poynter
Outward Bound, 1886
Oil on canvas, 50 x 50 cm (19½ x 19½″)
Tate Gallery, London

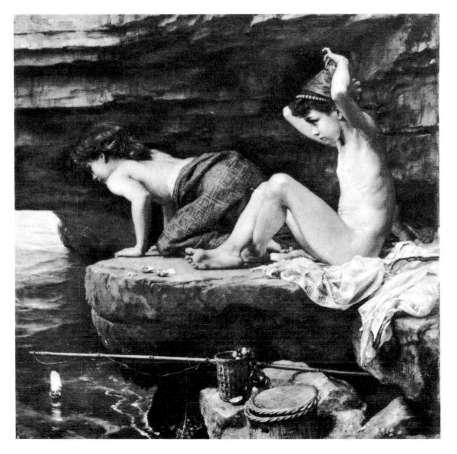

The Family Crisis

Scenes illustrating the critical situations which break out from time to time in families were much less common than odes to happiness. *The Family Apportionment* by Maksimov refers to the decline of patriarchal Russia and the appearance of new economic and social structures based on profit. After the emancipation of the serfs in 1861, inheritance, that is to say the habit of sharing out assets among the members of a family, became common practice in peasant families. The painter has taken it on himself to show the negative aspects of this change, especially on the human level, as well as the psychological

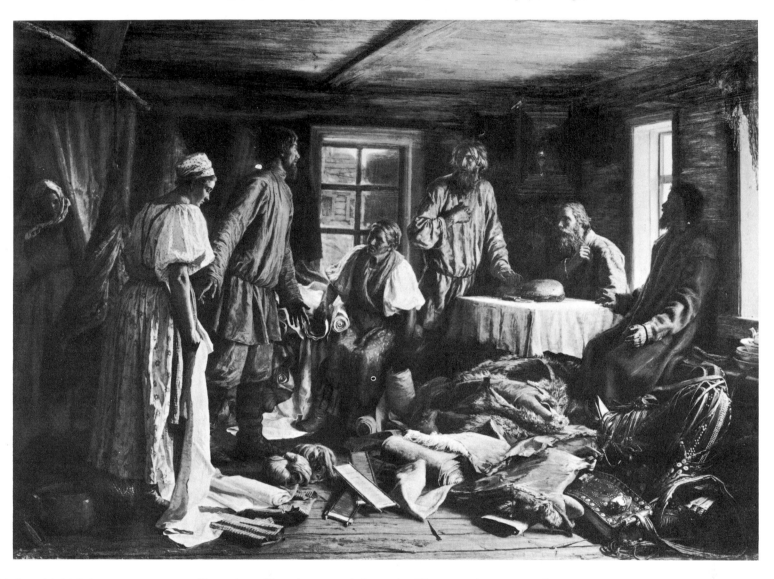

Vassily Maksimovich Maksimov
The Family Apportionment, 1876
Oil on canvas, 106 x 148 cm (42¾ x 58¼")
Tretyakov Gallery, Moscow

conflicts that directly ensued from it. The reactions vary from one character to another; while the young woman is silent, lowering her eyes in a dignified attitude, her husband seems to be defending their interests with bitter vehemence. The arrangement of the hut and the simplicity of the individuals sums up effectively the conditions of the Russian peasant after the reform. The faces, gestures and clothes seem to have been captured instantaneously.

Family rows were sometimes the result of a particular vice, gambling, alcohol or immorality. Painters took up this theme, in principle, with the intention of putting the public on its guard against those who had fallen by the wayside through some sort of unacceptable behaviour. The exaggeratedly didactic nature of such works meant that their creators were reduced to naive melodrama; and even an artist as skilful as Echtler in his *Ruin of a Family by Gambling* was not exempt from this. Although the actors of the drama are simple village people, there is no question but that the moral one can draw from it aims at a much wider significance. The general disorder of

the place, especially in the foreground, emphasizes the attitude of each of the characters and the part he plays in the event. It is difficult to decide whether to attach more importance to the drama itself, or to the details; and this weakens the intended impact.

This passion for gambling seems, incidentally, to have less tragic repercussions when it affects members of high society, as Louis Dubois shows us in *Roulette*. The nervous tension of the players, and their psychological reactions, are fundamental to the painting. One might say that it is really a series of portraits with no cohesive elements to bind them together. The only connecting link is the direction in which the players' eyes are looking: they converge irresistibly towards the

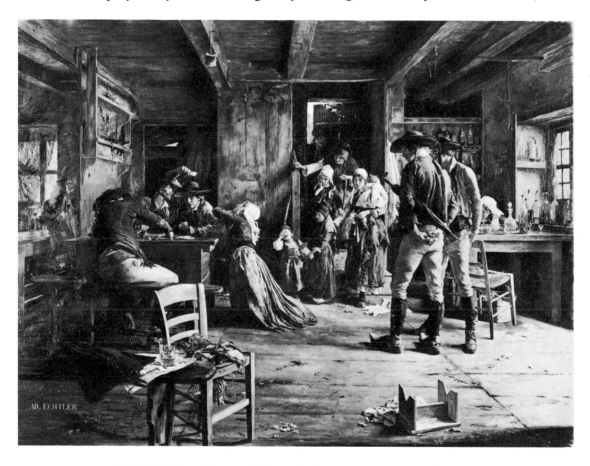

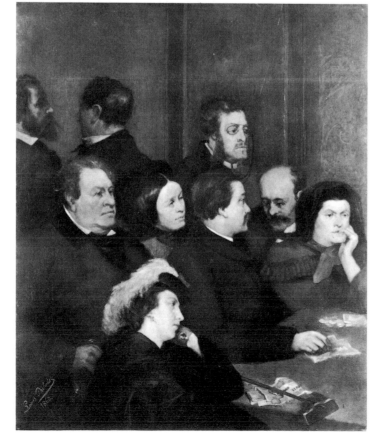

Adolf Echtler
Ruin of a Family by Gambling
Oil on canvas, 150 x 170 cm (59 x 66⅞")
Staatliche Kunstsammlungen Dresden,
Gemäldegalerie Neue Meister

Louis Dubois
Roulette, 1860
Oil on canvas, 153 x 124 cm (60¼ x 48⅞")
Musées Royaux des Beaux-Arts de
Belgique, Brussels

same centre, which does not in fact appear within the picture itself. The subtly weary, melancholy faces of the women, no doubt resigned to losing their money, encapsulate the state of mind which is dominant amongst the guests.

Old age itself, as a social category, was not avoided by the Realists. Angelo Morbelli, better known for his Pointillist works, has also left us a series of pictures inspired by what he saw at the Milanese institution for aged paupers, the Pio Albergo Trivulzio.

The Evening of Life is one of these pictures, and it is distinguished by a very thoroughly researched style. Without being afraid of becoming monotonous, the artist has used the way the benches are arranged

Angelo Morbelli
The Evening of Life
Oil on canvas, 100 x 161 cm (39⅜ x 63⅜")
Civica Galleria d'Arte Moderna,
Milan

Stanislaw Lentz
Group Portrait of the Scientific Circle of Warsaw
Oil on canvas, 179 x 264 cm (70½ x 104")
National Museum, Warsaw

to resurrect the grim unwelcoming air of the room and its inflexible regimentation, so out of key with the humble desires of the old men. There is a parallel treatment of disciplined arrangement in Lentz's *Group Portrait of the Scientific Circle of Warsaw*, but here it is at one with the official character of the worthy assembly and the eminent social role of each of its members. Perhaps the artist also wanted to stress the importance of the will and effort of individuals in the search for glory.

Politics, Science and the Arts

It is in the nature of Bourgeois Realism for its original conceptions and stylistic characteristics to be seen to better effect in scenes of daily life than in compositions of great complexity or ceremony. Political history rejects allegory, and is best perceived through the actual events of which its fabric is made. Raffaelle Sernesi, an inspired supporter of Garibaldi, has devoted to his fellow-Garibaldians one of his most successful works. His painting *Patriots at Target Practice* takes us back to one of those ostensible sporting occasions which assumed all the importance of veritable political meetings. In this scene the eye is drawn to a refined and elegant couple, somewhat reminiscent of some of Manet's figures, and to a man wearing a *bersagliere* hat, busy reloading the rifles. The attitudes of the characters provide a very accurate picture of the atmosphere at shooting matches: moments of tension while the marksman concentrates are followed by long intervals when he rejoins the noisy and animated spectators.

Raffaelle Sernesi
Patriots at Target Practice
Oil on canvas, 46 x 56 cm (18⅛ x 22″)
Brera, Milan

151

Vladimir Egorovich Makovsky
An Evening with Friends, 1875–97
Oil on canvas, 108 x 144 cm (42½ x 56⅝″)
Tretyakov Gallery, Moscow

The struggles of the Russian intellectuals followed a different pattern and found their inspiration in different methods. Sustained by a true ideology, they were carried on clandestinely and demanded total self-denial from the militants. *An Evening with Friends* was completed after many years' work on the theme of revolutionary meetings; Makovsky brings to it the feverish and enthusiastic atmosphere in which all the conspirators are at one with each other, despite the differences in age and temperament. The impression of unity derives here from the horseshoe shape of the composition, and, to an even greater extent, from the light surrounding the oil-lamp in the centre of the canvas.

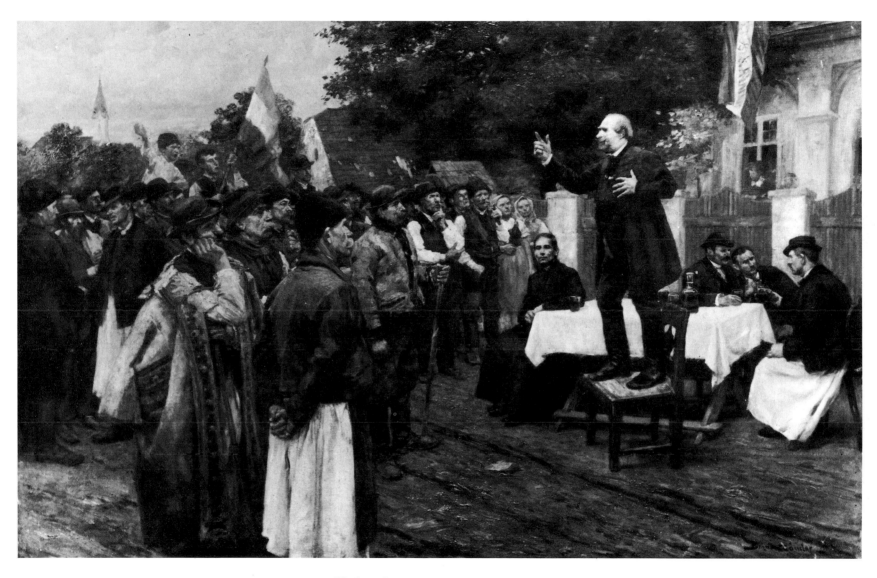

Sándor Bihari
Electoral Speech, 1890
Oil on canvas, 75 x 127 cm (29½ x 50″)
Hungarian National Gallery, Budapest

Looking at *Electoral Speech* by Sándor Bihari, we can easily imagine the ironic smile on the artist's face at the heady, smooth eloquence of politicians. Precariously perched on a chair, the orator harangues an audience of doughty-looking Hungarian peasants. The presence of the priest and the professional agitator behind him are a clear indication of what the painter thought of politics and of this type of meeting.

The sciences and the arts too attracted comment from of the painters of the period, the former for their much-admired experimental researches, and the latter as an expression of collective aspirations, or as a mysterious profession combined with an eccentric way of life.

153

Thomas Cowperthwait Eakins
The Gross Clinic, 1875
Oil on canvas, 236 x 192 cm (96¼ x 78⅝″)
By courtesy of Jefferson Medical College,
Thomas Jefferson University, Philadelphia

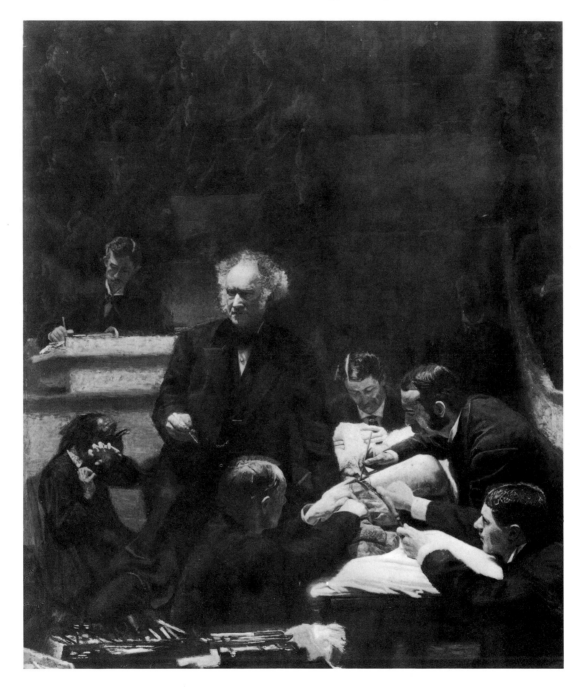

The Gross Clinic by Eakins shows the celebrated surgeon and teacher Samuel David Gross at a moment in the middle of an operation when he turns to his students to give an explanation; this was a tribute to a science which was then on the point of winning its first significant victories. There was also, here, 'a profound interest in human destiny and an objective, calm study of the minutest parts of the human body'.[28] And yet it seems that certain details were not in the public taste, since this picture did not achieve the success it deserved. Whatever the case, its debt to the *Anatomy Lesson* by Rembrandt, and the disturbing effect of the lighting, add a philosophical dimension to it which is perfectly at harmony with the subject.

Henri Gervex
*Doctor Péan Operating at Saint-Louis
Hospital*
Oil on canvas, 242 x 188 cm (95¼ x 74″)
Musée de l'Assistance Publique, Paris

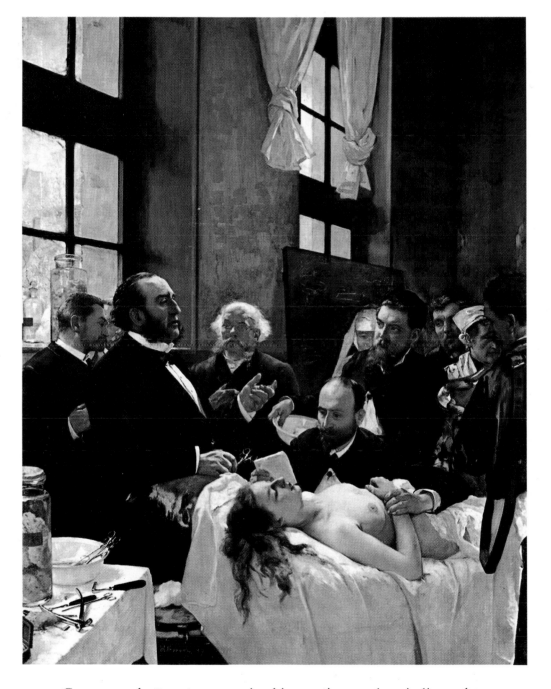

Gervex was better at overcoming his emotions and prejudices when,
ten years later, he in his turn painted the Parisian doctor Péan
explaining to his colleagues how to use haemostatic clamps. The
artist has treated his subject with a calm objectivity, comparable
perhaps to the coolness of his practitioner; and, due to his use of
light colours and to the simplicity of the construction, he manages,
perhaps unwittingly, to convey a timely message. Medicine here is
liberated from the superstitious prejudices of the unsophisticated and
presented as a quite prosaic activity.

The role of art in social life increased as new strata of the population
arrived on the cultural scene. But the very essence of this culture

August Allebé
The Museum Attendant, 1870
Oil on panel, 62 x 34 cm (24⅜ x 13⅜")
Rijksmuseum H.W. Mesdag, The Hague

August Allebé
The Museum Attendant, 1870
Oil on panel, 62 x 53 cm (24⅜ x 20⅞")
Stedelijk Museum, Amsterdam

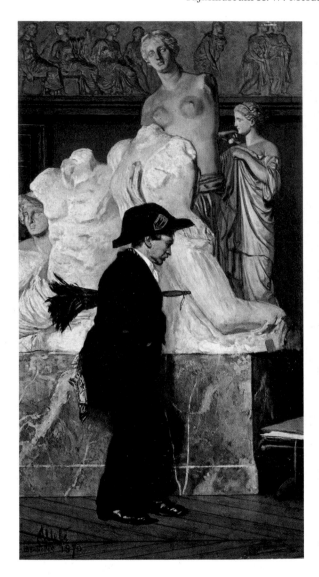

and its traditional content caused a rupture between the rich middle classes and the proletariat. The latter did not have the free time, nor did they yet feel the need to go in search of this cultural heritage. Allebé's *Museum Attendant* waddles on his rounds more attentive to his feather duster than to the masterpieces of the Greek period; the distinguished-looking young couple approaching from the other end of the room appear struck with admiration. Later the artist did away with this contrast between the social classes and divided his subject into two separate pictures which can be seen today in two different museums.

Bourgeois Realist painting shows the studio of the painter, an alchemist's laboratory in which miracles and marvels were prepared, in a cultural and at the same time an erotic light. In fact, artists have always collected objects of all kinds to stimulate them in their work or to serve them as first-hand records. William Chase had in his studio in New York a collection of paintings, fabrics, books, furniture, and also possessed, according to *The Art Journal,* 'rare ceramics,

William Merritt Chase
In the Studio, c. 1880
Oil on canvas, 70 x 99 cm (28½ x 40⅛")
The Brooklyn Museum, New York

Egyptian jugs, painters' brushes, strange statuettes of Saints and Virgins, crucifixes and a great number of other objects which it is not possible to list'.[29]

The painter has managed to convey this abundance of treasures in a picture entitled *In the Studio* by means of the contrast between the shimmering colours on the one hand and the dark wood of the floor and dresser on the other. In the same sensitive vein, and in harmony with this world of objects, there is a woman sitting turning the pages of a book. Her white dress and her plumed hat do not clash in this studio which is lit by a quivering whitish light. The work as a whole already heralds the break with the narrative tradition. But despite this sophistication, the painter's studio, for the uninitiated, continues to evoke an exotic way of life, free from all moral constraint; there is a good example of this in *Studio Corner* by István Csók.

Artists had succeeded, by the end of the nineteenth century, in forming themselves into a large and powerful community. At a time when the current innovators had already given birth to the most

157

István Csók
Studio Corner, 1905
Oil on canvas, 106 x 185 cm (41¾ x 72⅞″)
Hungarian National Gallery, Budapest

Jules-Alexandre Grün
A Friday at the Salon, 1911
Oil on canvas, 360 x 616 cm (141¾ x 234½″)
Musée des Beaux-Arts, Rouen

significant of art works, when Impressionists and Post-impressionists, Nabis, and later Fauves and Cubists, were carving a path for Modern Art, art for the majority of people still really meant Bourgeois Realism of all ages and shades, as well as the works of certain of the Symbolists. The whole of this distinguished set came together in Grün's painting, *A Friday at the Salon*. This work was very well received on account of the portraits of contemporaries whom the artist had included in it; 'it is hard to say what one should admire the more,' writes a journalist of the period: 'the truth to life of the facial expressions, attitudes and gestures, or the amazing virtuosity of execution'.[30]

Gabriel Cornelius von Max
The Jury of Apes (Monkey Critics)
Oil on canvas, 85 x 107 cm (33½ x 42⅛")
Bayerische Staatsgemäldesammlungen,
Munich

Realist painting had to adhere to very strict principles as far as virtuosity of execution was concerned, and always referred back to concrete reality. Nevertheless this did not stop people speculating at length as to which part of this reality ought to be selected and reproduced by the artist, and what contributory role might be played by the imagination. The arbitrary nature of the resulting judgments, and the questionable competence of official censors faced with young artists, are maliciously illustrated in one of Gabriel von Max's pictures, *The Jury of Apes*.

The Portrait

Anton Romako
Maria Magda, Countess Kufstein, 1885
Oil on canvas, 79 × 63 cm (31⅛ × 24¾")
Österreichische Galerie des 19.
Jahrhunderts, Vienna

Léon Bonnat
Madame Pasca, 1874
Oil on canvas, 232 × 132 cm (91⅜ × 52")
Louvre, Paris

In Evening Dress

The one thing that in the past had been the preserve of the kings and rulers of the world, or at least the rich – namely having one's effigy, sometimes life-size, perpetuated in a durable material – became accessible, in the course of the nineteenth century, to much wider circles. In point of fact, there is no essential difference between the Bourgeois Realist portrait and those of earlier periods except in technique of execution, fidelity to the original, and costume. The resulting works include some genuine masterpieces. Let us quickly add that while the psychological verisimilitude of these works was tied to a particular social context, it reveals at the same time the mediocrity and precariousness of bourgeois values. Women, above all, were always ready to put on their most extravagant hats and pose docilely for any dauber; this was all the more heroic since the latter sometimes made outlandish demands, obliging his female sitter to present herself in an attire that cost her a fortune.

It is difficult to discuss the portrait without mentioning the name of the French painter Léon Bonnat. The portrait of *Madame Pasca*, who was then a fashionable actress, belongs to the first period, indubitably the best, and showing signs of a very clear influence from Spanish painting, especially Goya. It is thought that this was a request from a friend, and the choice of richly ornate frame can be laid at the door of the artist himself, who was keen to provide a contrast with the pure and spacious perspective of the canvas.

Here again, a comparison can be made with Manet, as it can for many other Bourgeois Realists. Born a year apart, Manet and Bonnat had chosen themselves the same masters. Displayed on large surfaces,

Valentin Aleksandrovich Serov
Madame O.K. Orlova, 1911
Oil on canvas, 237 x 160 cm (93¼ x 63″)
Russian Museum, Leningrad

Giovanni Boldini
Marchesa Casati, c. 1911
Oil on canvas, 136 x 176 cm (53½ x 69¼″)
Galleria Nazionale d'Arte Moderna,
Rome

greys, blacks and whites are dominant in their sober palette. While one turned to visual impressions, the other abided by the lessons of the Académie and persisted in imitating reality. Where Manet is liberated from the object, Bonnat remains dependent on it; hence the astonishing rendering of Madame Pascal's gown, which is completely true to the original. While the prominent facial features tend to remind us of the portraits of Ingres, the energetic and expressive hand, into which he has put the full power of his creative will, is a summary in itself of Bonnat's aesthetic creed. To keep the spectator's attention concentrated on the model, the artist has deprived the background of its decorative role, giving it a fuzziness completely foreign to Manet's manner.

Thirty-five years later, Serov painted the portrait of *Madame Orlova.* This is a powerful work, whose evocative strength is tied as much to the enigmatic and inscrutable expression of the actress with her haughty bearing as to her elegant dress and the discreet taste of the salon, furnished without extravagance of style. It appears that the

artist was not immune to the experiments of modern painting, to judge by the tone contrasts, the contrasting light and dark parts of the dress and the bold observation of accidental light. As for the tastes and social ideas of the period, their presence is clearly implied.

Bourgeois Realist painting responded to the evolution of the avant-garde, with its elimination of narrative context, and underwent changes of its own. With certain painters like Sargent, and above all Boldini, the structure of surfaces, brush-strokes and lines became emancipated, although at the same time they indulged themselves too often in stressing the perfections and social prestige of the sitter. When Boldini paints the *Marchesa Casati*, a distinguished if

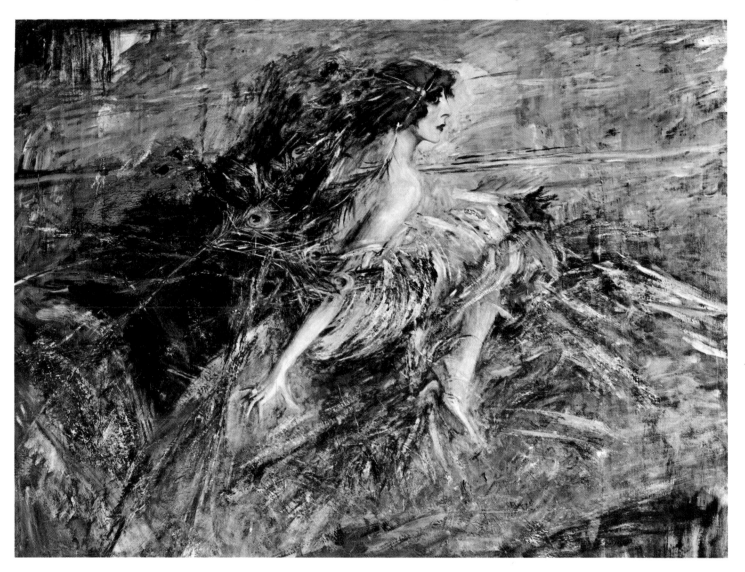

eccentric figure in Roman society, he freely stylizes her dress and her body. Her face, her shoulder, her fingers, as well as part of her leg, make up a vision of grace and sophistication. The diaphanous dress, and the peacock feathers with which she is surrounded, suggest evanescence, movement, the passage of time, thus echoing the Marchesa's personality. To this end the painter uses whiplash streaks of light which cut across the surface of the picture.

In Everyday Dress

Portraits in town clothes were more common than those in evening dress, they also have the advantage of being more explicit about the period, giving us a more precise picture of the bearing, sartorial taste and demeanour of those in society. The sitters were no less wealthy, nor were the painters any more reasonable about their prices, for 'the meanest portrait of a lady in society is quoted at 750 louis', according to a contemporary.[31] Without any doubt this well-rewarded speciality greatly contributed to the fact that, towards the end of the century, a certain number of artists found themselves in the higher reaches

Ilya Efimovich Repin
Baroness Varvara Ivanovna Iskul, 1889
Oil on canvas, 196 x 71 cm (77⅛ x 28")
Tretyakov Gallery, Moscow

Jacques-Emile Blanche
Madame Vasnier, 1888
Pastel on card, 130 x 70 cm (51⅛ x 27½")
Musée du Petit-Palais, Paris

of the bourgeoisie. The works of Repin, Blanche, Kramskoy, Stevens, Giron and Roll, to name but a few, illustrate the close connivance between painters and the ruling classes.

Alfred Stevens
Lady in Pink, 1886
Oil on canvas, 87 x 57 cm (34¼ x 22½″)
Musées Royaux des Beaux-Arts de
Belgique, Brussels

Dukszta-Dukszynska
Girl with Parasol, 1888
Oil on canvas, 84×65 cm (33⅛ x 25⅝″)
National Museum, Warsaw

Ivan Nikolayevich Kramskoy
Unknown Woman, 1883
Oil on canvas, 75×99 cm (29½ x 39″)
Tretyakov Gallery, Moscow

Pál Szinyei Merse
Lady in Lilac, 1874
Oil on canvas, 103 x 77 cm (40½ x 30¼")
Museum of Fine Arts, Budapest
Corvina Archives, Budapest

Alfred-Philippe Roll
M. Alphand, 1888
Oil on canvas, 156 x 130 cm (61⅜ x 50⅛")
Musée du Petit-Palais, Paris

Charles Giron
Parisienne, c. 1883
Oil on canvas, 200 x 99 cm (78¾ x 39")
Musée du Petit-Palais, Paris

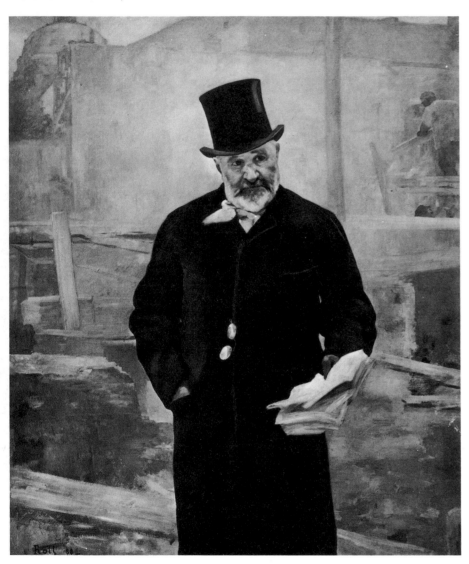

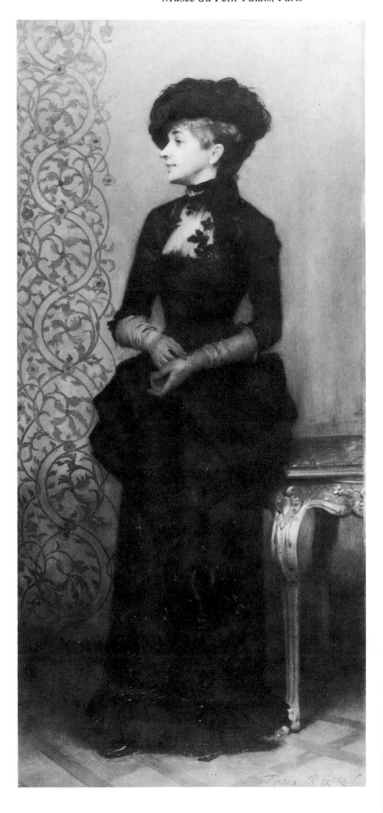

Giovanni Costa
At the Spring
Oil on canvas, 208 x 160 cm (82 x 63″)
Galleria Nazionale d'Arte Moderna,
Rome

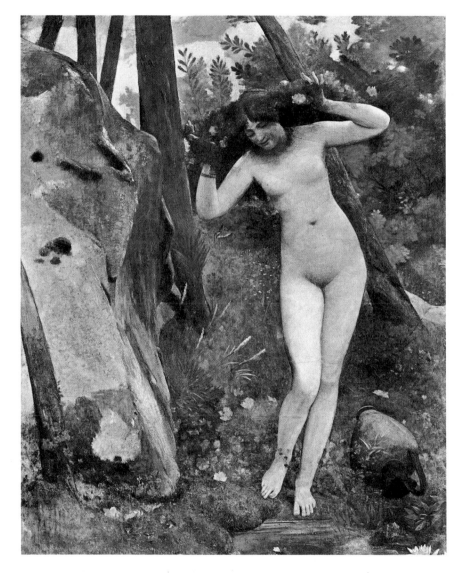

In the Open Air

Does the nude in *At the Spring* by the Italian, Giovanni Costa,
symbolize Nature, or is she the idealized portrait of a young girl who
has come for a swim? Of course the first does not exclude the second,
just as the recourse to frank, overt colours, very similar to recent
French examples, does not displace the high-minded insipidity of
attitude and gesture that conforms to the idea of beauty current in
the nineteenth century. Hébert convincingly exploits these contradic-
tions in his portrait entitled *Music*: the position of the fingers and
the sentimental expression of the model are matched by the curious
contrast between the crude green of the plants and the delicate
pink of the carnations and the dress.
The same idiosyncrasy can be found in Sargent, one of the best
portrait painters of the turn of the century, a period between two
centuries and two ages of painting. Nobody has equalled his ability
to render the personality of a face. Nobody has handled his subject

Antoine-Auguste-Ernest Hébert
Music
Oil on canvas, 63 x 48 cm (24¾ x 18⅞")
Musée du Petit-Palais, Paris

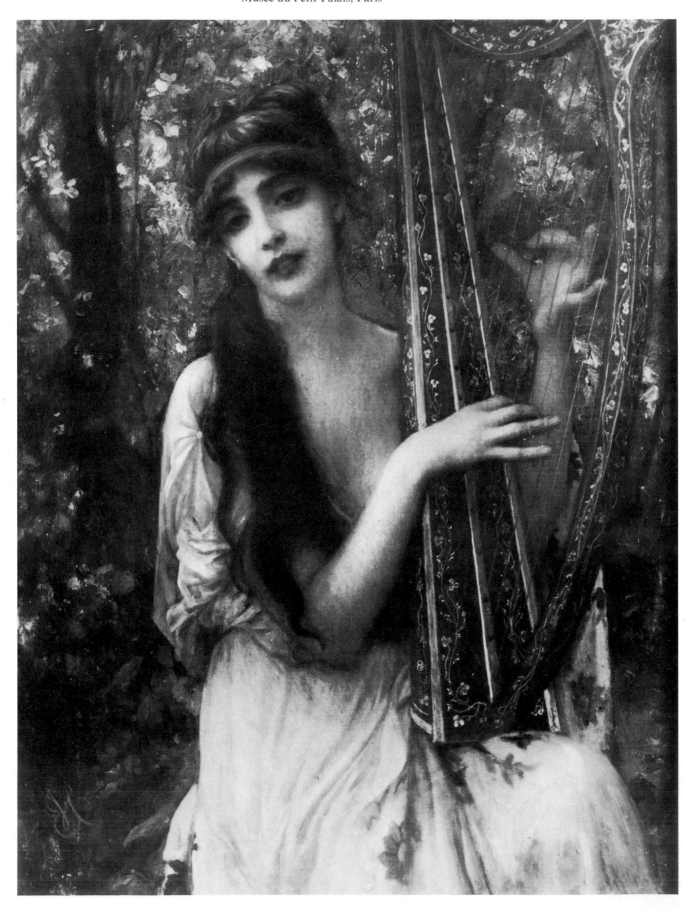

John Singer Sargent
On his Holidays, 1901
Oil on canvas, 132 x 235 cm (52¼ x 92½″)
By courtesy of the Trustees of
The Lady Lever Art Gallery, Port
Sunlight

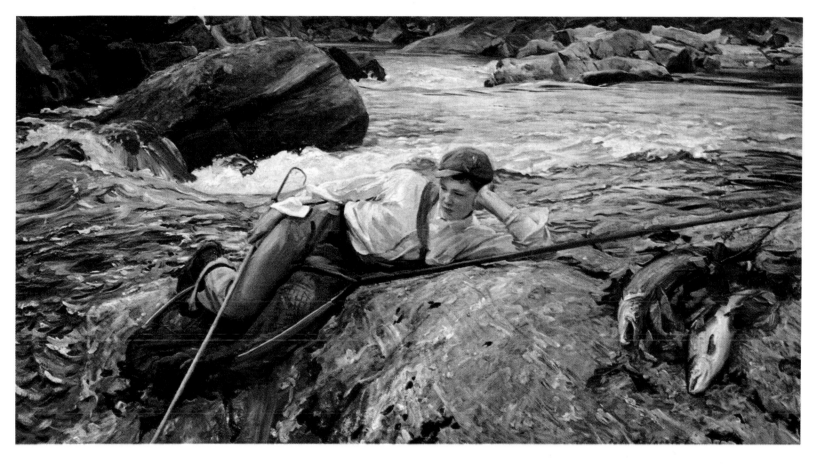

with such facility and naturalness, generalizing some parts and show-
ing others in detail. In this he was the successor of Hals or even
Velázquez, while owing a debt to certain contemporaries, such as
Carolus-Durand with whom he had worked. Nevertheless there are
certain of his works where precision takes over from the desire to
generalize. *On his Holidays,* painted in Norway, represents the son of
a friend. Stretched out on a rock, looking apathetic and resigned, he
does not seem to have derived any pleasure from the fish he has
caught. The rapidly moving stream and the cold rocks that surround
him betoken solitude; Sargent liked to introduce a discreetly reflective
theme into his work.

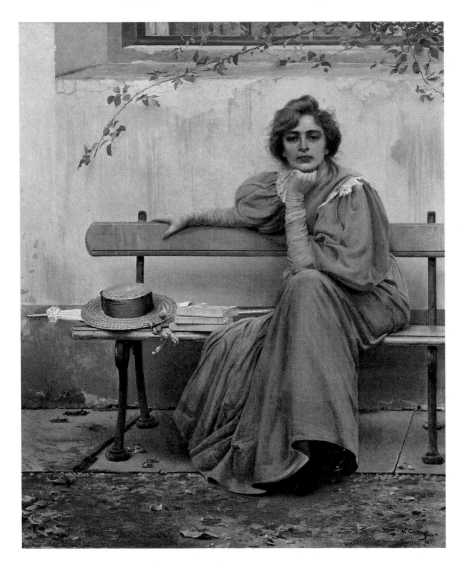

Meditative Poses

As in the other traditional genres, a philosophical or moral intention
can be the lifeblood of a portrait. So in *Daydreams* by Vittorio Corcos
we have a fine example of a woman personifying meditation, with all
the characteristics of the realist style. In other paintings, a woman
is caught in the heat of a conversation, as by Chabas, or in a
melancholy and expectant attitude, as by Sant; elsewhere she is to be
found fairly and squarely facing the spectator, offering him her smile
and sympathy, as in Quinsac, and in Andrez she even tries to step out
of the frame to come and meet him.

When Tolstoy spoke of the portrait of his favourite heroine Anna
Karenina, he said it was so successful that the figure seemed 'to want
to leap out of the frame'; and then he added: 'if she had no life it
was only because she was more beautiful than any living creature
could be'.[32]

Paul Emile Chabas
Madame Danièle Lesueur, 1895
Oil on canvas, 118 x 78 cm (46½ x 30¾")
Musée du Petit-Palais, Paris

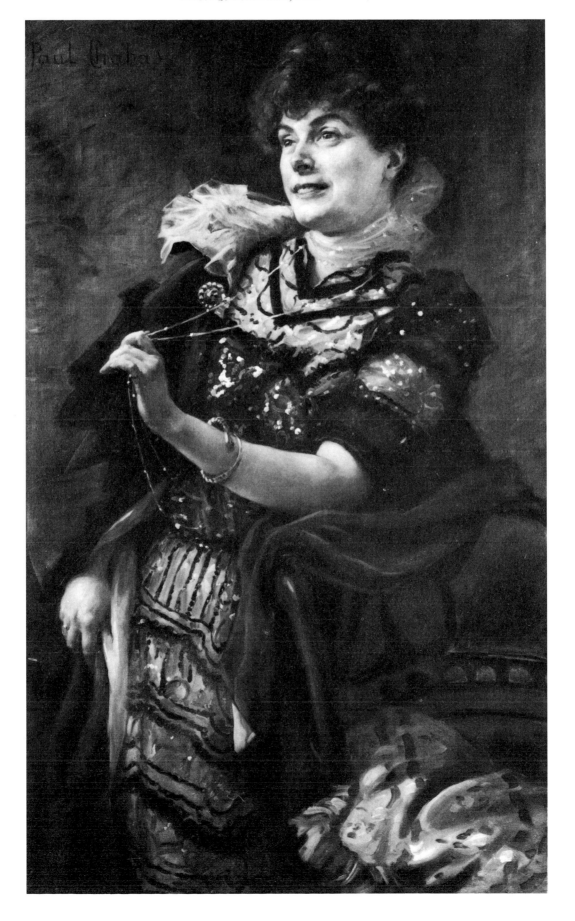

Paul-François Quinsac
Woman with Gold Crown
Oil on canvas, 69 x 51 cm (27⅛ x 20⅛″)
Gérard Lévy, Paris

James Sant
Waiting
Oil on canvas, 61 x 51 cm (24 x 20⅛″)
Hamburger Kunsthalle

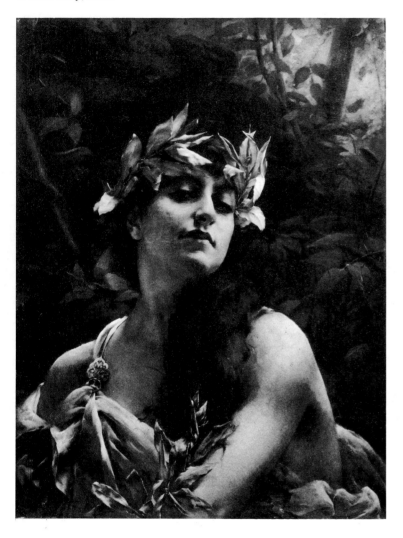

Gyula Benczúr
Janos Hock, 1900
Oil on canvas, 55x43 cm (21⅝ x 17″)
Hungarian National Gallery, Budapest

P. Andrez
Portrait of a Woman, 1890
Oil on canvas, 73 x 92 cm (28¾ x 36¼″)
Gérard Lévy, Paris

Epilogue

The aim of this work is not and never could be to retrace the whole history of Bourgeois Realist painting, which would have called for a totally different approach and a different use of the material. It would have required vast researches into the most diverse fields, as well as an examination of the mutual influences between artists within the same country, quite apart from the international effects of some of them. All these would be necessary conditions for drawing up a panorama of one of the most productive currents in the history of painting.

At the time of Bourgeois Realism, the regional and national schools did not clearly show the particular features which give artistic schools their individuality. Much more so than at the time of the great traditional styles, Romanesque and Gothic, Renaissance and Baroque, Europe and the Americas at the end of the nineteenth century were an arena in which experiments and discoveries were being constantly produced and exchanged. So the process of unification of artistic expression, set in motion under the auspices of Neoclassicism, continued with increased vigour. Almost the whole world, as has rarely happened in history, shared common perspectives in artistic matters. These perspectives related as much to techniques and to the spirit in which the work was carried out as to the content itself. Modes of expression were comprehensible to everyone because they were closely linked to a vision of a world which was confined to empirical reality. The basic inspiration came from the desire to illustrate the ideas specific to the period, and to promote the most positive and useful aspects of the life of bourgeois society.

This book is an attempt to draw attention to this school of painting, which fell into oblivion in spite of its close links with the ideas of the period that preceded our own, ideas which in many ways determined the way we live today. Whether or not a stimulus has been given to others to carry out further research which might complement or demolish the arguments presented here, the book will at least have had the small merit of posing the fundamental question: can we provide a clear picture of our evolution, of the process of artistic creation and its continuity, without taking into account the point of view of previous generations? Can we do so if we ignore the labours of artists who, at a time not so very far distant from or dissimilar to our own, worked with conviction, professional conscientiousness, and sometimes even with passion, to produce objects for which they, like their contemporaries, felt a need?

To illustrate this argument, the author has had recourse as far as possible to those works whose whereabouts are known. So the foundations of his analyses, or of his personal impressions, can at any moment be subjected to examination. For the majority of works presented in this book, when he has wanted to define their aesthetic value, the author has made his selection on the basis of the originals, looking at the draughtsmanship, colours and composition for the signs of an unquestionable originality.

Notes

1. Salvador Dali, 'Manifeste en hommage à Meissonier', exhibition catalogue, Paris, Hôtel Meurice, 1967.

2. Charles Morazé, Preface in *Histoire du peuple français*, Paris, Nouvelle Librairie de France, 1967, p. 7.

3. Jean Dubuffet, *Asphyxiante culture*, Paris, J. J. Pauvert, 1968, pp. 11, 25, 27, 40.

4. Jean Duvignaud, *Sociologie de l'art*, Paris, Presses Universitaires de France, 1967, p. 4.

5. Ibid., p. 122.

6. Marguerite Perrot, *Le Mode de vie des familles bourgeoises 1873–1953*, Paris, Armand Colin, 1961, p. 3.

7. Ibid., p. 99.

8. Charles Morazé, op. cit., p. 10.

9. Abbé de Saint-Pierre, 'Projet pour perfectionner l'éducation', quoted by Bernard Groethuysen in *Origines de l'esprit bourgeois en France*, Paris, NRF/Gallimard, 1956, I, 99.

10. Bernard Groethuysen, op. cit., p. 53.

11. Geneviève Lacambre, 'Lucien Lévy-Dhurmer', *Revue du Louvre*, Paris, 1973, 1, p. 30.

12. Pius IX, *Acta SS. D. N. Pii PP. IX ex quibus excerptus est Syllabus*, Rome, Typis Rev. Camerae Apostolicae, 1865, p. 213.

13. Philippe van Tieghem, *Dictionnaire des littératures*, Paris, Presses Universitaires de France, 1968, III, 3284.

14. *Istoria russkogo iskustva*, Moscow, Izdatelstvo 'Nauka', 1965–68, IX, 183.

15. Ibid., p. 186.

16. Olivier Merson, 'La peinture en France (Expos. de 1861)', quoted in 'Equivoques: peintures françaises du XIXe siècle', exhibition catalogue, Paris, Musée des Arts Décoratifs, 1973.

17. Charles Baudelaire, 'Salon de 1859', in *Œuvres complètes*, Paris, Gallimard, 1961, p. 1064.

18. 'Moreau de Tours', *L'Illustration*, 1885, quoted in 'Equivoques...', op. cit.

19. J. M. Guyau, *Les Problèmes de l'esthétique contemporaine*, Paris, Librairie Félix Alcan, 1935, p. 81.

20. Alfred Fouillée, *La Morale, l'art et la religion d'après Guyau*, Paris, Librairie Félix Alcan, 1923, p. 210.

21. Theodore Reff, 'Further Thoughts on Degas's copies', *Burlington Magazine*, London, 1971.

22. Hippolyte Taine, *Philosophie de l'art*, Paris, Hachette, 1909, I, 22.

23. Jeremy Maas, *Victorian Painters*, London, Barrie and Jenkins, 1970, p. 244.

24. John Quille Millais, *The Life and Letters of Sir John Everett Millais*, London, Methuen, 1899, II, 39.

25. Ibid., p. 40.

26. Jean-Marie Mayeur, 'La France bourgeoise devient républicaine et laïque', in *Histoire du peuple français,* op. cit., p. 118.

27. '19th-Century America; Paintings and Sculpture', exhibition catalogue, New York, The Metropolitan Museum of Art, 1970, entry no. 147.

28. Ibid., no. 155.

29. Ibid., no. 172.

30. 'Jules-Alexandre Grün', *L'Illustration,* Paris, 1911, quoted in 'Equivoques...', op. cit.

31. Jacques Lethève, *La Vie quotidienne des artistes français au XIXe siècle*, Paris, Hachette, 1968, p. 216.

32. Leon Tolstoy, *Anna Karenina*, part 7, end of ch. 9.

Biographies

Abbéma, Louise

born Etampes, 30 October 1858; died Paris, 1927
Painter; engraver, sculptress and writer. Pupil of Chaplin, Henner and Carolus-Duran. Enjoyed great success at an early age.

Agneessens, Edouard

born Brussels, 24 August 1842; died Uccle, 20 August 1885
Genre and portrait painter. Studied at Brussels Academy of Fine Arts and later in the 'free studio' of Portaels. Also worked in St Petersburg.

Alexander, John White

born Allegheny City (Pennsylvania), 7 October 1856; died 1 June 1915, place of death unknown
Portrait painter; illustrator. Pupil of Frank Duveneck at Polling in Bavaria. Later met Whistler in Italy and was influenced by him.

Allebé, August

born Amsterdam, 19 April 1838; died there, 10 January 1927
Genre, portrait and animal painter; lithographer. Studied under Greive in Amsterdam and at the Antwerp Academy of Fine Arts. Lithographic work in Paris with Mouilleron. Director of Amsterdam Academy of Fine Arts, 1880–1906.

Alma-Tadema, Sir Lawrence

born Dronrijp (Leeuwarden), 8 January 1836; died Wiesbaden, 24 June 1912
History and portrait painter. Pupil of Wappers and De Keyser at the Antwerp Academy of Fine Arts, and also of Baron Leys. In 1869 he settled in England, where his works enjoyed enormous success.

Andrez, P.

second half of 19th century
Figure and portrait painter, working in France; probably of Spanish origin. Showed two paintings at the Paris Salon in 1892.

Avy, Marius-Joseph

born Marseilles, 21 September 1871; place and date of death unknown
Genre and landscape painter; illustrator and decorative artist. Pupil of Maignan and Bonnat.

Bacon, John Henry

born London, 1868; died there, 1914
Genre and portrait painter. Studied at Royal Academy Schools.

Barabás, Miklós

born Markusfalva, 1810; died Budapest, 1898
Portrait and genre painter; lithographer. Studied at Vienna Academy of Fine Arts.

Bargellini, Giulio

born Florence, 1875; died Rome, 1936
Genre and history painter; lived in Rome.

Benczúr, Gyula (Julius de)

born Nyereguyháza, 28 January 1844; died there, 1920
History and portrait painter. Pupil of Piloty at Munich Academy of Fine Arts where he later taught.

Béraud, Jean	born St Petersburg, 12 January 1850; died Paris, 1936 Painter of Parisian life. Attended Lycée Bonaparte and studied law before entering Bonnat's studio at the Paris Ecole des Beaux-Arts.
Bianchi, Mosè	born Monza, 1840; died there, 1904 Genre, landscape and portrait painter. Trained as engineer before taking up painting. Pupil of Bertini at Brera Academy, Milan; spent two fruitful and decisive years in Venice and Paris.
Bihari, Sándor	born Reybanya, 1856; died Budapest, 28 March 1906 Genre painter. Pupil of Würzinger in Vienna and of Jean-Paul Laurens in Paris.
Blanche, Jacques-Emile	born Paris, 1 February 1861; died there, 1942 Figure and society portrait painter in France and England; also a writer. Pupil of Gervex and Humbert. He remained throughout his career a prominent member of Parisian high society.
Boldini, Giovanni	born Ferrara, 31 December 1842; died Paris, 12 January 1931 Genre and especially portrait painter. Studied at Florence Academy of Fine Arts, spent several years in London, and lived from 1872 onwards in Paris.
Bonnat, Léon	born Bayonne, 20 June 1833; died Monchy-Saint-Eloi, 8 September 1922 Portrait, landscape and history painter. Earliest training in Spain under José Madrazo. Studied at Ecole des Beaux-Arts in Paris under Léon Cogniet. Went to Italy on bursary from his native town; later bequeathed a fine collection of paintings to the Bayonne museum.
Bouguereau, William Adolphe	born La Rochelle, 30 November 1825; died there, 19 August 1905 Painter of religious and mythological subjects, also of portraits and figure subjects. His father marked him out for a career in commerce, but his aptitudes and inclinations led him to the Ecole des Beaux-Arts in Paris, where he studied under Picot (1846–50). Spent four years in Italy before returning to Paris to embark on one of the most brilliantly successful artistic careers of the period.
Braekeleer, Henri de	born Antwerp, 11 June 1840; died there, 20 June 1888 Painter of interiors, portraits, landscape and still-life; etcher. Pupil of his father, Ferdinand de Braekeleer the elder, and of his uncle, Henri Leys.
Brito, José de	born Minho, 1855; died Oporto, 1946 History, genre and portrait painter. Studied at the School of Fine Arts in Oporto, and in Paris under Laurens and Constant.
Brown, John George	born Durham, 1831; died New York, 1913 Genre painter and engraver. Studied in Newcastle-upon-Tyne, and at the Royal Scottish Academy. Lived mainly in America.
Cabanel, Alexandre	born Montpellier, 28 September 1824; died Paris, 23 January 1889 Painter of religious and mythological subjects. Pupil of Picot; later, as a professor at the Ecole des Beaux-Arts in Paris, he became internationally famous.
Calderon, Philip Hermogenes	born Poitiers, 1833; died London, 1898 History and genre painter. Pupil of Leigh in London and Picot in Paris. Lived in London.

Cammarano, Michele	born Naples, 1835; died there, 1920 Painter of military subjects. Studied under Smargiassi, and, more importantly, under Palizzi, whom he succeeded as professor at the Naples Institute of Fine Arts.
Cercone, Ettore	born Messina, 23 November 1850; died Sorrento, 1896 Painter and naval officer. Visited China, Japan, India and Australia. Studied under Morelli.
Chabas, Paul Emile	born Nantes, 1869; died there, 1934 Portrait and figure painter, specializing in the female nude. Pupil of Bouguereau and Robert-Fleury.
Chantron, Alexandre-Jacques	born Nantes, 28 January 1842; died 1918, place of death unknown Initially a painter of religious subjects. Later specialized in the female nude. Also painted genre and historical subjects, portraits and still-lifes. Pupil of Bouguereau and Robert-Fleury.
Chaplin, Charles	born Les Andelys, 8 June 1825; died Paris, 20 January 1891 Portrait painter and engraver; some early landscapes. Pupil of Drolling.
Chase, William Merritt	born Indiana, 1 November 1849; died New York, 25 October 1916 Genre, landscape and portrait painter. Studies at National Academy of Design, New York, and Munich Academy of Fine Arts. Taught at Art Students' League (founded to counter the conservatism of the National Academy of Design).
Corcos, Vittorio	born Livorno, 4 October 1859; died Florence, 8 November 1933 Portrait and landscape painter. Studied under Pollastrini in Pisa, under Morelli in Naples (1878–79), and in the studio of Bonnat in Paris (1880–86).
Coromaldi, Umberto	born Rome, 21 October 1870; died there, 5 October 1948 Landscape and marine painter; also painted female figure subjects. Studied at Rome Institute of Fine Arts and later under Mancini. President of Accademia di San Luca, Rome.
Costa, Giovanni (Nino)	born Rome, 1826; died Marina di Pisa, 1903 Painter (endowed with a 'lyrical temperament', according to Bénézit) and writer. Pupil of Camuccini, Goghetti, Agricola and Podesti; linked by friendship with the Macchiaioli group, especially Fattori and Signorini, and also with Corot.
Cremona, Tranquillo	born Pavia, 1837; died there, 10 June 1878 History and portrait painter. Pupil of Trécourt in Pavia, later of Molmenti, Grigoletti, Zona and Liparisi in Venice and finally of Bertini at the Brera Academy, Milan.
Csók, István	born Hungary, 13 February 1865; died there, 1961 Genre painter. Pupil of Hackl and Bouguereau.
Czachorski, Wladyslaw	born Lublin, 22 September 1850; died Munich, 1911 Genre and portrait painter. Pupil of Anschütz, Wagner and Piloty at Munich Academy of Fine Arts. Lived in Warsaw.
Debat-Ponsan, Edouard-Bernard	born Toulouse, 25 April 1847; died Paris, 29 January 1913 Painter of genre, of religious and patriotic subjects, and of portraits and landscapes. Pupil of Cabanel.

Defregger, Franz von	born Stronach (Pustertal), 30 April 1835; died Munich, 2 January 1921 History and genre painter. Pupil of Piloty. Taught at Munich Academy of Fine Arts from 1883 onwards.
Dubois, Louis	born Brussels, 1830; died there, 27 April 1880 Genre and portrait painter. Pupil of Couture.
Dukszta-Dukszynska (Emilie)	born St Petersburg, 1847; died Warsaw, 1898 History, genre and portrait painter.
Eakins, Thomas Cowperthwait	born Philadelphia, 25 July 1844; died there, 25 June 1916 Genre and portrait painter. Studied at the Pennsylvania Academy of the Fine Arts and at the Ecole des Beaux-Arts in Paris, under Gérôme and Bonnat.
Echtler, Adolf	born Danzig, 5 January 1843; died Munich, 25 September 1914 Genre painter. Studied under his father, Edouard, and at the Venice, Vienna and Munich Academies of Fine Arts.
Edouard, Albert Jules	born Caen, 12 April 1845; place and date of death unknown History and genre painter. Pupil of Cornu, Gérôme, Cogniet and Delaunay.
Fildes, Sir Luke	born Liverpool, 18 October 1844; died there, 1927 Genre painter; also portraitist and illustrator. Studied at the South Kensington and Royal Academy Schools.
Forbes, Stanhope	born Dublin, 1857; died 1948, place of death unknown Genre painter. Studied at Dulwich College, Lambeth School of Art and the Royal Academy. Further studies in Berlin, and in Paris under Bonnat.
Forsberg, Nils (the elder)	born Riseberg, 17 December 1842; died 1934, place of death unknown Genre painter. Pupil of Bonnat. Worked mainly in France.
Friant, Emile	born Dieuze, 16 April 1863; died Paris, 1932 Genre painter and sculptor. Enjoyed remarkable early success. Pupil of Cabanel.
Frith, William Powell	born Aldfield (Yorkshire), 9 January 1819; died London, 2 November 1909 History and genre painter. Studied initially at Sass's Drawing School, then at the Royal Academy Schools.
Gehrts, Karl	born Hamburg, 11 May 1853; died Endenich (Bonn), 17 June 1898 Genre and history painter. Studied at Weimar School of Fine Arts under Brütt and Gussow, later under Bauer. Lived in Düsseldorf.
Gérôme, Jean-Léon	born Vézoul, 11 May 1824; died Paris, 10 January 1904 History and genre painter; sculptor and engraver. Pupil of Delaroche and Gleyre. Travelled widely; visited Turkey, the Balkans, Egypt. His works were extremely popular and were reproduced in engravings and photographs. Professor at Paris Ecole des Beaux-Arts.
Gerson, Wojciech	born Warsaw, 1 July 1831; died there, 25 February 1901 History, genre and portrait painter. Studied under Piwarski and Breslauer in Warsaw and at the St Petersburg Academy of Fine Arts. Professor at Warsaw School of Painting and Drawing.

Gervex, Henri	born Paris, 1852; died there, 7 June 1929 Painter of scenes from Parisian life; decorative painter. Pupil of Cabanel and Fromentin. Enjoyed enormous international reputation.
Giacomotti, Félix-Henri	born Quingey, 19 November 1828; died Besançon, 10 May 1909 Portrait, history and genre painter. Pupil of Picot.
Gierymski, Aleksander	born Warsaw, 1849; died Rome, 5 March 1901 Genre and landscape painter. Studied at Warsaw School of Painting and Drawing, and under Anschütz and Piloty in Munich.
Giraud, Sébastien-Charles	born Paris, 17 January 1819; died Sannois, 1892 Painter of interiors and landscapes. Studied under his brother Eugène and at the Paris Ecole des Beaux-Arts.
Giraud, Victor-Julien	born Paris, 12 January 1840; died there, 19 February 1871 Genre painter. Pupil of his father Eugène, and of Picot.
Giron, Charles	born Geneva, 2 April 1850; died Genthod-Bellevue, 9 June 1914 Genre and portrait painter. Pupil of Cabanel.
Giudici, Rinaldo	born Venice, 1856; place and date of death unknown Genre painter.
Glaize, Auguste-Barthélemy	born Montpellier, 15 December 1807; died Paris, 8 August 1893 Painter of historical, religious and genre subjects; lithographer. Pupil of Eugène and Achille Devéria.
Grün, Jules-Alexandre	born Paris, 26 May 1868; died there, 1945 Genre, portrait and still-life painter. Pupil of Guillemet.
Hayez, Francesco	born Venice, 10 February 1791; died Milan, 10 February 1881 History and portrait painter. Studied first under Zanotti and later under Maggiotti; later moved to Rome, where he was a protégé of Canova, and in 1821 to Milan, where he taught at the Brera Academy.
Hébert, Antoine-Auguste-Ernest	born La Tronche (Grenoble), 3 November 1817; died there, 5 November 1908 History, genre and portrait painter. Studied law; simultaneously studied painting under David d'Angers and Delaroche, and later at the Paris Ecole des Beaux-Arts where he was a professor from 1882 onwards.
Herkomer, Sir Hubert von	born Waal (Bavaria), 26 May 1849; died Budleigh Salterton, 31 March 1914 Portrait, landscape, history and genre painter; engraver and sculptor. Moved to England c. 1862 with his father, a wood engraver.
Hodgson, John Evan	born London, 1 March 1831; died there, 19 June 1895 Genre, history and landscape painter. After a short period in commerce he entered the Royal Academy Schools in 1853; later became librarian and professor of painting at Royal Academy.
Hoff, Karl Heinrich	born Mannheim, 8 September 1838; died Karlsruhe, 13 May 1890 Painter of genre and costume subjects. Studied at Karlsruhe Academy of Fine Arts under Schirmer and Des Coudres, and at Düsseldorf under Vautier and Achenbach.

Hollosy, Simon	born Mamarossziget, 2 February 1857; died Tesco, 8 May 1918 Genre and landscape painter; illustrator. Studied under Székely and at the Munich Academy of Fine Arts. Founded a private school of painting in Munich, attended mainly by young Hungarians.
Jamin, Paul-Joseph	born Paris, 9 February 1853; died there, 10 July 1903 History, genre and portrait painter. Studied under Boulanger and Jules Lefebvre, and at the Paris Ecole des Beaux-Arts.
Johansen, Viggo	born Copenhagen, 3 January 1851; died there, 1935 Genre painter. Studied at Copenhagen Academy of Fine Arts, where he was later Director.
Keller, Albert von	born Gais (Appenzell), 27 April 1844; died Zurich, 14 June 1920 History and genre painter. Studied under Lenbach and Ramberg at the Munich Academy of Fine Arts.
Khnopff, Fernand	born Grembergen, 12 September 1858; died Brussels, 12 November 1921 Painter of portraits and Symbolist compositions; pastellist, sculptor and lithographer. Studied under Mellery at the Brussels Academy of Fine Arts, and under Jules Lefebvre in Paris.
Knaus, Ludwig	born Wiesbaden, 5 October 1829; died Berlin, 7 December 1910 Genre and portrait painter. Studied at the Düsseldorf Academy of Fine Arts under Sohn and Schadow. Lived in Düsseldorf and, from 1874, in Berlin where he had his own studio at the Academy of Fine Arts.
Korzukhin, Alexei Ivanovich	born Ukiusky Savody (Perm), 23 March 1835; died St Petersburg, 30 October 1894 Painter of genre, portraits and churches. Studied at the St Petersburg Academy of Fine Arts.
Kramskoy, Ivan Nikolayevich	born Novaya Sotnia, 8 June 1837; died St Petersburg, 6 April 1887 Painter of portraits and religious subjects. Studied at the St Petersburg Academy of Fine Arts.
Laszczynski, Boleslaw	born Grabow, 1842; died Krakow, 1909 Genre and portrait painter.
Lavalley, Alexandre-Claude-Louis	born Paris, 9 August 1862; died there, April 1927 Genre painter. Pupil of Cabanel, Maillot and Bouguereau.
Lecomte du Noüy, Jules-Jean-Antoine	born Paris, 10 June 1842; died there, 19 February 1923 Portrait, history and genre painter; sculptor. Pupil of Signol, Gleyre and Gérôme. After completing his studies he travelled widely in the East.
Leighton, Frederick, Lord	born Scarborough, 3 December 1830; died London, 25 January 1896 Painter of historical, genre and mythological subjects; illustrator, decorative painter and sculptor. Studied independently in a number of European centres: Rome, Florence, Frankfurt and Paris.
Lentz, Stanislaw	born Warsaw, 1863; died there, 19 October 1920 Portrait painter. Studied under Benczúr and Wagner in Munich.
Leroux, Louis-Hector	born Verdun, 27 December 1829; died Angers, 11 November 1900 History and genre painter. Pupil of Picot.

Leslie, George Dunlop	born London, 2 July 1835; died there, 21 February 1921 Genre, portrait and landscape painter. Studied under his father, Charles Robert Leslie, at the Royal Academy Schools.
Lewis, John Frederick	born London, 14 July 1805; died Walton-on-Thames, 1876 Watercolourist, painter of genre and animal subjects. Studied under his father, the engraver Frederick Christian Lewis. Travelled to Spain, Rome, Athens, Constantinople and Cairo.
Leys, Henri (Hendrik), Baron	born Antwerp, 18 February 1815; died there, 26 August 1869 History, genre, portrait and mural painter; engraver. Studied at Antwerp Academy of Fine Arts under Braekeleer.
Liezen-Mayer, Sándor	born Raab, 24 January 1839; died Munich, 18 February 1898 History painter. Studied at Vienna Academy of Fine Arts and under Piloty in Munich. Director of the Stuttgart School of Fine Arts.
Liphart, Ernst Friedrich von	born Ratshof (Dorpat), 24 August 1847; died Leningrad, 1934 History painter; draughtsman and engraver. Pupil of Krüger in Dorpat. Later worked in Florence and went from there to Spain with Lenbach and Baron von Schack. Lived in Paris (1873–76) where he studied under Jules Lefebvre. Lived from 1886 onwards in St Petersburg, becoming Curator of the Hermitage Museum in 1905.
Lotz, Károly	born Hessen-Homburg, 16 December 1833; died Budapest, 1904 History, mural and portrait painter. Studied under Rahl in Vienna.
Madrazo y Garreta, Raymond (Raimundo) de	born Rome, 24 July 1841; died Versailles, 15 September 1920 Genre and portrait painter. Studied under his father, Federico, in Madrid, and under Cogniet in Paris.
Maignan, Albert	born Beaumont-sur-Sarthe, 14 October 1845; died Saint-Prix, 29 September 1908 History and genre painter. Pupil of Noël and Luminais.
Makovsky, Konstantin Egorovich	born Moscow, 30 June 1839; died Petrograd, 17 November 1915 History, genre and portrait painter. Studied at Moscow School of Fine Arts and at St Petersburg Academy of Fine Arts.
Makovsky, Vladimir Egorovich	born Moscow, 26 January 1846; died Petrograd, 21 February 1920 Genre painter. Studied at Moscow School of Fine Arts. Professor at Petrograd Academy of Fine Arts. Brother of Konstantin.
Maksimov, Vassily Maksimovich	born 1844; died 18 November 1911, place of birth and death unknown Genre and portrait painter. Worked in studio of an icon painter in St Petersburg and later studied at Academy of Fine Arts there.
Maldarelli, Federico	born Naples, 2 October 1826; died there, 7 December 1893 History and portrait painter. Pupil of Angelini. Director of School of Fine Arts in Naples.
Malhoa, José	born Caldos de Rainha, 1855; died Figueiro dos Vinhos, 1933 Genre, portrait and landscape painter. Studied at National School of Fine Arts in Lisbon.
Martens, Willem Johan (Wilhelm Johannes)	born Amsterdam, 1839; died Berlin, 2 February 1895 Genre, portrait and landscape painter. Pupil of Pieneman. Worked in Rome, and, towards the end of his life, in Berlin.

Martineau, Robert Braithwaite

born London, 19 January 1826; died there, 13 February 1869
History and genre painter. Studied for the Bar before turning to painting. Studied under Holman Hunt and at Royal Academy Schools.

Masriera y Manovens, Francisco

born Barcelona, 21 October 1842; died there, 15 March 1902
Genre and portrait painter. Pupil of Serro. Worked frequently with his brother, José.

Matejko, Jan

born Krakow, 28 July 1838; died there, 1 November 1893
History and portrait painter. Studied at Krakow School of Fine Arts and at the Academies of Fine Arts in Munich and Vienna. Later directed the Krakow School of Fine Arts.

Max, Gabriel Cornelius von

born Prague, 23 August 1840; died Munich, 24 November 1915
Painter of historical and religious subjects; illustrator. Pupil of Piloty, influenced also by Delaroche. Taught at Munich Academy of Fine Arts.

Meissonier, Jean-Louis-Ernest

born Lyon, 21 February 1815; died Paris, 31 January 1891
History and genre painter. Pupil of Cogniet. In his lifetime had one of the 19th century's greatest reputations.

Menzel, Adolf von

born Breslau (Wroclaw), 8 December 1815; died Berlin, 9 February 1905
History and genre painter; engraver. Studied at Berlin Academy of Fine Arts, where he became a member of the Senate in 1875.

Merson, Luc-Olivier

born Paris, 21 May 1846; died there, 15 November 1920
Painter of religious and historical subjects. Son of a painter and art critic (Charles-Olivier Merson), he studied under Chassevent and Pils at the Paris Ecole des Beaux-Arts. Later resigned from professorship at the school in protest at what he considered to be a slackening of standards as a result of developments in modern art.

Millais, Sir John Everett

born Southampton, 8 June 1829; died London, 13 August 1896
Portrait, landscape, history and genre painter; illustrator. Studied at Royal Academy Schools from the age of 11. Brilliant success at an early age. With Holman Hunt and Rossetti, formed Pre-Raphaelite Brotherhood in 1848. Strongly influenced by John Ruskin, whose former wife he married in 1855.

Morbelli, Angelo

born Alessandria, 1853; died Milan, 1919
Landscape and genre painter; his favourite theme was aged inmates of poorhouses. Studied both music and painting, the latter at the Brera Academy under Bertini and Casnedi. Towards the end of the century, adopted a Pointillist technique under the influence of Grubicy.

Moreau de Tours, Georges

born Ivry-sur-Seine, 1848; died Bois-le-Roi, 12 January 1901
Painter of portraits and of historical and military subjects. Pupil of Marquerie and Cabanel.

Morelli, Domenico

born Naples, 4 August 1826; died there, 13 August 1901
Painter of religious subjects, also of portraits and genre. Studied under Angelini and Guerra at Naples Academy of Fine Arts, and later under Mancinelli. Became professor at Naples Academy of Fine Arts.

Munkácsy (Lieb), Mihály

born Munkács, 20 February 1844; died Endenich (Bonn), 1 May 1900
Painter of historical and religious subjects, genre, portraits and

landscape. Studied at Budapest Academy of Fine Arts, under Rahl in Vienna and Sándor Wagner in Munich. Lived in Paris and enjoyed international renown.

Muzzioli, Giovanni

born Modena, 10 February 1854; died there, 5 August 1896
History and genre painter. Studied under Simonazzi and Asioli in Modena, and under Podesti and Coghetti in Rome. Worked for many years in Florence.

Nesterov, Mikhail Vassilievich

born Ufa, 19 May 1862; died Moscow, 18 October 1942
Painter of religious subjects, of genre and portraits. Studied at Moscow School of Fine Arts and at Petrograd Academy of Fine Arts.

Neureuther, Eugen Napoleon

born Munich, 3 January 1806; died there, 23 March 1882
History painter; engraver and illustrator. Studied at Munich Academy of Fine Arts. Took part in management of the Nymphenburg porcelain factory and of the Munich School of Applied Arts.

Orchardson, Sir William Quiller

born Edinburgh, 27 March 1832; died London, 13 April 1910
Genre, history and portrait painter. Studied at Trustees' Academy in Edinburgh, during which time influenced by Scott Lauder.

Palmaroli y González, Vicente

born Zarzelejo (Madrid), 5 September 1834; died there, 25 January 1896
History, genre and portrait painter. Studied under Madrazo and at Academia de San Fernando in Madrid. Directed Spanish Academy in Rome and Madrid art gallery.

Pennasilico, Giuseppe

born Naples, 19 March 1861; died Genoa, 1940
Genre, portrait and animal painter. Studied under Morelli in Naples. Later moved to Genoa, when he developed an active practice.

Perov, Vassily Grigorievich

born Tobolsk, 21 December 1833; died Moscow, 29 May 1882
Genre and portrait painter. Studied at Moscow School of Fine Arts and in Paris. Professor at Moscow School of Fine Arts.

Piloty, Karl Theodor von

born Munich, 1 October 1826; died Ambach, 21 June 1886
History painter. Studied at Munich Academy of Fine Arts, where he was Director from 1874 onwards.

Postiglione, Salvatore

born Naples, 20 December 1861; died there, 28 November 1906
Painter of religious, historical and genre subjects. Pupil of his father, Luigi Postiglione, and Morelli.

Poynter, Sir Edward John

born Paris, 20 March 1836; died London, 26 July 1919
History and genre painter; watercolourist and decorative painter. Studied briefly at Royal Academy Schools and later under Gleyre in Paris. Lived in London from 1860 onwards.

Predić, Uroš

born Orlovat, 7 December 1857; died Belgrade, 11 February 1953
Painter of genre, historical and religious subjects and portraits. Studied at Vienna Academy of Fine Arts and under Griepenkerl.

Quinsac, Paul-François

born Bordeaux, 1858; place and date of death unknown
Portrait and figure painter. Pupil of Gérôme.

Ranzoni, Daniele

born Intra, 3 December 1843; died there, 20 October 1889
Portrait and landscape painter. Studied at the Brera Academy in Milan under Bertini, and at the Albertina Academy in Turin. His

output, disrupted by a succession of mental and physical disorders, was small, but his posthumous reputation was high.

Régamey, Guillaume Urbain
born Paris, 22 September 1837; died there, 3 January 1875
History and genre painter; illustrator. Pupil of L. P. G. Régamey and Boisbaudran.

Repin, Ilya Efimovich
born Chuguzhev, 5 August 1844; died Koukkala (Finland), 29 September 1930
History, genre and portrait painter; engraver. The dominant figure in late 19th-century Russian painting. Worked initially with an icon painter at Chuguzhev and later studied at the St Petersburg Academy of Fine Arts. Study trips to Italy and France.

Rochegrosse, Georges-Antoine
born Versailles, 2 August 1859; died there, 1938
History painter; illustrator and lithographer. Pupil of Boulanger and Lefebvre.

Roll, Alfred-Philippe
born Paris, 1 March 1846; died there, 27 October 1919
Painter of portraits and of genre, military and mythological subjects, of landscapes and seascapes. Pupil of Gérôme, Bonnat and Harpignies. President of the Société Nationale des Beaux-Arts.

Romako, Anton
born Atzgersdorf (Vienna), 20 October 1834; died Döbling, 8 March 1889
Portrait, figure and landscape painter. Studied under Rahl in Vienna, Kaulbach in Munich and Werner in Venice. After a period of fame, while he lived in Rome from 1857 to 1874, he returned to Vienna, where he fell into neglect and eventually killed himself.

Sant, James
born Croydon, 23 April 1820; died London, 12 July 1916
History and genre painter. Studied under Varley and Calcott, and at Royal Academy Schools.

Sargent, John Singer
born Florence, 12 January 1856; died London, 15 April 1925
Portrait and genre painter; decorative painter. Studied independently in Rome and Florence and attended studio of Carolus-Duran in Paris.

Sernesi, Raffaelle
born Florence, 29 December 1838; died Bolzano, 11 August 1866
Landscape and portrait painter; painted a few group subjects. Pupil of Ciseri, later influenced by the Macchiaioli group.

Serov, Valentin Aleksandrovich
born St Petersburg, 7 January 1865; died Moscow, 22 November 1911
Painter of portraits, genre and landscape. Studied under Köpfing in Munich and Repin in Paris, also at the St Petersburg Academy of Fine Arts.

Siemiradzki, Henryk
born Bilhorod (Kharkov), 10 October 1843; died Strzalkovo, 23 August 1902
Painter of historical and mythological subjects. Studied at St Petersburg Academy of Fine Arts and later in Munich and Rome.

Solomon, Solomon Joseph
born London, 16 September 1860; died Birchington, 27 July 1927
History and genre painter. Studied at the Royal Academy Schools and under Cabanel in Paris.

Stevens, Alfred
born Brussels, 11 May 1823; died Paris, 24 August 1906

Genre and portrait painter. Pupil of Navez in Brussels and Roqueplan in Paris.

Storey, George Adolphus	born London, 7 January 1834; died there, 29 July 1919 Genre and portrait painter. Studied under Dulang in Paris, at the Leigh School and Royal Academy Schools in London, where he taught perspective.
Surikov, Vassily Ivanovich	born Krasnoyarsk, 12 January 1848; died Moscow, 6 March 1916 History, genre and portrait painter. Studied at St Petersburg Academy of Fine Arts.
Székely, Bertalan	born Kolozsvár, 8 May 1835; died Matyasföld (Budapest), 21 August 1910 Painter of historical and mythological subjects. Studied under Rahl in Vienna, and under Piloty at the Munich Academy of Fine Arts.
Szinyei Merse, Pál	born Sziny-Ujfalu, 4 July 1845; died Jernye, 2 February 1920 Genre, landscape and portrait painter. Pupil of Piloty in Munich. Professor at the Budapest Academy of Fine Arts.
Szyndler, Pantaleon	born Warsaw, 26 July 1856; died February 1905, place of death unknown Genre and portrait painter. Studied at the Warsaw School of Painting and Drawing, later in Munich and Rome, and in Paris under Cabanel.
Tarenghi, Enrico	born Rome, 1856; place and date of death unknown Painter of genre and architectural subjects; watercolourist.
Tissot, James Jacques Joseph	born Nantes, 15 October 1836; died Château de Bouillon (Doubs), 8 August 1902 Painter of historical, religious and genre subjects, landscapes and portraits; engraver and modeller. Pupil of Lamotte and Flandrin. After the 1870–71 war and the Paris Commune, in which he played an active part, he moved to England. His scenes of London life enjoyed great success. At the height of his career he abruptly moved to Palestine where he worked on scenes from the life of Christ. Later he withdrew to the abbey of Bouillon, where he worked on Old Testament themes.
Uhde, Fritz Karl Hermann von	born Wolkenburg (Saxony), 22 May 1848; died Munich, 25 February 1911 Genre, portrait and landscape painter. Studied at the Dresden Academy of Fine Arts, became a cavalry officer. Largely self-taught as a painter, he later studied for a time under Munkácsy in Paris.
Vaznetsov, Viktor Mikhailovich	born Vyatka, 1848; died Moscow, 1926 Painter of historical, religious and genre subjects. Abandoned theological college to study in St Petersburg under Kramskoy and at the Academy of Fine Arts.
Veloso-Salgado, José	born Orense (Spain), 1864; died Lisbon, 1945 History and genre painter. Studied at the Lisbon National School of Fine Arts, later in Paris under Cabanel, Delaunay, Cormon and Constant.
Vereshchagin, Vassily Vassilievich	born Novgorod, 26 October 1842; died Port Arthur, 13 April 1904 Painter of historical, military and factual subjects; writer. Attended Naval Academy in St Petersburg, then went to the School of the

Society for the Support of the Arts and the St Petersburg Academy of Fine Arts. Later studied under Gérôme in Paris. Died while serving as a war artist.

Wagner, Sándor (Alexander von)	born Budapest, 16 April 1838; died Munich, 19 January 1919 Pupil of Blaas and Geiger at the Vienna Academy of Fine Arts, and of Piloty at Munich, he was also professor at the Munich Academy of Fine Arts.
Waterhouse, John William	born Rome, 1849; died London, 1917 Painter of historical and mythological subjects. Studied under his father in Leeds, at the South Kensington Art Schools and the National Academy. The dominant influence in his art was that of Alma-Tadema.
Werner, Anton Alexander von	born Frankfurt an der Oder, 9 May 1843; died Berlin, 4 January 1915 Painter of historical (mainly contemporary) subjects; illustrator. Studied at Frankfurt an der Oder and Karlsruhe. Directed Berlin Academy of Fine Arts.
Ziem, Félix François Georges Philibert	born Beaune, 26 February 1821; died Paris, 10 November 1911 Marine painter. Studied at Dijon School of Architecture. Found most of his subjects in Venice and its Lagoon, in Constantinople and on the Bosphorus.
Zmurko, Franciszek	born Lvov, 1859; died Warsaw, 1910 Genre, figure and portrait painter. Studied under Wagner in Munich, and under Matejko.

Outline Bibliography

Allem, Maurice, *La Vie quotidienne sous le Second Empire*, Paris, Hachette, 1948.

Alloway, Lawrence, *The Venice Biennale 1895–1968*, Greenwich, New York Graphic Society, 1968.

Baudelaire, Charles, *Œuvres complètes*, Paris, Gallimard, 1961.

'Baudelaire', exhibition catalogue, Paris, Réunion des Musées Nationaux, 1968.

Bénédite, Léone, *La Peinture au XIXe siècle d'après les chefs-d'œuvre des maîtres et les meilleurs tableaux des principaux artistes*, Paris, Flammarion, 1909.

Bénézit, E., *Dictionnaire des peintres, sculpteurs et graveurs*, Paris, Gründ, 1956.

Boime, Albert, *The Academy and French Painting in the Nineteenth Century*, London, Phaidon, 1971.

Burnand, Robert, *La Vie quotidienne en France de 1870 à 1900*, Paris, Hachette, 1947.

Cassou, Jean, *Situation de l'art moderne*, Paris, Minuit, 1950.

Clive, Mary, *The Day of Reckoning*, London, Macmillan, 1964.

Crespelle, Jean-Paul, *Les Maîtres de la belle époque*, Paris, Hachette, 1966.

Dali, Salvador, 'Hommage à Meissonier', exhibition catalogue, Paris, Hôtel Meurice, 1967.

Dorfles, Gillo, *Kitsch*, London, Studio Vista, and New York, Dutton, 1968.

Dubuffet, Jean, *Asphyxiante culture*, Paris, J. J. Pauvert, 1968.

Duvignaud, Jean, *Sociologie de l'art*, Paris, Presses Universitaires de France, 1967.

Duvignaud, Jean, *Sociologie du théâtre: Essai sur les ombres collectives*, Paris, Presses Universitaires de France, 1965.

'Equivoques: Peintures françaises du XIXe siècle', exhibition catalogue, Paris, Musée des Arts Décoratifs, 1973.

Fouillée, Alfred, *La Morale, l'art et la religion d'après Guyaud*, Paris, Félix Alcan, 1923.

Francastel, Pierre, *Art et technique aux XIXe et XXe siècles*, Paris, Minuit, 1956.

Francastel, Pierre, *Histoire de la peinture française, II: Du classicisme au cubisme*, Paris, Gonthier, 1967.

'French Symbolist Painters', exhibition catalogue, London, Arts Council of Great Britain, 1972.

Gaunt, William, *The Restless Century: Painting in Britain 1800–1900*, London, Phaidon, 1972.

Groethuysen, Bernard, *Origines de l'esprit bourgeois en France, I: L'Eglise et la bourgeoisie*, Paris, Gallimard, 1956.

Guyau, Jean-Marie, *Les Problèmes de l'esthétique contemporaine*, Paris, Félix Alcan, 1935.

Halbwachs, Maurice, *Esquisse d'une psychologie des classes sociales*, Paris, Marcel Rivière, 1964.

Hansen, Hans Jürgen, *Das pompöse Zeitalter: Zwischen Biedermeier und Jugendstil*, Oldenburg and Hamburg, Stalling, 1970.

Histoire du peuple français: Cent ans d'esprit républicain, Paris, Nouvelle Librairie de France, 1967.

Istoria ruskogo iskustva, IX–X, Moscow, Izdatelstvo 'Nauka', 1965–1968.

'Jean-Léon Gérôme, 1824–1904', exhibition catalogue with introduction by G. M. Ackerman, Dayton, The Dayton Art Institute, 1972.

Jourdain, Francis, 'L'Art officiel de Jules Grévy à Albert Lebrun', *Le Point*, Mulhouse, 1949, XXVII.

Joyce, James, *The Critical Writings of James Joyce*, London, Faber and Faber, 1959.

Lacambre, Geneviève, 'Lucien Lévy-Dhurmer', *Revue du Louvre*, Paris, 1973, 1.

Lanoux, Armand, *1900: La Bourgeoisie absolue...*, Paris, Hachette, 1973.

Lethève, Jacques, *La Vie quotidienne des artistes français au XIXe siècle*, Paris, Hachette, 1968.

Maas, Jeremy, *Victorian Painters*, London, Barrie and Jenkins, 1970.

Mack Smith, Denis, *Storia d'Italia dal 1861 al 1958*, Bari, Editori Laterza, 1966.

'Makart', exhibition catalogue, Baden-Baden, Staatliche Kunsthalle, 1972.

'Marcel Proust en son temps', exhibition catalogue, Paris, Musée Jacquemart-André, 1971.

Millais, John Quille: *The Life and Letters of Sir John Everett Millais*, London, Methuen, 1899.

Moles, Abraham A., *Le Kitsch: l'art du bonheur*, Paris, Mame, 1971.

Morpurgo-Tagliabue, Guido, *Savremena estetika: Pregled*, Belgrade, Nolit, 1968.

'Mostra di Vittorio Corcos', exhibition catalogue, ed. Dario Durbé, Livorno, Comitato Estate Livornese, 1965.

The Nineteenth Century: The Contradictions of Progress, London, Thames and Hudson, and New York, McGraw-Hill, 1970.

'The Nineteenth Century in America: Paintings and Sculpture', exhibition catalogue, New York, The Metropolitan Museum of Art, 1970.

Ormond, Richard: *Sargent: Paintings, Drawings, Watercolours*, London, Phaidon, 1970.

'La Peinture romantique anglaise et les préraphaélites', exhibition catalogue, Paris, Les Presses artistiques, 1972.

Perneczky, Géza, *Munkácsy*, Budapest, Corvina, 1970.

Perrot, Marguerite, *La Mode de vie des familles bourgeoises 1873–1953*, Paris, Armand Colin, 1961.

Pius IX, *Acta SS. D. N. Pii PP. IX ex quibus excerptus est Syllabus*, Rome, Typis Rev. Camerae Apostolicae, 1865.

Pogány, Gábor O., *Die ungarische Malerei des 19. Jahrhunderts*, Budapest, Corvina, 1971.

Ponteil, Félix, *Les Classes bourgeoises et l'avènement de la démocratie, 1815–1914*, Paris, Albin Michel, 1968.

Propyläen-Weltgeschichte, VIII: Das neunzehnte Jahrhundert, Frankfurt am Main and Berlin, Ullstein, 1960.

Réau, Louis, *L'Art russe de Pierre le Grand à nos jours*, Paris, Henri Laurens, 1922.

Reff, Theodore, 'Further Thoughts on Degas's Copies', *Burlington Magazine,* London, 1971.

Rheims, Maurice, *The Flowering of Art Nouveau*, London, Thames and Hudson, and New York, Harry N. Abrams, 1966.

Schurr, Gérald, *1820–1920: Les Petits Maîtres de la peinture, valeur de demain*, Paris, La Gazette, 1969.

Taine, Hippolyte, *Philosophie de l'art*, Paris, Hachette, 1909.

Torino 1902, polemiche in Italia sull'Arte Nuova, Turin, Martano, 1970.

Van Tieghem, Philippe, *Dictionnaire des littératures*, Paris, Presses Universitaires de France, 1968.

Vogt, Paul, *Was sie liebten... Salonmalerei im XIX. Jahrhundert*, Cologne, M. DuMont Schauberg, n.d.

Wiercinska, Janina, *Towarzystwo Zachety Sztuk Pieknych w Warszawie*, Warsaw, Instytut Sztuki Polskiej Akademii Nauk, 1968.

Acknowledgments

Without the kind support of friends and specialists in many countries this attempt at a survey of a truly cosmopolitan style could never have been undertaken, particularly as I was anxious to base my interpretations as far as possible on study of the original works. My heartfelt thanks to all those who have given me advice and help.

First of all I must thank Madame Geneviève Lacambre, Conservateur at the Department of Paintings of the Louvre, who drew my attention to a number of little-known works, and who very kindly read the book in manuscript. I am also grateful, for help with the choice of works, to Dottoressa Palma Bucarelli, Director of the Galleria Nazionale d'Arte Moderna in Rome, Professor Wladyslawa Jaworska, of the Institute of Art of the Polish Academy of Sciences and Arts, Senhor José-Augusto França, editor of the periodical *Colóquio-Artes* in Lisbon, and Professor Julián Gallego, of the Autonomous University of Madrid.

I owe a further debt of gratitude, for generous co-operation, to Mrs Nora Aradi, Director of the Institute of Art History of the Hungarian Academy of Sciences; Mr Edmund A. Bator, Cultural Attaché at the US Embassy in Belgrade; Monsieur Pierre Bouvet, Director of the Musée de Laval; Madame Denise Breteau, of Paris; Mademoiselle Thérèse Burollet, Director of the Musée Cognacq-Jay in Paris; Monsieur Jean Cluseau-Lanauve, the painter, of Paris; Professor Gillo Dorfles, of the University of Cagliari; Dr Dario Durbè, Curator at the Galleria Nazionale d'Arte Moderna in Rome; Mrs Magda van Emde Boas-Starkenstein, the art critic, of Amsterdam; Professor H.L.C. Jaffé, of the University of Amsterdam; Monsieur Jean Lacambre, Conservateur at the Inspection Générale des Musées classés et contrôlés in Paris; Madame Francine-Claire Legrand, Conservateur at the Musées Royaux de Belgique; Monsieur Jean-Hubert Martin, Conservateur at the Musée National d'Art Moderne in Paris; Mademoiselle Gilberte Martin-Méry, Director of the Musée des Beaux-Arts in Bordeaux; the Director of the Musée des Beaux-Arts in Pau; Señor Luis Gonzales Robles, Director of the Museo Español de Arte Contemporáneo in Madrid; Dr István Solimar, Curator at the Hungarian National Gallery in Budapest; Professor Julius Starzynski, Director of the Institute of Art History in Warsaw; Dr Eva Visi-Strobl of the Hungarian National Gallery in Budapest; Mademoiselle Jeannine Warnot, the art critic, of Paris; and Mr Gabriel White, of London.

The owners and administrators of the following private and public collections have been kind enough to allow me to reproduce works in their care: those of Monsieur Gérard Lévy, Paris; Mr C.J.R. Pope, London; Monsieur Gérard Séligman, Paris; Monsieur Charles Vincens Bouguereau, Lyon; Monsieur Robert Walcker, Paris; and the following institutions: Archives Départementales, Besançon; Bayerische Staatsgemäldesammlungen, Munich; Brooklyn Museum; City Art Gallery, Bristol; City Art Gallery and Museum, Glasgow;

Civica Galleria d'Arte Moderna, Milan; Magyar Nemzeti Galéria, Budapest; Galleria Nazionale d'Arte Moderna, Rome; State Tretyakov Gallery, Moscow; Staatliche Kunstsammlungen, Gemäldegalerie Neue Meister, Dresden; Hamburger Kunsthalle; Jefferson Medical College, Jefferson University of Philadelphia; Lady Lever Art Collection, Port Sunlight; Laing Art Gallery and Museum, Newcastle-upon-Tyne; Leighton House, London; Mairie de Sermaise-les-Bains; Metropolitan Museum of Art, New York; Musée d'Arras; Musée de l'Assistance Publique, Paris; Musée des Augustins, Toulouse; Musée des Beaux-Arts, La Rochelle; Musée des Beaux-Arts, Nancy; Musée des Beaux-Arts, Nantes; Musée des Beaux-Arts, Rouen; Musée Bernadotte, Pau; Musée Carnavalet, Paris; Musée du Château, Compiègne; Musée de Dijon; Museum voor Schone Kunsten, Ghent; Musée de l'Impression sur Etoffes, Mulhouse; Musée du Louvre, Paris; Panorama Mesdag, The Hague; Museu Nacional de Arte Antiga, Lisbon; Narodni Muzej, Belgrade; Nationalmuseum, Stockholm; Muzeum Narodowe, Warsaw; Musée du Petit Palais, Paris; Musée de Picardie, Amiens; Museo del Prado, Madrid; Musée Raymond Lafage, Lisle-sur-Tarne; State Russian Museum, Leningrad; Musées Royaux des Beaux-Arts de Belgique, Brussels; Museu da Cidade, Lisbon; Museum of Fine Arts, Boston; Österreichische Galerie des 19. Jahrhunderts, Vienna; Pinacoteca di Brera, Milan; Museu do Ultramar e Etnográfico, Lisbon; Staatliche Museen Preussischer Kulturbesitz, Berlin; Stedelijk Museum, Amsterdam; Tate Gallery, London.

The Amsterdam publisher Mr Andreas Landshoff has made a major contribution. His confidence in my work, and the patience with which he waited for the result of my researches, have often saved me from losing heart.

Monsieur Sacha Tolstoï skilfully and sympathetically translated and adapted my manuscript from the Serbo-Croat original.

I must end by giving due acknowledgment to my wife, Milica Čelebonović. She collected the documentary material, and throughout the work on this book she was constantly a patient and interested confidante and critic.

Photo Credits

The author and publisher wish to thank the following sources for the photographs reproduced:

Archives Corvina, Budapest (pp 129, 139, 167).
Archives Photographiques, Paris (pp 21, 124).
Archivio Fotografico dei Civici Musei, Milano/Castello Sforzesco (pp 58, 70, 145, 147, 150, 151).
Photo Bläuel, Munich (pp 74, 88).
Braun & Cie., Mulhouse (p 53).
Photographie Bulloz, Paris (pp 94, 110, 111, 121, 127, 146, 164, 168, 168, 170, 173).
Cercle d'Art, Paris (pp 19, 52, 100).
Copyright A. C. L., Bruxelles (pp 70, 130, 145, 146, 149).
Courtauld Institute of Art, London (p 119).
Deutsche Fotothek, Dresden (pp 142, 149).
Glasgow Art Gallery (p 133).
Grün (p 158).
Ralph Kleinhempel, Hamburg (pp 96, 97, 105, 130, 140, 144, 144, 174).
Photo Neil Koppes, Scotsdale, Ariz. (p 77).
Gérard Levy, Paris (pp 88, 174, 176).
Studio Lourmet 77-Paris/G. Routhier (pp 10, 48, 49, 56, 60, 73, 83, 93, 103, 116, 117, 122, 155, 161).
Photo Studio Madec, Nantes (p 55).
Photo J. Mierzecka (p 104).
Museo del Prado, Servicio de Fotografías y Publicaciones, Madrid (pp 23, 136, 137).
Copyright National Museum, Stockholm (p 106).
Fotostudio Otto, Wien (p 160).
Philadelphia Museum of Art, photograph by A. J. Wyatt, Staff Photographer (p 154).
Photo M. Plassard – Agence Top, Paris (p 39).
Polska Akademia Nauk, Instytut Sztuki Pracownia Fotographieczna (p 12).
Monsieur Rémy, Dijon (pp 68, 87)
Photo N. D. Roger-Viollet, Paris (pp 41, 43, 44, 89, 90).
Foto H. Romanovski (pp 150, 166).
Photo J. R. Roustan, Paris (pp 122, 126).
Scala, Florence (pp 82, 163, 169, 172).
Service de Documentation photographique de la Réunion des Musées Nationaux, Paris (pp 29, 113, 128).
Foto St. Sobkowics, Warsaw (p 64).
Foto Soprintendenza alle Gallerie, Rome (pp 59, 62, 66, 67, 81, 86, 108, 133, 136).
Foto Stedelijk Museum, Amsterdam (pp 146, 156).
Walter Steinkopf, Berlin (p 107).

Index

Artists' names only are listed; page numbers in *italic* refer to the illustrations.